PALMETTO **PORTRAITS** PROJECT

PALMETTO **PORTRAITS** PROJECT

A collaboration among the Medical University of South Carolina,
Halsey Institute of Contemporary Art at the College of Charleston,
and South Carolina State Museum

Palmetto Portraits Project
Photographers and Locations on the MUSC Campus

Series I—Hollings Cancer Center
Jack Alterman, Charleston
Jon Holloway, Greenwood
Phil Moody, Rock Hill
Nancy Santos, Charleston
Mark Sloan, Charleston
Michelle Van Parys, Charleston

Series II—College of Dental Medicine
Vennie Deas-Moore, Columbia
Caroline Jenkins, Greenwood
Nancy Marshall, McClellanville
Milton Morris, Charleston
Kathleen Robbins, Columbia
Sam Wang, Clemson

Series III—James W. Colbert Education Center and Library
Gayle Brooker, Charleston
Julia Lynn, Charleston
Blake Praytor, Greenville
Ruth Rackley, Clinton
Cecil Williams, Orangeburg

Series IV—College of Dental Medicine
Jeff Amberg, Columbia
Brett Flashnick, Columbia
Squire Fox, Charleston
Andrew Haworth, Columbia
Molly Hayes, Charleston
Stacy L. Pearsall, Charleston
Chris M. Rogers, Charleston

This publication accompanies the exhibition
Palmetto Portraits Project at the South Carolina State Museum and on the MUSC campus.
This project is a multiyear collaboration among the Medical University of South Carolina,
Halsey Institute of Contemporary Art at the College of Charleston,
and South Carolina State Museum, in Columbia.

Partial funding for this publication was made possible by **FUJiFILM**

Copublishers:
Halsey Institute of Contemporary Art
School of the Arts
College of Charleston
161 Calhoun Street
Charleston, South Carolina
29424
843.953.5680 T
www.halsey.cofc.edu

The Medical University of South Carolina
Colcock Hall
179 Ashley Avenue
Charleston, South Carolina
29425
843.792.2211 T
http://musc.edu/

Produced by the Publishing Department
Halsey Institute of Contemporary Art
Editor: Mark Sloan
Editorial assistance: Roberta Sokolitz
Graphic Designer: Mark Lawrence of Gil Shuler Graphic Design
Graphic Design assistance: Anne Norris
Copy Editor: Gerald Zeigerman
Printing: R. L. Bryan, Columbia, South Carolina
Project website: http://palmettoportraits.musc.edu/

ISBN: 978-0-615-35474-3

Available through the Halsey Institute of Contemporary Art

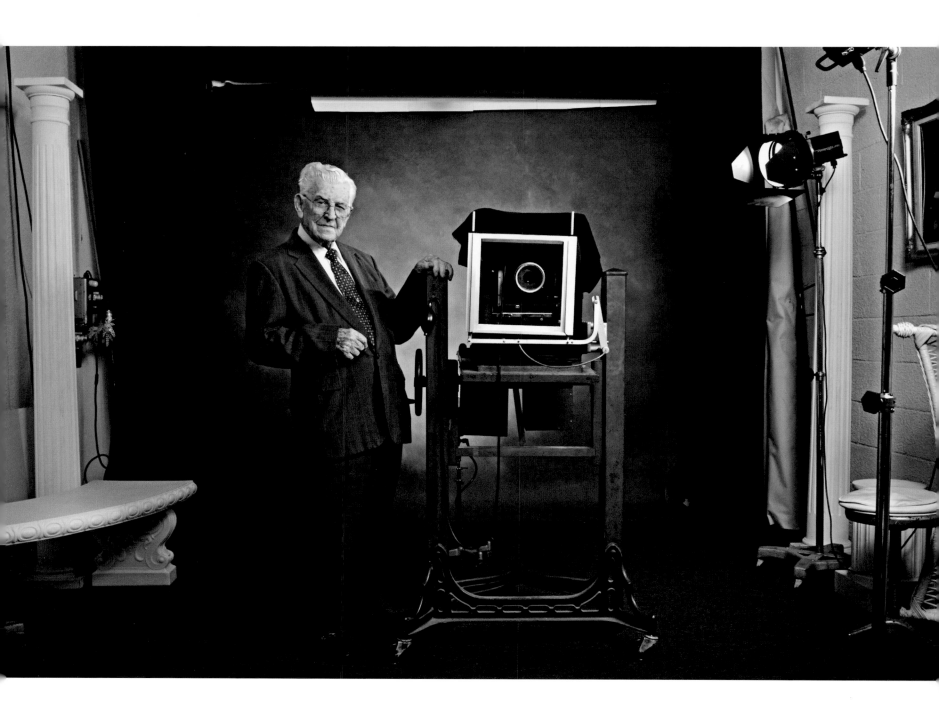

Elwood J. Lackey, Photographer, 2009. Orangeburg, SC. **Photographer: Andrew Haworth**

Contents

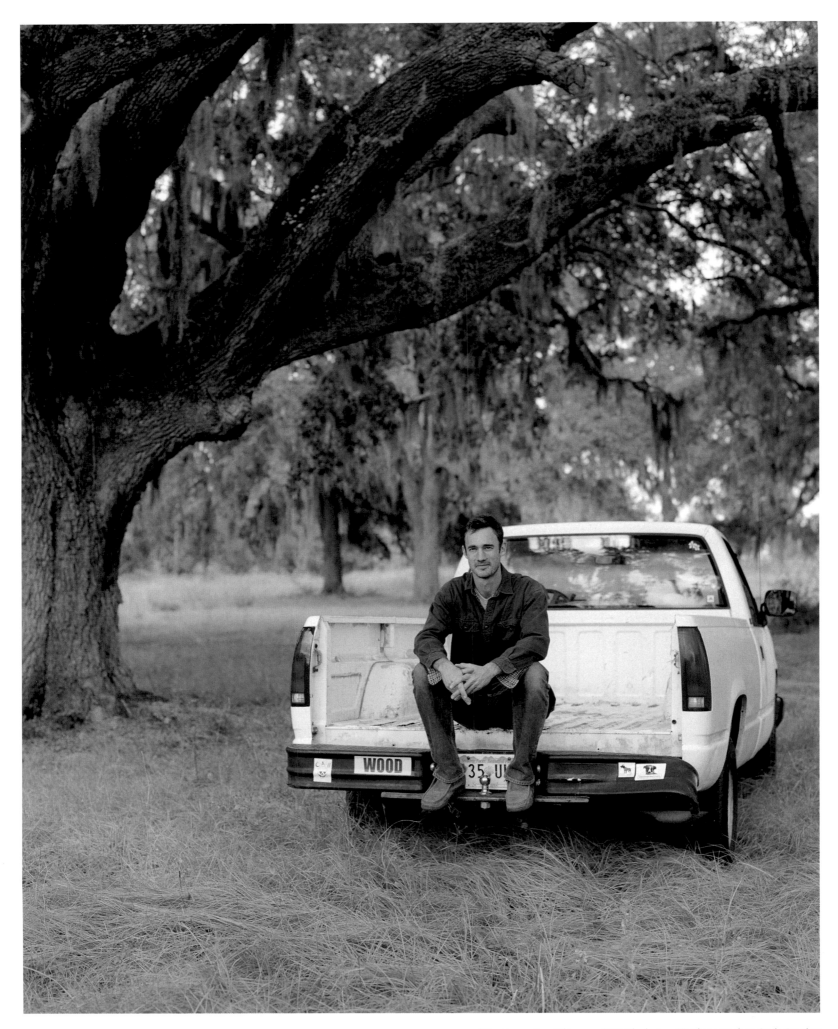

Mike Moran, Tree Whisperer, 2008. Charleston, SC. **Photographer: Gayle Brooker**

Preface

Raymond S. Greenberg, MD, PhD
President, Medical University of South Carolina
Charleston, South Carolina

Art is a human activity having for its purpose the transmission to others of the highest and best feelings to which men have risen.

—Leo Tolstoy

The campus of the Medical University of South Carolina is a hub of constant activity. On any given day, one can find students rushing to classes, scientists heading to laboratories, and clinicians dashing to clinics and hospitals. Even to the casual observer, it is clear that everyone here has a purpose. What may not be apparent in the blur of all these different activities is that a shared mission underlies the entire enterprise. Ultimately, every lecture, research experiment, and clinical encounter is motivated by our core reason to exist as an academic health center—to help improve the lives of others.

Of course, in the press of our busy days, it is easy to lose sight of this. More often than not, we find ourselves dealing with the practicalities of getting through overflowing schedules, rarely pausing to reflect on why we are here in the first place. All of us—students, faculty, staff, and especially those in leadership roles—could benefit from a regular reminder that we are not at the university to advance our own personal agendas or satisfy our own desires, we are here to serve the needs of others. It is a lesson that we hope to instill in those who are just entering the health professions, but even the most seasoned among us can benefit from a periodic reinforcement of this message.

It was in that spirit that the *Palmetto Portraits Project* was conceived. Our goal was to create a visual call to purpose for the university community. To do this, we needed to break with convention, or at least one time-honored academic custom; instead of the tradition of gracing our public spaces with paintings of venerated institutional leaders from the past, we would reserve places of honor for the public that we serve. Admittedly, we have not departed entirely from the culture of worshipping distinguished heroes from the university's past. After all, with nearly two centuries of prior role models, it is reassuring to know that they are looking over our collective shoulders. Nevertheless, what we have sought to do is strike a balance between paying homage to our professional exemplars and celebrating the larger community in which we are privileged to live and serve.

To construct a faithful photographic documentary of the people of our state, we set out to assemble images of South Carolinians of all ages, races, regions, religions, cultures, and traditions. By depicting these subjects in their homes, work sites, houses of worship, and places of relaxation and escape, we hoped to frame the subjects within the authentic context of their respective lives.

Keeping these broad outlines in mind, we engaged some of the most gifted photographers in the state. Each was encouraged to interpret the assignment through their own personal vision and allow their creativity full play. The photographers worked independently, and yet, at the end of the four-year project, the individual artistic contributions came together to create an indelible family album of the people of South Carolina.

As the *Palmetto Portraits Project* approaches completion, one may reasonably ask whether it has accomplished its intended purpose. If one believes Edward Steichen's statement that "photography is a major force in explaining man to man," then surely this collection goes a long way toward helping us understand South Carolinians. For people "from away," there is no better visual primer on our people. Even someone who was born and raised here is likely to see our state somewhat differently after viewing this collection.

Still, one has to wonder if such photographs as these can speak to a deeper sense of purpose, like reminding us of our obligation to serve others. Unfortunately, we have no quantitative data to answer that question; what we do have, though, are isolated reports from individuals about their reactions to the work. The example that I hold most dear is the student who told me that he first saw the *Palmetto Portraits Project* while visiting campus for admission interviews, and was so moved that he ultimately chose to attend the Medical University over several other schools.

The truth is that we can never predict or fully understand how an image will affect a viewer, if it is even noticed in the first place. It seems likely that a good proportion of those on campus, including many who walked by the Palmetto Portraits on a daily basis, never stopped to look at them. Among those who did observe the photographs, many probably did so only in passing, without much reflection on why the images were there or what they were intended to communicate. Yet, for some, perhaps a small minority, these portraits undoubtedly made a difference—and that alone justified the entire effort.

(P. 9) Elfton Dorsey, 2006. Georgetown, SC.
Photographer: Jon Holloway

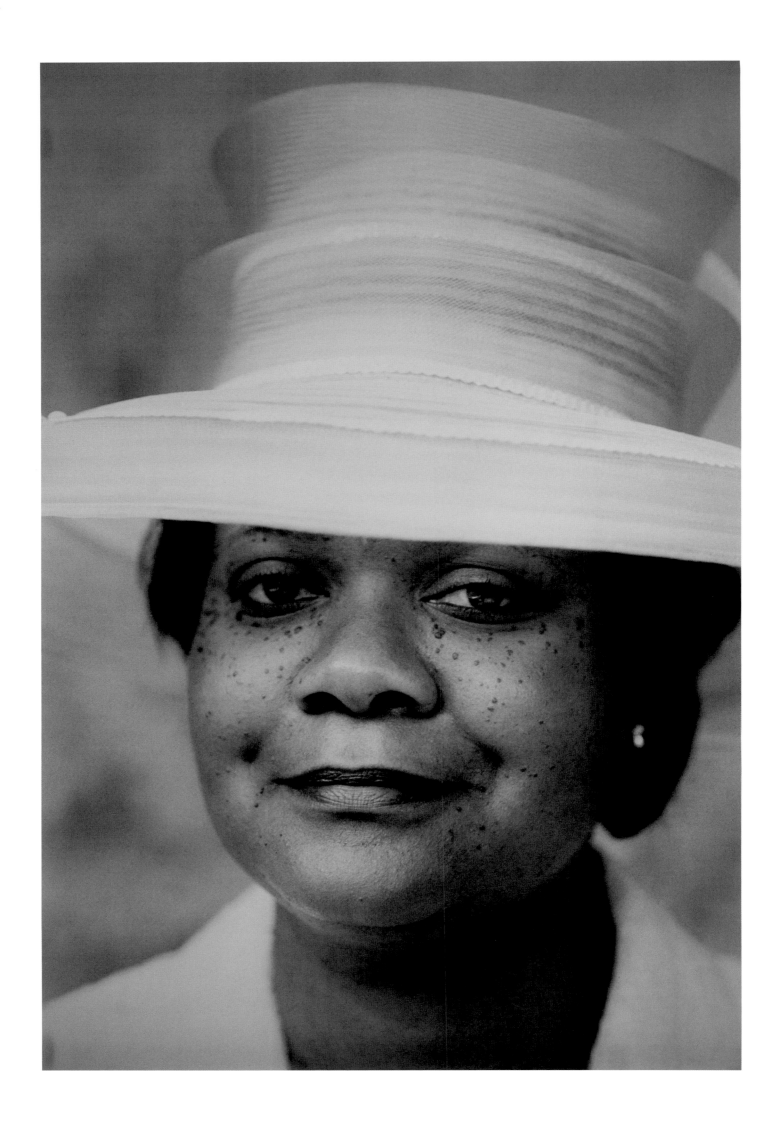

Privileged Access

Mark Sloan
Director & Senior Curator
Halsey Institute of Contemporary Art
College of Charleston
School of the Arts

Photographers have been using their cameras to provide access to hidden worlds since the invention of the medium in 1839. Sometimes, these photographs reveal the exotic or remote—exploding supernovas, say, or ethnographic images of pygmy bushmen—while others probe the more intimate, and no less inscrutable, terrain of the human portrait. The best portrait photographers have always presented us with images that transcend mere representation of the sitter. In these photographs, the subject is both revealed and concealed, and the mystery deepened.

The twenty-four photographers selected for the *Palmetto Portraits Project* give us privileged access to their subjects and the worlds they inhabit. Each was afforded free reign to make whatever portraits they found most interesting or compelling; tourists were fair game, as were students. The only stipulation was that they make portraits of South Carolinians. Some photographers stayed close to home and pursued family and friends, others gave themselves assignments that propelled them into unfamiliar communities. Stacy Pearsall, a decorated combat photography veteran of the War on Terror, focused on recruits from all the branches of the military stationed in South Carolina. Molly Hayes chose to explore the anachronistic pursuits of history reenactors, giving us a glimpse into the delicate balance between authenticity and practicality. Of particular interest is the portrait of the surgeon in Jon Holloway's collection (page 176): It is his own father performing his last surgery before retirement. Jack Alterman was able to convince Mama of Mama's Used Cars, in Charleston, to pose in the middle of US Highway 17 (resplendent in her pink outfit below) during rush-hour traffic, thanks to his lifelong acquaintance with her. Privileged access, indeed.

The give-and-take between photographer and subject is fundamental to all these portraits; at times, it is easy to denote the relationship between them. Squire Fox concentrates on close friends and family, so the easy smiles and quirky charm come off unimpeded by the presence of the photographer. Scottish immigrant Phil Moody chose to photograph mill and factory workers in the Upstate just as they are losing their jobs to workers overseas; the tension reflecting this reality is palpable. Ruth Rackley used her camera to document the quiet strength of family farms—her own and others. The concept of hometown is explored by several of the photographers, including Andrew Haworth and Caroline Jenkins. Such varying approaches illustrate this project's biggest strength: diversity.

Taken as a whole, there is a tremendous range in age, ethnicity, geography, occupation, and pastimes (roller derby, anyone?). It is heartening to contemplate the sheer variety of encounters these collected photographs represent. A great assortment of styles abound, from formal studio poses to candid environmental portraits. There are both black-and-white and color photographs (even hand-coated platinum prints by Nancy Marshall), film and digital capture, small- and large-format cameras in use, as well as artificial and natural lighting. Special attention ensured that all areas of the state were represented in some way. What might future anthropologists think of us as they examine this idiosyncratic slice of humanity?

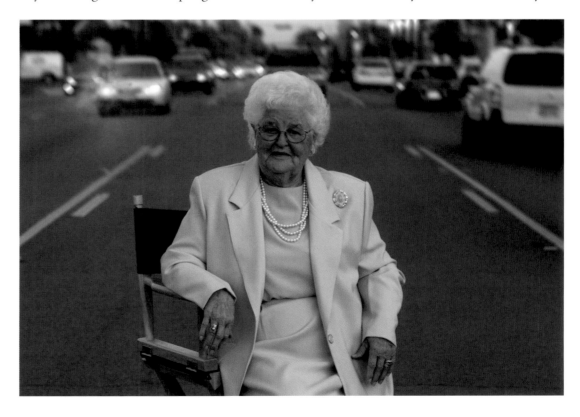

(P. 10) Libby Armstrong, 2006. Charleston, SC. **Photographer: Jack Alterman**

(P. 11) Julia Yamrose, U.S. Army Private, Fort Jackson, 2007. Columbia, SC. **Photographer: Stacy L. Pearsall**

The project got its start as a photographer-driven enterprise. Michelle Van Parys, Jack Alterman, and I were talking with Dr. Ray Greenberg about his idea to surround his students, faculty, staff, and visitors with images of the people the Medical University serves. We hit upon a plan for a multiyear, multiphotographer format, and Van Parys suggested that the photographers from the first year should select their replacement for the ensuing year—and so it went, for all four years. This format encouraged maximum diversity while ensuring the highest-quality images. We are fortunate that all of the artists selected for inclusion are accomplished professionals whose reputations extend well beyond South Carolina. We are especially indebted to Ray Greenberg, the president of the Medical University of South Carolina, whose singular vision animates the entire undertaking.

This project was a grand experiment. We did not know what we might end up with when we started, but that was more than half the fun. The selection process was set up so that each photographer laid out his or her photographs (up to twenty) on a long table for the committee to review. Then, each artist described their overall approach, and offered anecdotes about specific images. At that point, the photographer was asked to leave the room while the committee deliberated and selected the photographs for inclusion.

Once the images were selected, the photographers had a few months to prepare two identical sets of prints. One set was framed and installed in the various clinical and educational buildings on the Medical University campus, the second set went to the permanent collection of the South Carolina State Museum, in Columbia. The museum collection enables the project to be enjoyed as one cohesive exhibition. This aspect helped make the photographers, subjects, and project administrators aware of the potential historical significance of our efforts.

The essay by Josephine Humphreys lends yet another layer of privileged access to the endeavor; she is a native South Carolinian capable of articulating what it means to be "from here." Her essay offers us a chance to feel a sense of kinship, even as we celebrate our differences (and eccentricities). In his afterword, Paul Matheny, chief curator of the South Carolina State Museum, places the collection in its rightful historical context, and wonders aloud how successive generations might utilize such a gathering of images.

Throughout, we have emphasized permanence and the preservation of the images in this unique project. Time is what we are up against. The *Palmetto Portraits Project* may have finished gathering new images, but its life as a cultural resource will continue for many years to come. Because we have assembled something precious and valuable, we offer this collection as a gift to the state of South Carolina, and hope that it may serve as an inspiration to anyone who wishes to extend this concept in ways that further enrich us all.

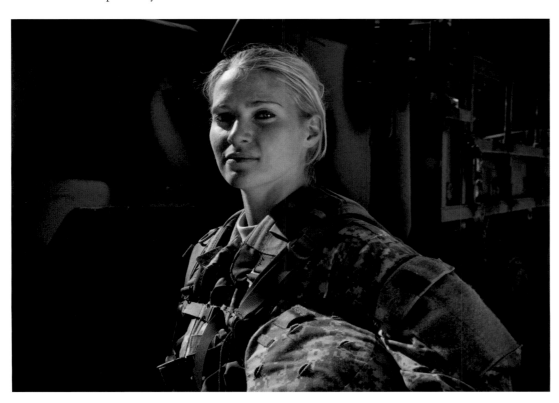

Palmetto Portraits

Josephine Humphreys

The first time I saw this remarkable array of photographs, I recognized a handful of them as people I actually know—a few friends, some passing acquaintances, a half-dozen familiar faces. I was excited to find them. Recognizing somebody in a crowd of strangers always seems like some kind of good omen. "Oh, there's Gary! And Leigh, Tom, Sully, Henry . . ."

And then a weird thing happened. One by one, face by face, I began to recognize all the rest, too—the strangers—as people I know.

No, I haven't met them in the flesh. But I have the feeling that I could almost tell each one's life story. The *almost* is important. I'm not clairvoyant; I don't really know anyone's true-life story. What I know is a true-to-life story, a version I make up but keep grounded in possible truth. Maybe I do this because I've been a serious people-watcher since my earliest years. Growing up a quiet child and something of a loner, I never felt lonesome. I was fascinated by everyone I knew, everyone I saw, even those I never saw but only heard stories about. Some children have an imaginary friend. I had hundreds of them.

Probably every child has an innate interest in other human beings. Don't babies automatically respond to images of the face—anything with eyes, nose, and mouth in the proper proportions? It makes sense that a youngster might take special notice of others of its species in the vicinity. Plus, a shy child becomes a good observer and listener. But I went beyond that; I couldn't help myself. In me, the fascination bordered on obsession. I'm not sure exactly what it was that hooked and drew me in: plain old curiosity, maybe, or some kind of need a psychiatrist could surely uncover. I collected people, or the images and memories of people, and began depositing them in my memory bank, where they seem to have remained pretty much intact over the years. Recently, I tried to make a list of all thirty students in my first-grade class. I hadn't seriously thought about them for nearly sixty years. But when I sought them, all those names and faces came back at a speed that astonished me, almost too fast to catch and write down. I still had them all.

I'm sure this obsession is what turned me into a novelist. A novelist is someone who can't let go of people. When I spot someone new and interesting, my brain starts spinning a story. Who is that woman? What brought her to this moment? What are her dreams and her troubles? What are her crimes? I will latch onto her and stow her away.

It's not surprising that I'm especially attached to the people of South Carolina. They have fueled thirty years of fiction-writing for me. The people in my novels are members of this family, not as true copies of specific real-life individuals but as imagined possible versions of the originals. I've never had trouble thinking up characters; they're everywhere around me! I can't even go to the Piggly Wiggly without being distracted by characters at every turn. One of the other prerequisites for being a novelist, in addition to being interested in people, is that you must actually fall in love with them. You must fall under their magic spell. Without exception, for me every individual is a compelling mystery, one that leads inevitably to a story, sometimes to a whole collection of stories, connecting and interweaving with the stories of other equally intriguing characters.

(P. 13) Todd Laliberte, 2007. Florence, SC. **Photographer: Milton Morris**

(P. 14 top) Vera Manigault, Sweetgrass Basket Maker, 2005. Mount Pleasant, SC. **Photographer: Nancy Santos**

(P. 14 bottom) R. J. Moore, Gas Station Owner for Forty Years at the Same Location, on Rosewood Drive, 2008. Columbia, SC. **Photographer: Jeff Amberg**

(P. 17) Elton Lyles, Greater St. John AME Church Member, 2009. Johns Island, SC. **Photographer: Chris M. Rogers**

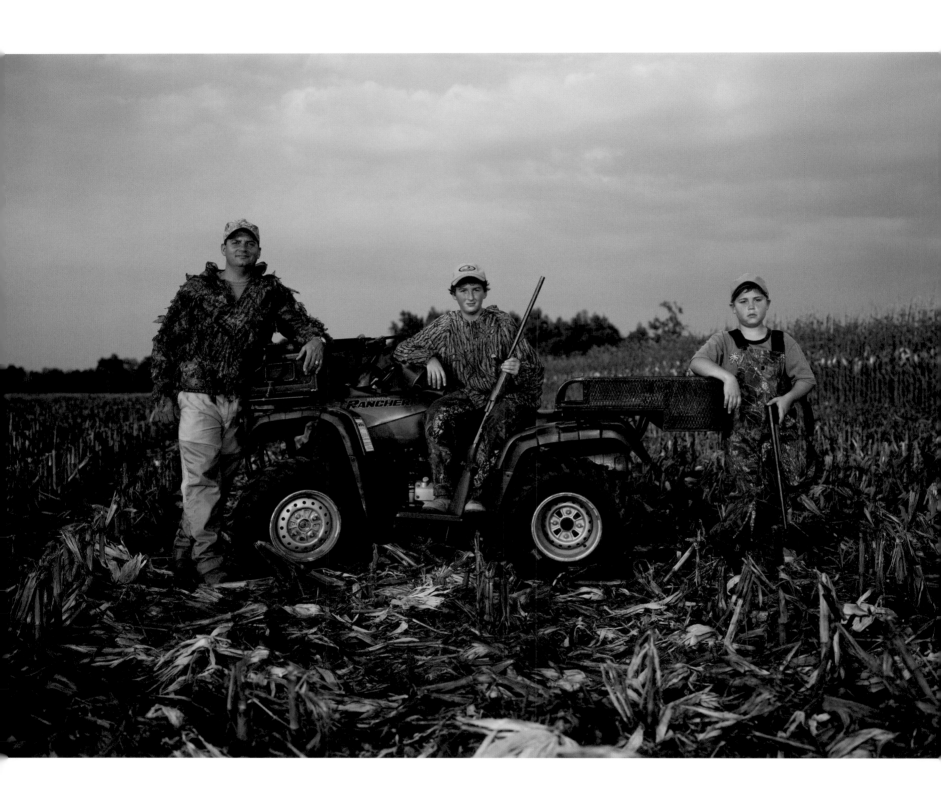

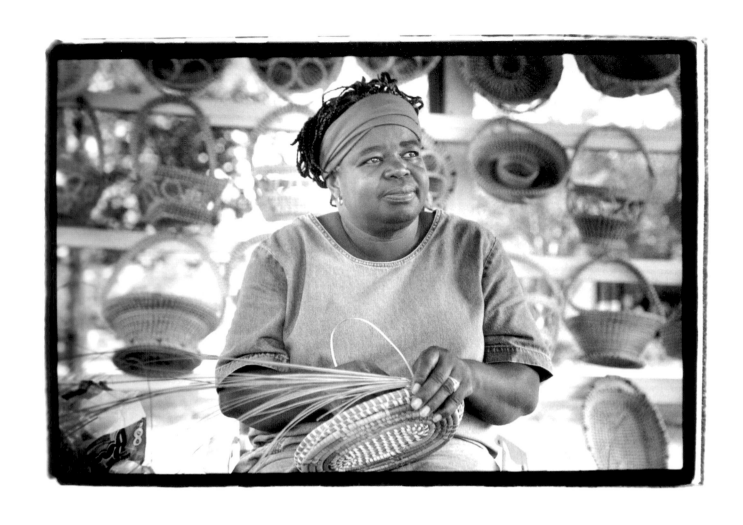

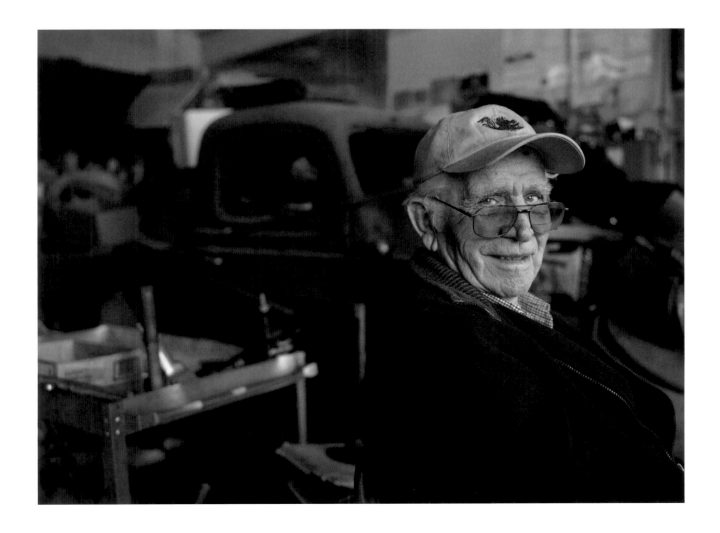

Sometimes, I wonder if I could write at all if I lived in a different place. But I won't ever know the answer to that question. I was born here and have lived my whole life here, and at this point in my life I'm not likely to be moving anywhere. I belong where I am. But if I had to guess, I'd say it's not impossible that some other place could provide a similar assortment of people whose stories would inspire me. I can't say that the folks pictured in this exhibit are any more intrinsically interesting than others the photographers might have found in Michigan or Vermont. But here's the special attraction: These people are mine. We are a cohort, bound together mostly by the simple fact that we are here, now. Place and time hold and link us.

Maybe it is too simple to say that culture depends on place and time (location and history). I'm sure there are other ingredients in the mix. But place and time must be the most potent. None of us doubts that the landscape has a grip on our hearts. At some point, whether in the childhood of a native South Carolinian or later in life for incoming arrivals, indelible images of the land, of oaks and moss, pinewoods, marshes, seashore, farmlands, and sandhills, the very grit of the dirt, and the feel of the sun at our latitude are permanently registered in our brains. We share the environment in our bodies—not merely as pictures in the brain but somewhere deeper, as something more elemental. So many of us spent our childhood years outdoors. I was an outdoorsy girl myself—hunted with my father, swam in the pluff-muddy creeks, and saw the view from every climbable tree. All my strongest early memories are linked to the land. But I believe our place is more than just a stage for the unfolding events of our lives; it is our habitat, and we are acclimated to it. We respond to it down in the blood and bone.

Looking at Alton Core on the Folly Pier, with his cast net over one shoulder, I can feel the salt air against my sunburnt skin. I smell the pluff mud with Goat the oysterman, navigating a tidal river. I've gone along with Todd Laliberte and his boys in the autumn chill of a cornfield in hunting season (there are crows cawing in the distance). And, oh, Paul West, I know that perch you've found on the top of Jumping Off Rock, with a goodly part of the gorgeous world stretching to the horizon.

As we share the land, we also share its story, our knowledge of times past. The words "history" and "story" have only rather recently diverged in meaning (by "recently," I mean within the past five hundred years or so). Both words originally meant an account of something that has happened. I like to use the word "history" that way, to mean not necessarily specific events but our version of those events—the story as we have heard or imagined it, as true as we can guess. The story connects us; it is the basis for our understanding of who we are today. The past stays like a buried treasure under our feet, unseen till storied into light, where it can enrich our lives and hint at new stories yet unearthed.

I'm still a shy and reclusive person. I might even be a real hermit. And yet—or, maybe, therefore—I truly think of myself as connected. Not simply to South Carolinians, of course, but to South Carolinians in a unique way—familiar in the true sense of the word. I know them. I'm drawn to them. I'm related to them. And, honestly, when I think about it, I can't help finding a spiritual dimension in this fascination. To me, all souls are valuable, mysterious, salvageable—even miraculous. It's possible that the work of a novelist is a sort of salvage operation, taking a complicated character and trying to glimpse and preserve what's of value in that human life, what kind of sanctity each heart holds. The goal of religious faith consists of that alone, for me: to recognize the worth and mystery of every soul.

South Carolinians are not without their serious disagreements and conflict, and our history is not free of injustice. I know that well enough. But, at the same time, I do think we have a sense of closeness, that sense of family, holding us together, almost in defiance of our differences. I remember hearing the writer Kaye Gibbons say that in the South we've had to learn how to love people we disagree with, because they are ours. This seems true to me, and might explain why people who don't fit in often end by . . . well, fitting in, or, at least, coexisting comfortably as eccentrics within a larger concentric group. We appreciate our "characters," the ones among us who take a different path or hear a different anthem. Even in cases of serious conflict—and we have had some serious conflict—connections remain.

There's a common expression around here that's logically contorted and inherently contradictory, but in usage makes entirely good Southern sense—and that's the phrase "Same difference." You use it when you want to say, "Well, all right, these things don't match. But so what? The difference makes no difference." That was, at first, my reaction to the *Palmetto Portraits*, but in fact the full impact of the exhibit

can't be appreciated unless we also hold the opposite view simultaneously. Let our differences be unimportant and not divisive, but let them also be important, as factors in the extraordinarily rich variety of South Carolina life.

And it's easy to see that the photographers here both see and cast their subjects in a variety of ways, whether it's against a stark, plain backgound or in a denser scene that somehow illuminates the subjects' lives. One figure I quickly recognize as kin to me is Remmie Wayne Boxx. Mr. Boxx sits in the midst of a grand miscellany, his collection of objects encroaching. The meaning of the collection is not clear, perhaps not even to the owner, but Mr. Boxx trusts (I can tell this from his face, the lift of his eyebrows) that everything in the room does or will soon have meaning. A high window lets in the sunlight. Like other artists, whether writers or painters or photographers, Mr. Boxx will find his inspiration in the clues that surround him. He will make something, and meaning will begin to settle over it.

Then there's the portrait of Jane McCollum. At one time, years ago, I would have recognized her as my favorite great-aunt, a sweet Summerville lady who killed snakes with a stick—the kind of person known as "a go-ahead woman." Now, I recognize this portrait as a sister, one I admire and would emulate. A strong woman of grace, unafraid of anything that is to come, plain in her outlook but as surely filled with knowledge and understanding as any scholar. She may be a farmer or a teacher or a pianist, I can't speculate yet—but I can feel the story spinning up around her. There is a mystery in it. Jane McCollum knows secrets that other people don't know.

Joal Hodges and I look as different as two people can look. I'm an older white woman and he's a young African American man. I haven't met him but I recognize him, maybe even more instantly than I do Remmie Boxx and Jane McCollum. Our kinship is the most complex of all the possible connections between South Carolinians. We have a history together, white people and black people in this state, and a lot of that history is bad, but what's more important is that we have a future together. When I think about the many reasons I've stayed to live out my life in this state, I believe one has always been my faith in that future, and the fulfillment of the promise inherent in a diverse culture. I have wanted to see come what I knew could come, an age in which differences in color would be considered just that: differences alone, just one among many variations. So, we may look different, Mr. Hodges and me, but we are closer than we appear to be.

I have to mention one more portrait I love, and that's the one of Nelson Garvin, proprietor of Nelson's Garbage Party Shop. He has created for himself a private nook in the back of the shop, and I know why. Many's the time I've longed for my own nook, and a sign like that one over the door: "STOP! NELSON ONLY." We're kindred spirits, Mr. Garvin. I'm with you.

People like to talk about the changes they've seen in South Carolina over the course of a lifetime, and fret over the losses. Generally, I am one of that type. Some days, I worry about the loss of farms and towns to gated communities and golf courses. Other days, I worry about the disappearance of our distinctive accents, our wilderness and wetlands, our sense of humor. I can get paranoid and fussy. New people are coming in. What havoc will they wreak? I was particularly upset one day when I was walking with a New Yorker who had moved to a gated community near Charleston five years ago. "What is that beautiful pink bush?" she asked me. I thought to myself, How could anyone live here for five years and not recognize an azalea in full bloom? If she hasn't taken the time to get to know the plants, will she ever know the people? I would consider it a heartbreaking loss if South Carolinians were to lose knowledge of each other.

But I don't think it will happen. Most new people fall under the spell of the place the same way we do, and begin making connections. Sometimes, they turn out to be more enthusiastically Carolinian than any native-born inhabitant, and meld their new stories with the old. I have read that an invading population will almost always adopt the culture of the new place rather than imposing their own. Whether that's historically true or not, I don't know, but let's not forget that everyone here was once a newcomer. Eighth-generation native, Hispanic immigrant, recent arrival from New Jersey—same difference. The *Palmetto Portraits* reveal that we are both old and new. We are farmers, preachers, artists, tradesmen, taxidermists, roller-derby queens, factory workers, soldiers, scientists. We are eccentric and ordinary, salt-of-the-earth and miscreants, strugglers and dreamers. Our wild variety is our strength and our real wealth, as long as we recognize ourselves.

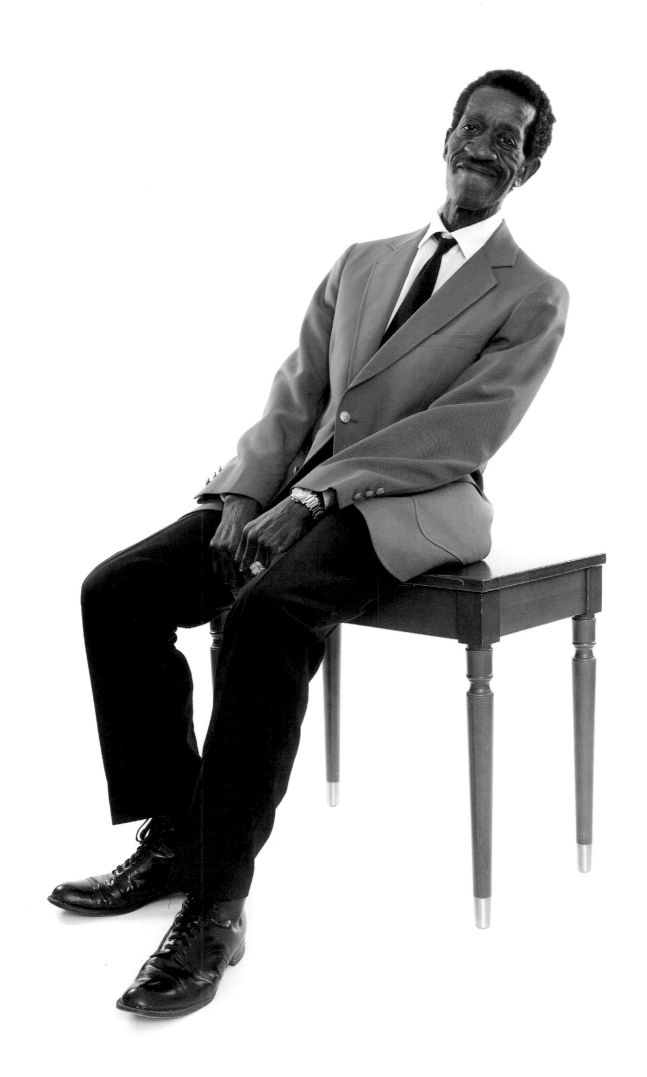

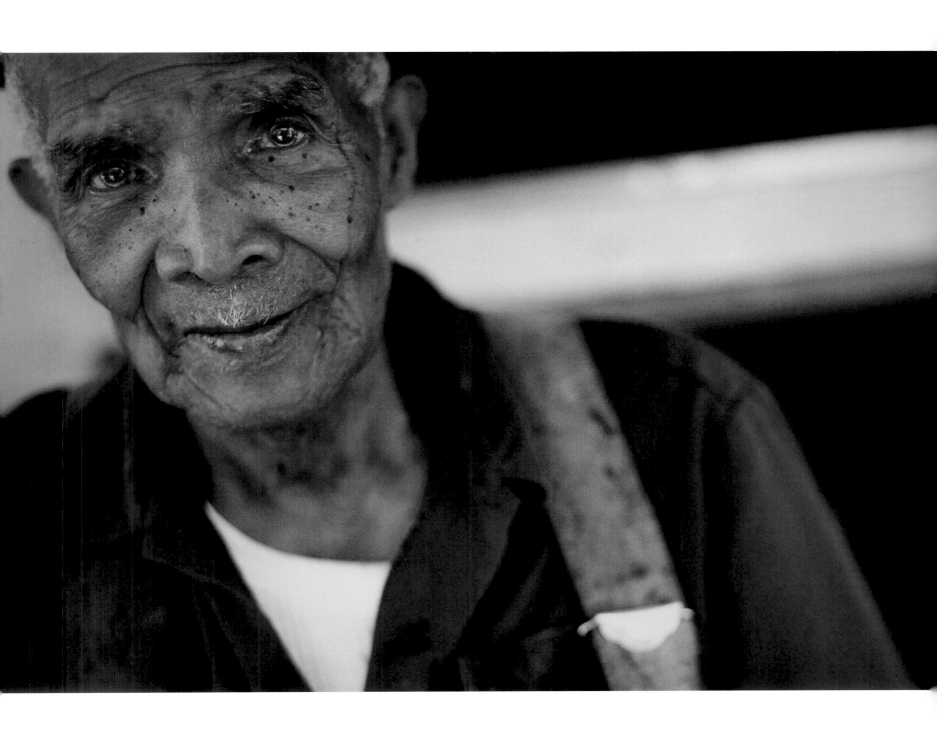

Sam Williams, 2000. Chappells, SC. **Photographer: Jon Holloway**

History of the Palmetto Portraits Project

In the first year of the *Palmetto Portraits Project* (2006), the Medical University of South Carolina comissioned six noted and emerging photographers to focus on portraying South Carolinians in the Lowcountry, the Piedmont, and the Upstate, reflecting the full range and diversity of the state's citizens, occupations, and recreational activities. In creating a collection of art to display within MUSC's educational and clinical buildings, the university hoped to remind students, faculty, staff, and visitors of those they serve at MUSC and throughout South Carolina.

Each photographer was given free rein on his or her subject matter. MUSC did not provide any guidelines or restrictions as to whom the photographers chose as their subjects.

At the conclusion of the inaugural year, the six photographers invited six additional photographers to create the second series for the *Palmetto Portraits Project*. This ongoing method was repeated for Series III and Series IV, concluding in 2009. In this way, these accomplished artists helped perpetuate the project, thereby broadening the scope of participation and reaching other photographers throughout the state.

MUSC and the selected photographers expanded the impact of the project by donating an identical set of finished photographs to the permanent collection of the South Carolina State Museum, in Columbia.

The *Palmetto Portraits Project* partners include MUSC, the Halsey Institute of Contemporary Art at the College of Charleston, and the South Carolina State Museum.

Jack Alterman

I love connecting with people through photography, and the *Palmetto Portraits Project* is an inspiring way to do exactly that.

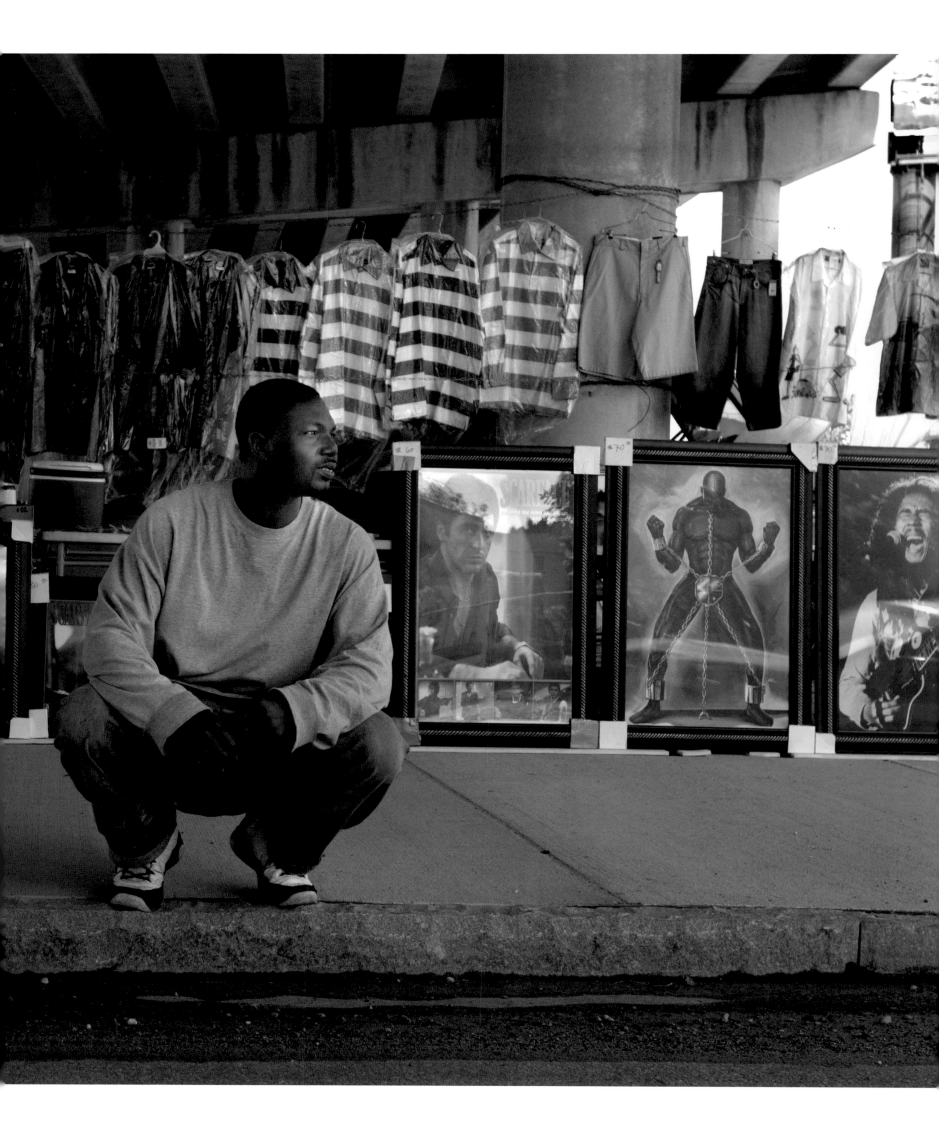

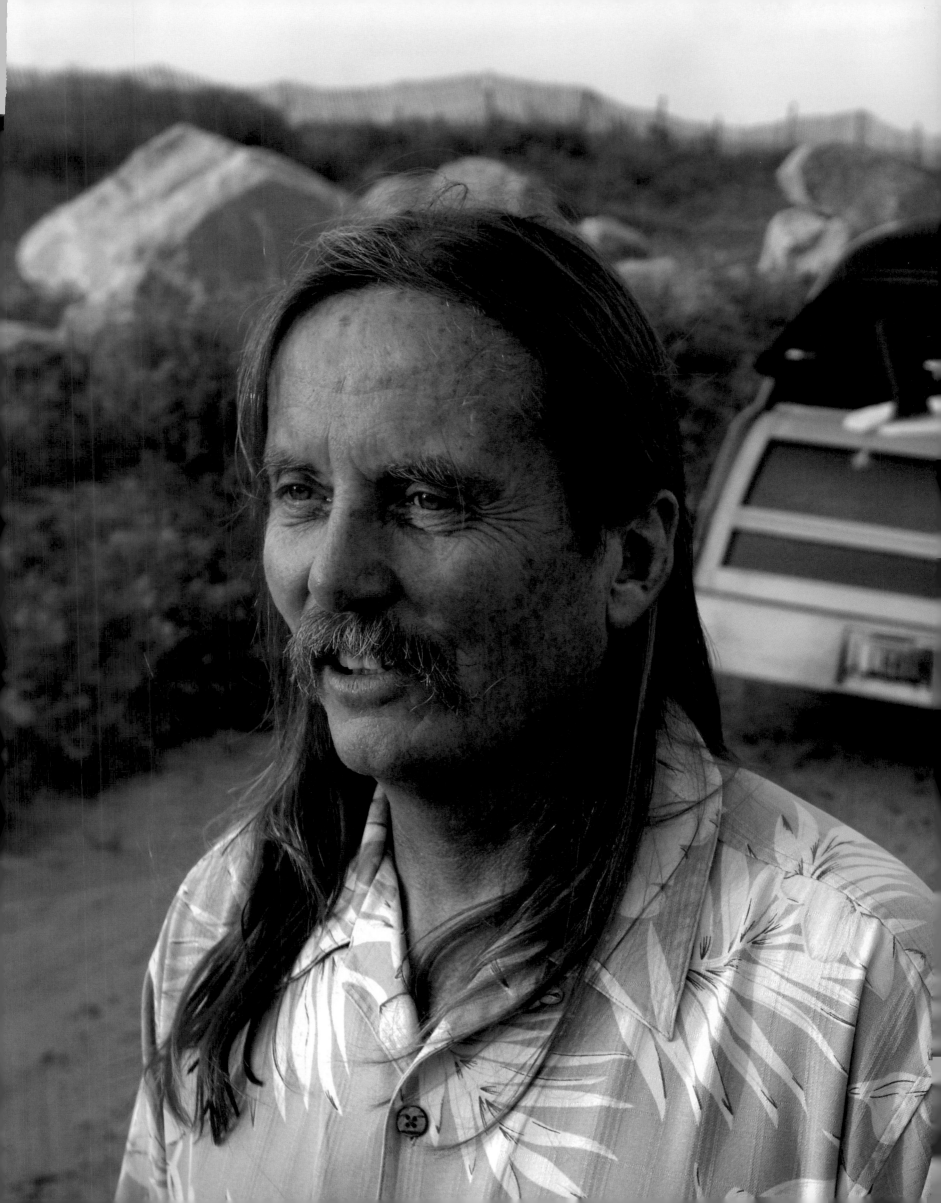

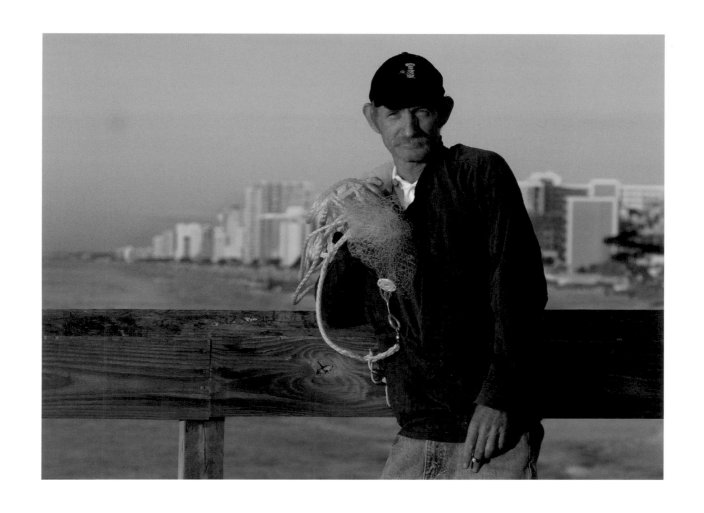

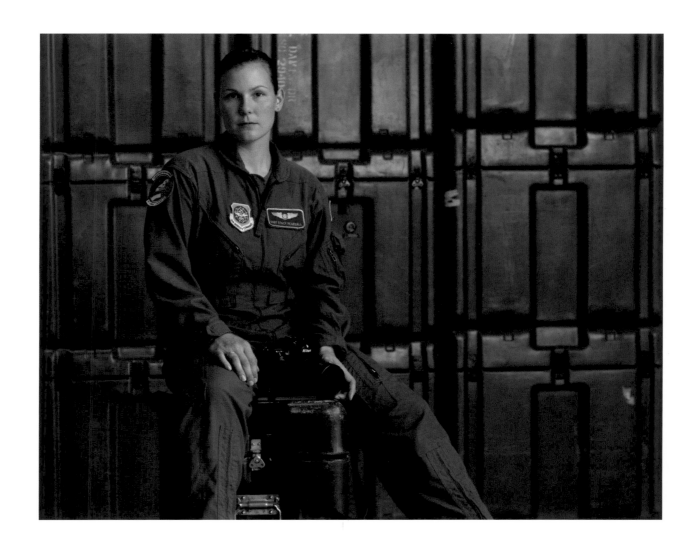

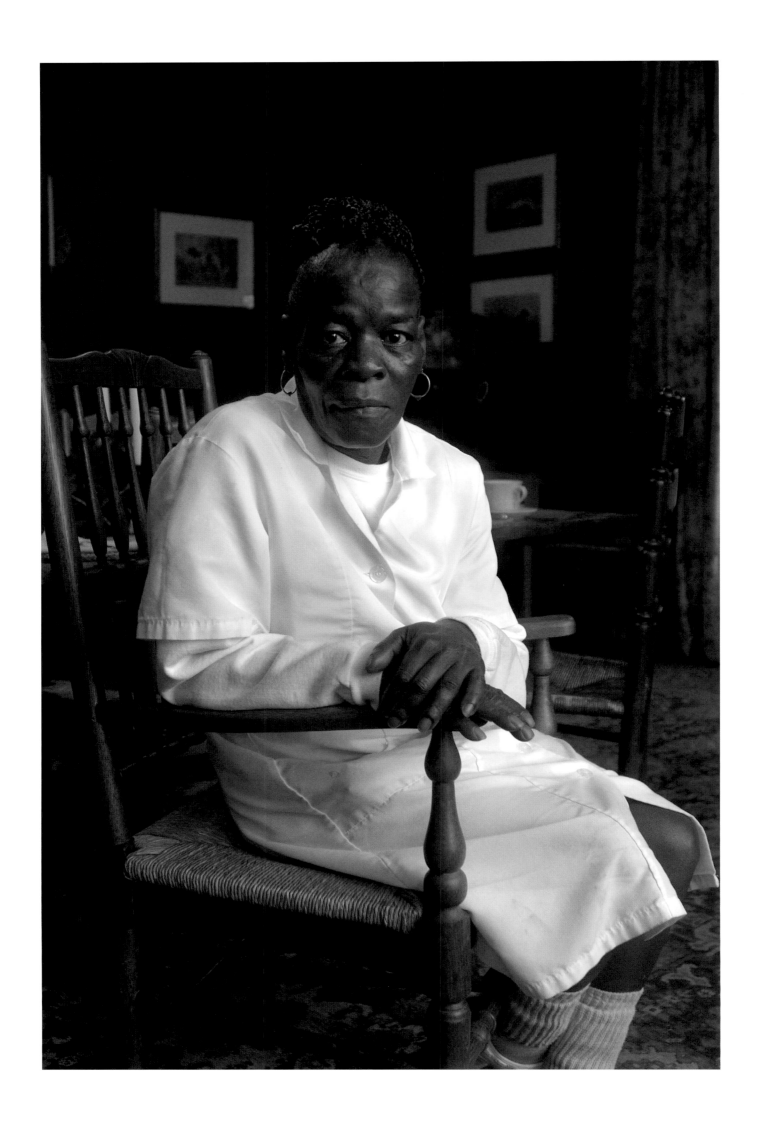

Jeff Amberg

People are my passion. Because everyone is different, every assignment is unique, so it never gets boring. For me, the *Palmetto Portraits Project* was a great opportunity to find interesting, everyday people to photograph. A perfect fit for my style.

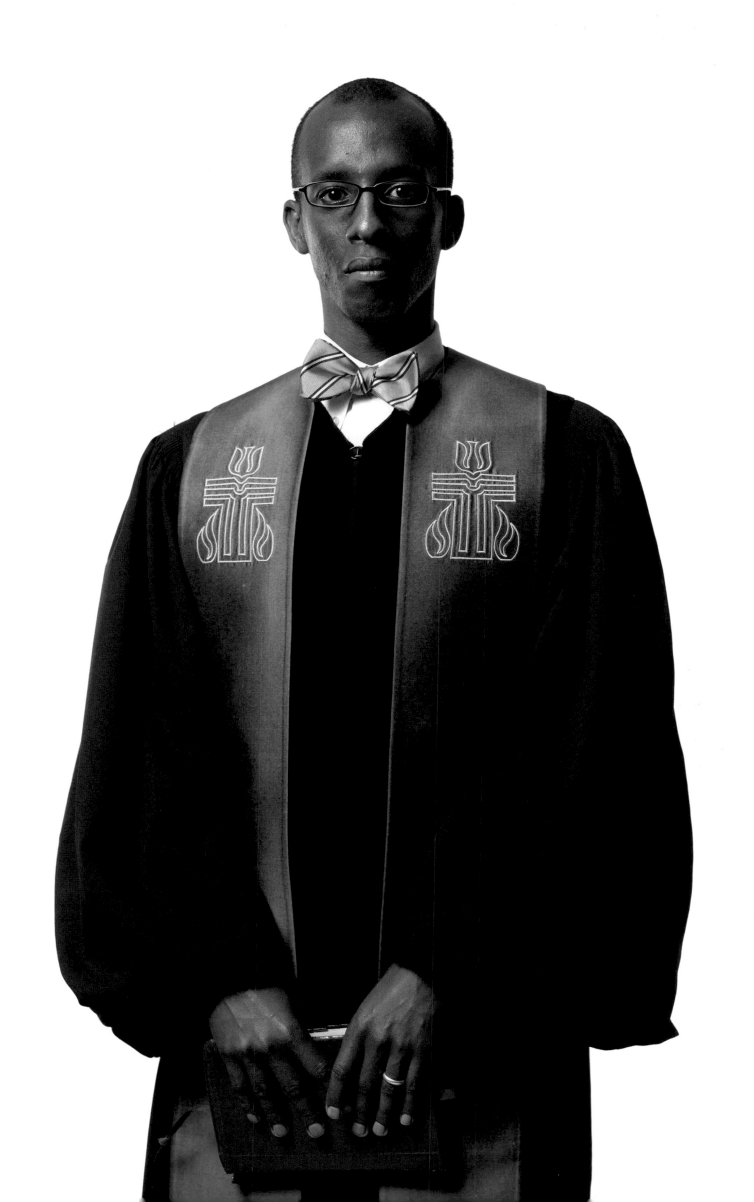

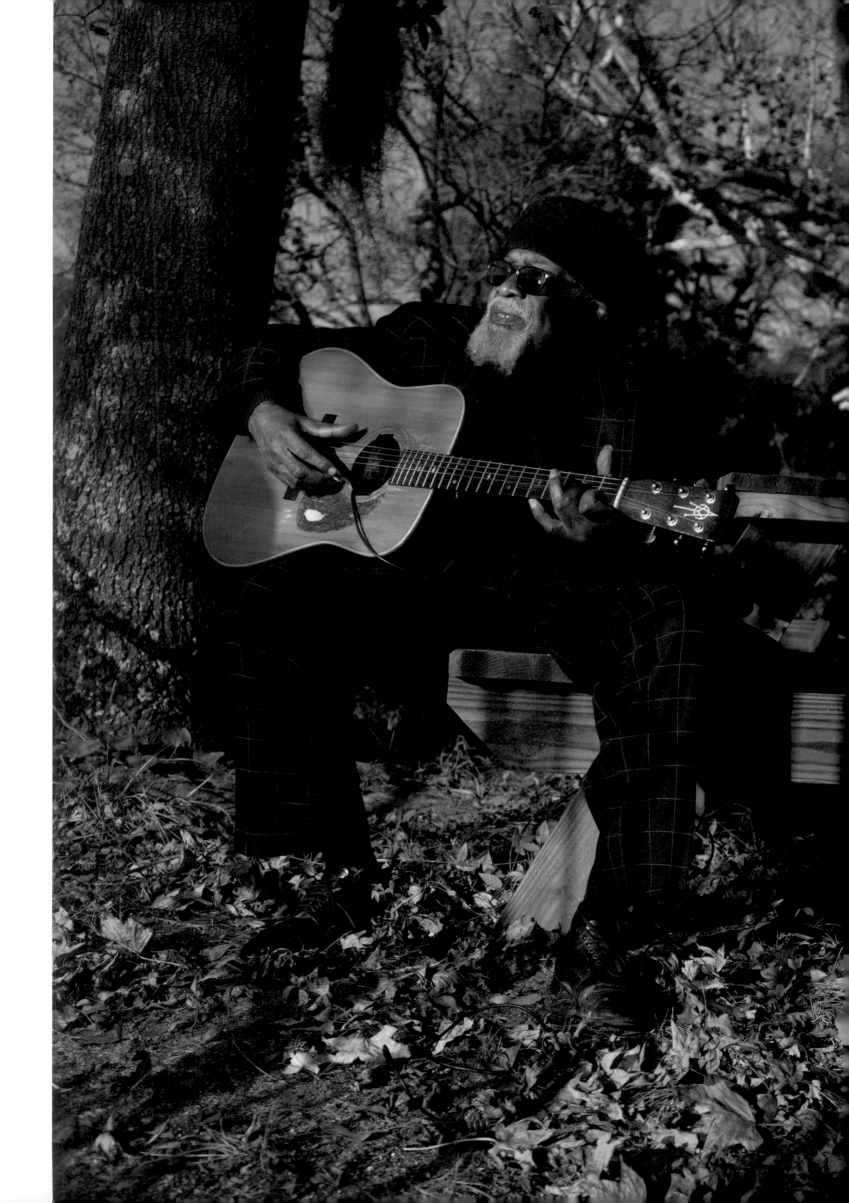

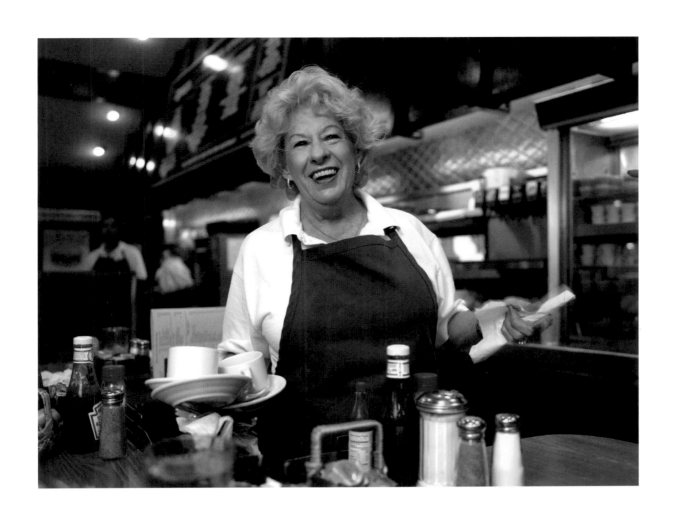

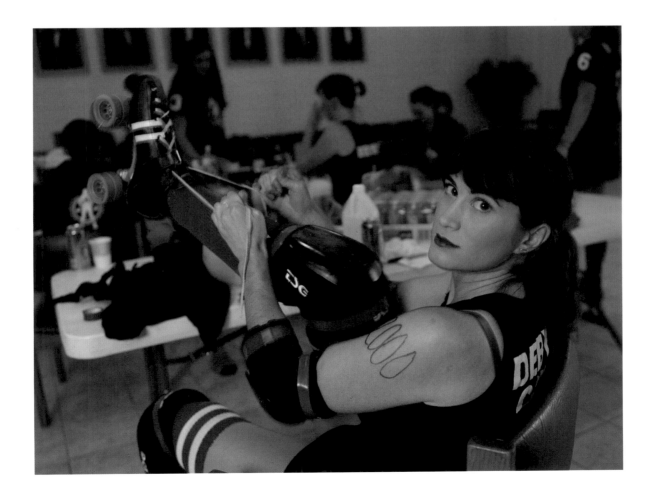

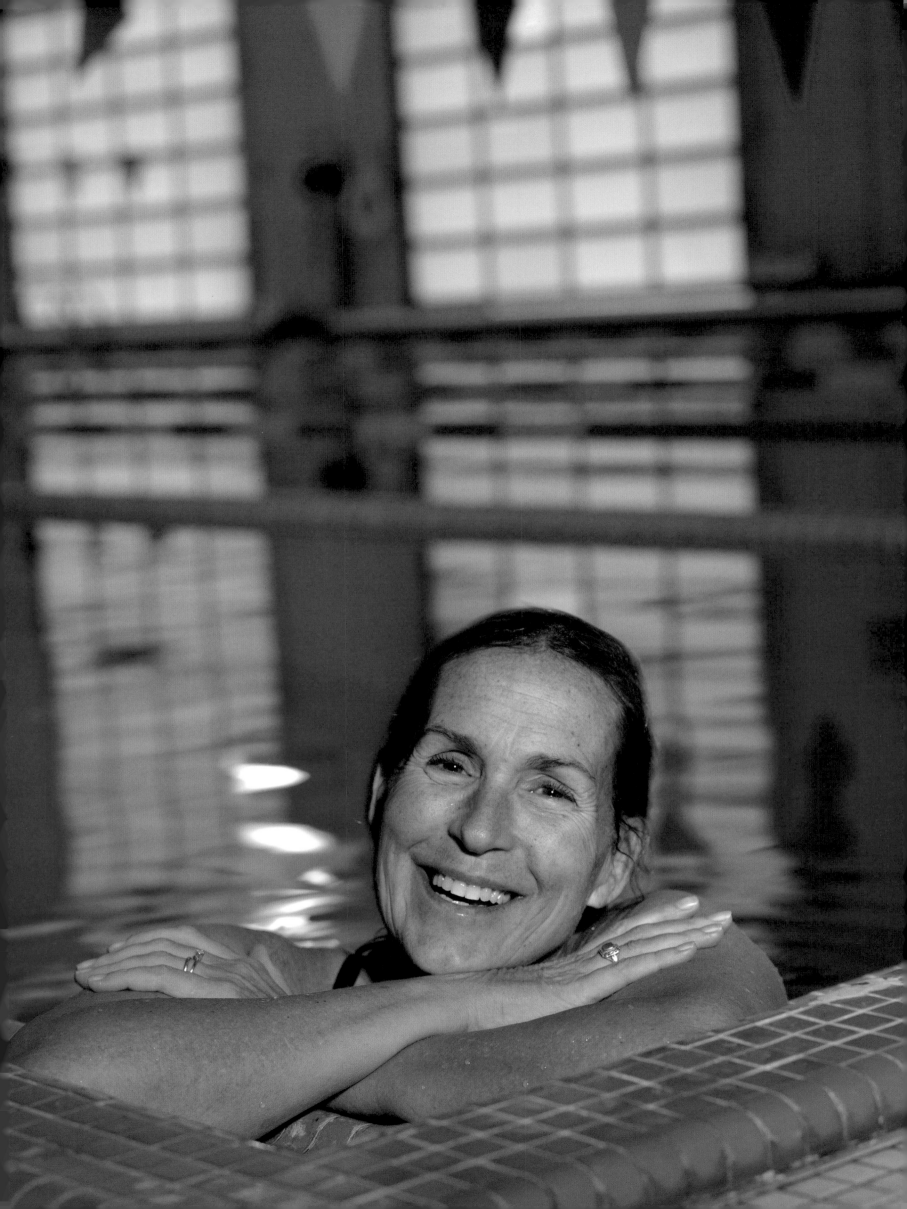

Gayle Brooker

Over the years, the theme of home has played an important role in my work. Home is where we feel the most at ease and are most likely to reveal our truest self. It is a place filled with complex emotions, yet it can be a grounding force. Like me, each one of my subjects calls the Charleston area home, so I chose this location as the constant for the series.

As a photographer, I collaborate with my subjects to draw out specific aspects of their personalities and reveal certain truths about who they are. Whether it's in a full-body grin, a serious gaze, or a slightly awkward pose, the unique characteristics of my subjects emerge in these ten portraits.

The backgrounds are simple, but they play an important roll in the description of the sitter. Each photograph was taken in or nearby the sitter's home or place of work. The familiarity of the chosen settings encouraged a relaxed sensibility and complimented the subject's true nature.

(P. 37) Mr. Johnson, 2008. Charleston, SC.

(P. 38) Josh Nissenboim and Helen Rice, 2008. Charleston, SC.

(P. 39) Beth Coiner, 2008. Charleston, SC.

(P. 40) Jay Clifford, 2008. Charleston, SC.

(P. 41 top) Kim Jones and Edna, 2008. Charleston, SC.

(P. 41 bottom) Cierah Sargent, 2008. Charleston, SC.

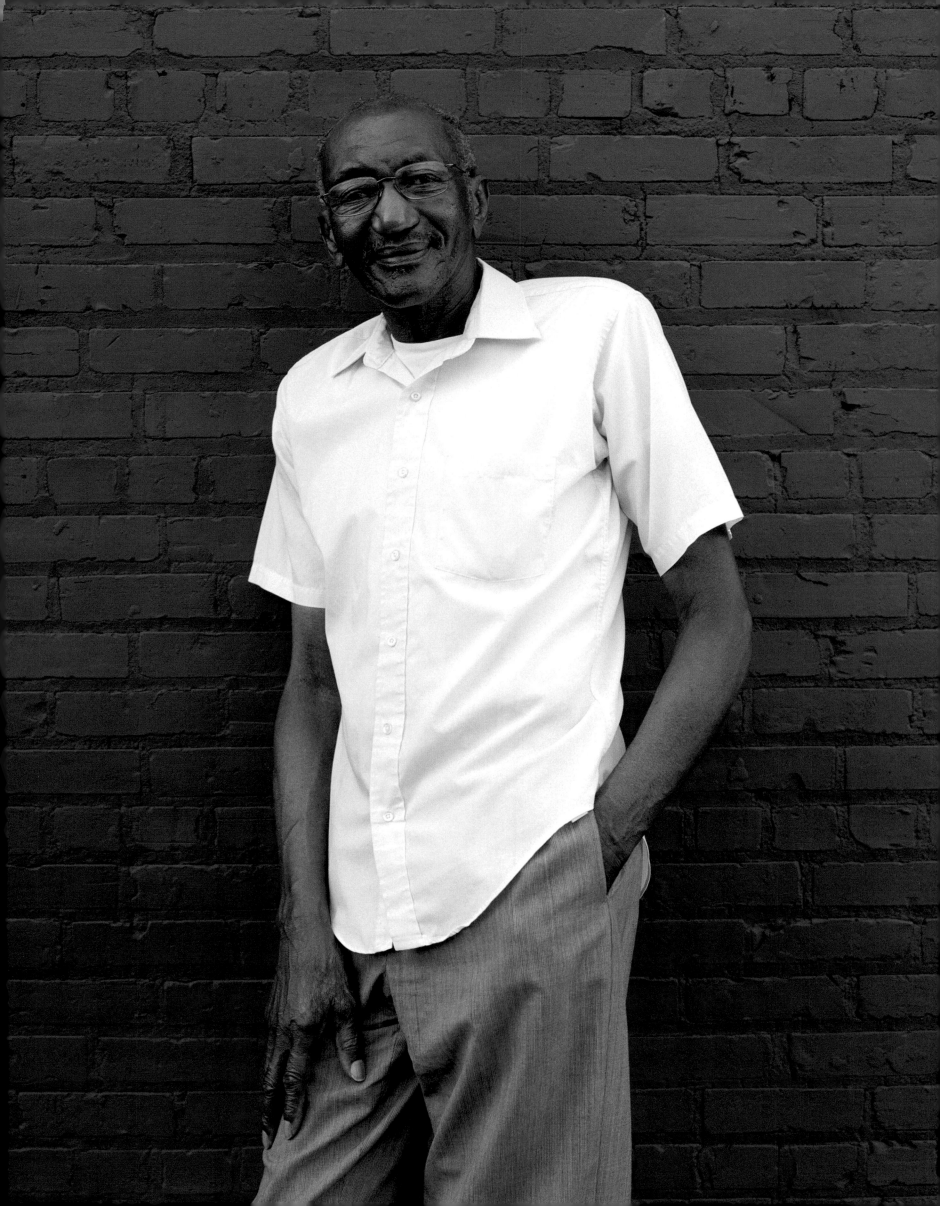

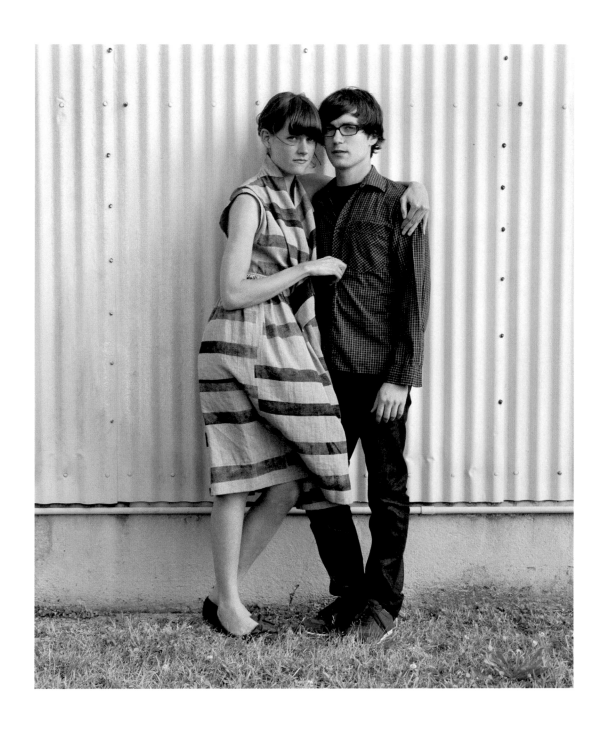

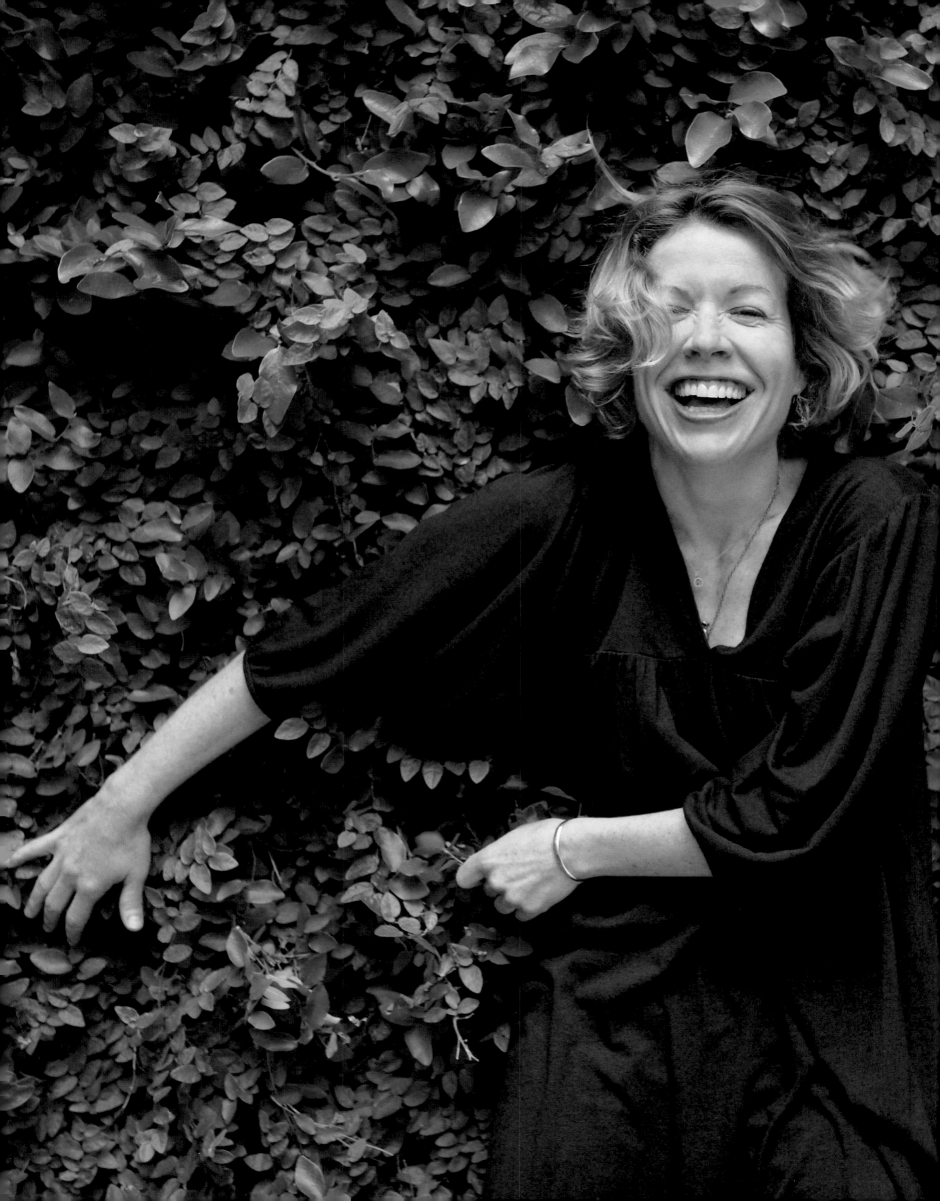

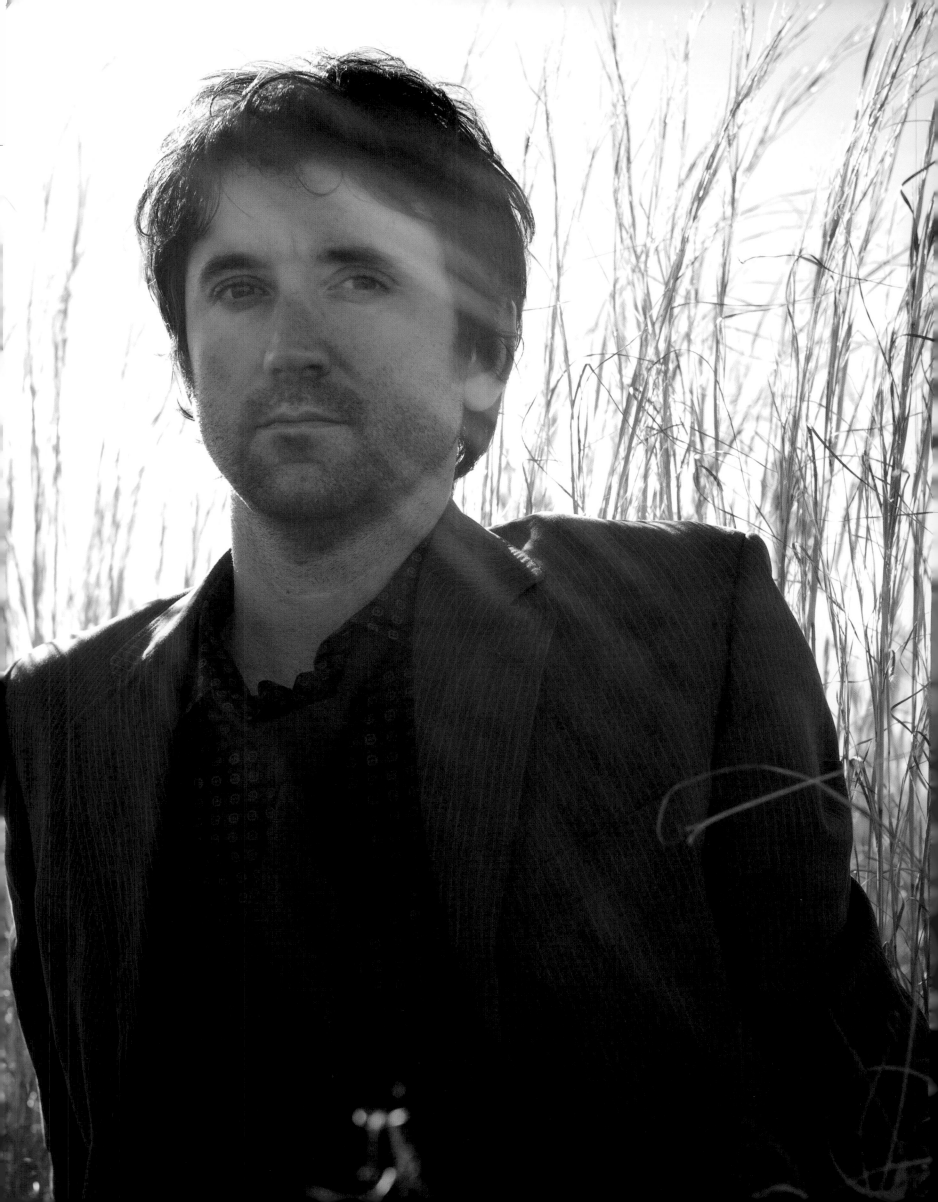

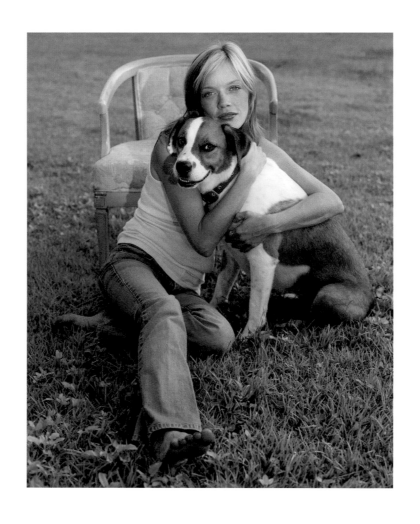

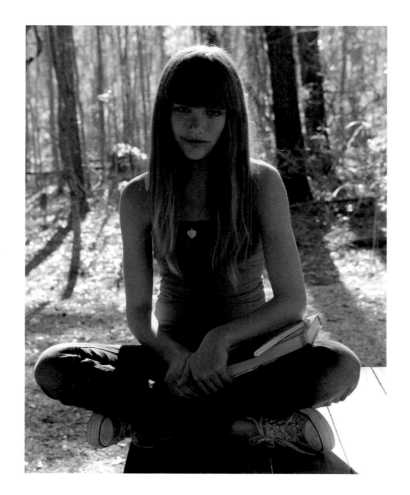

Vennie Deas-Moore

McClellanville, South Carolina, is the birthplace of this photodocumentarian. My work presents an insider's unromantic view of place and people seldom seen. I seek to portray the interconnectedness of culture, the value of work, a sense of stewardship, and the symbiotic relationship between the longtime black-and-white cultures. As a photographer, I am interested in capturing faces—freezing, for a moment, the course of cultural changes.

(P. 43) Off the Wall: Dancer from the Columbia City Ballet, 2006. Columbia, SC.

(P. 44) Folk Artist's Son: The Chicken Man's Son, 2006. Columbia, SC.

(P. 45) *Nutcracker* Dancer: Spanish Hot Chocolate, 2006. Columbia, SC.

(P. 46) Islam Grand Temple Shriner, 2006. Columbia, SC.

(P. 47) Phoenix: The Urban Record Store, 2006. Columbia, SC.

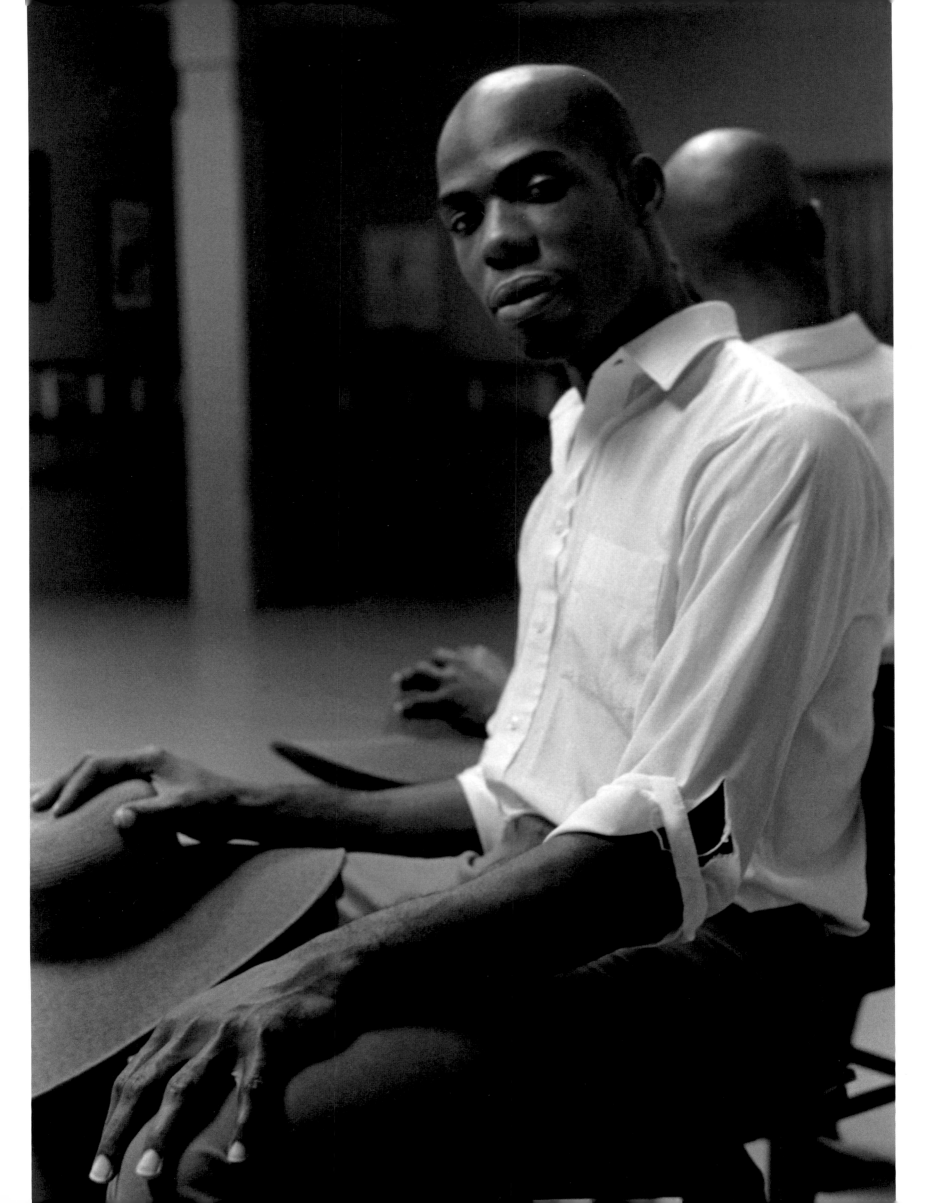

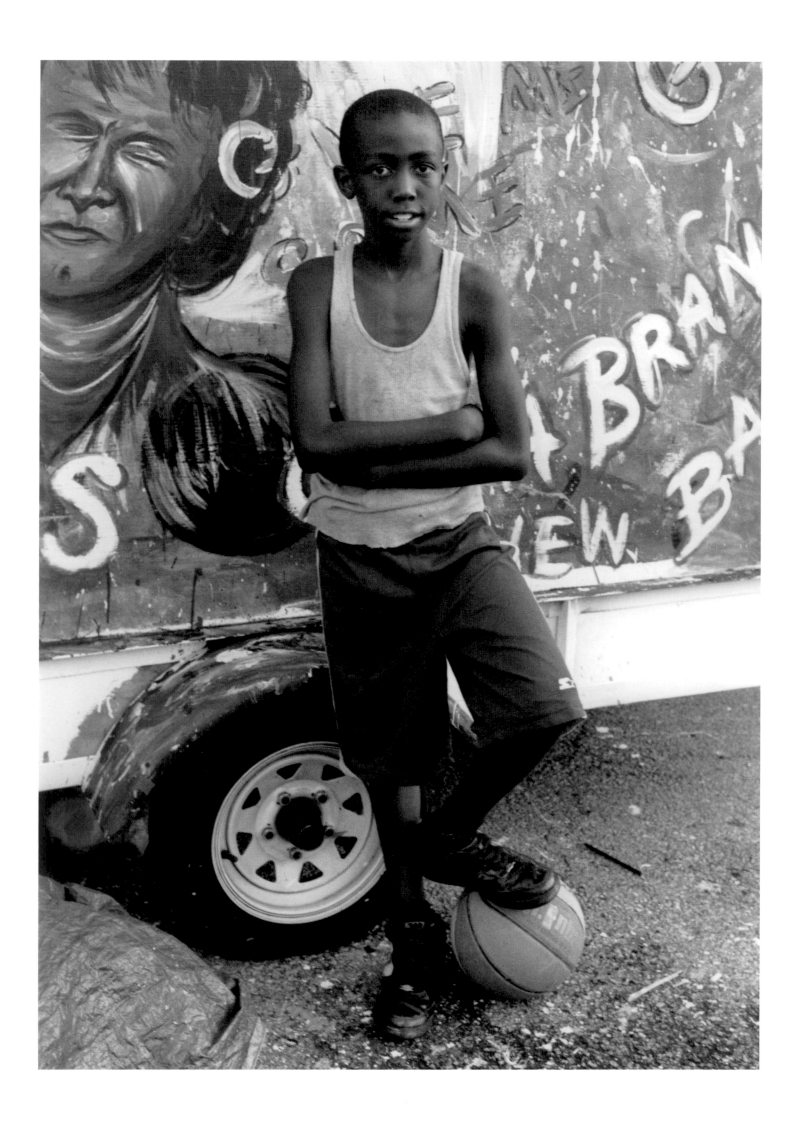

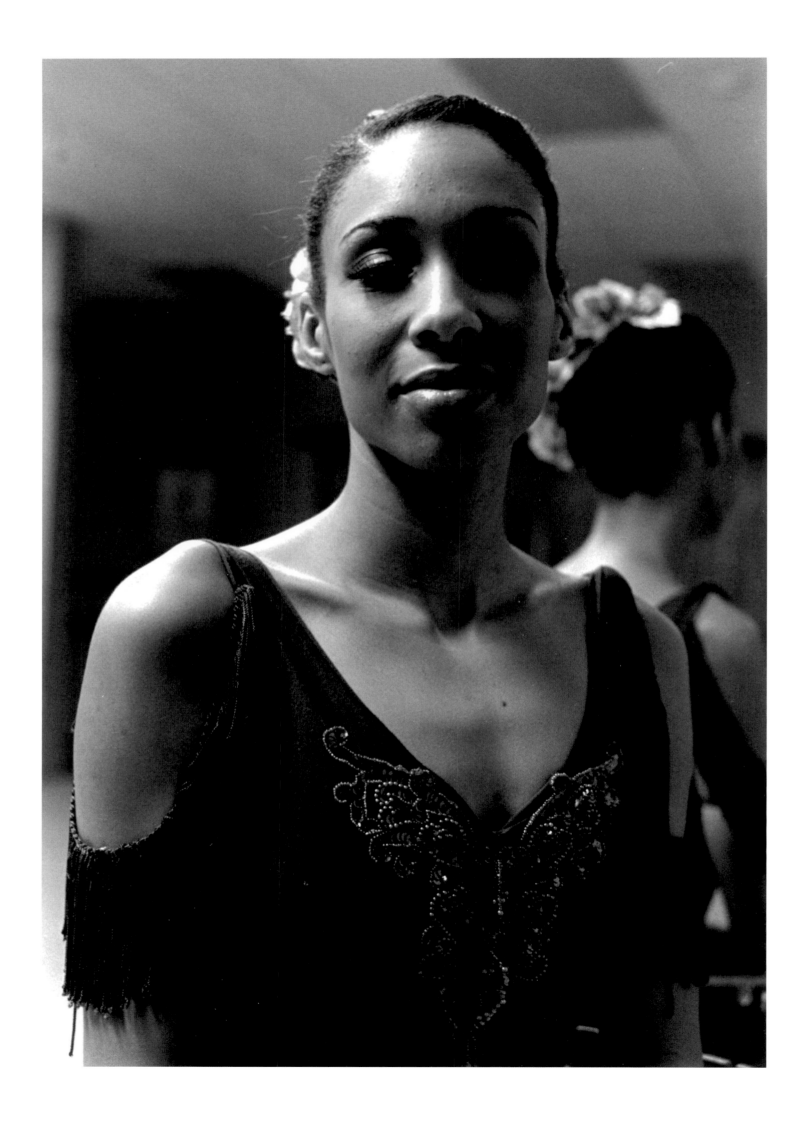

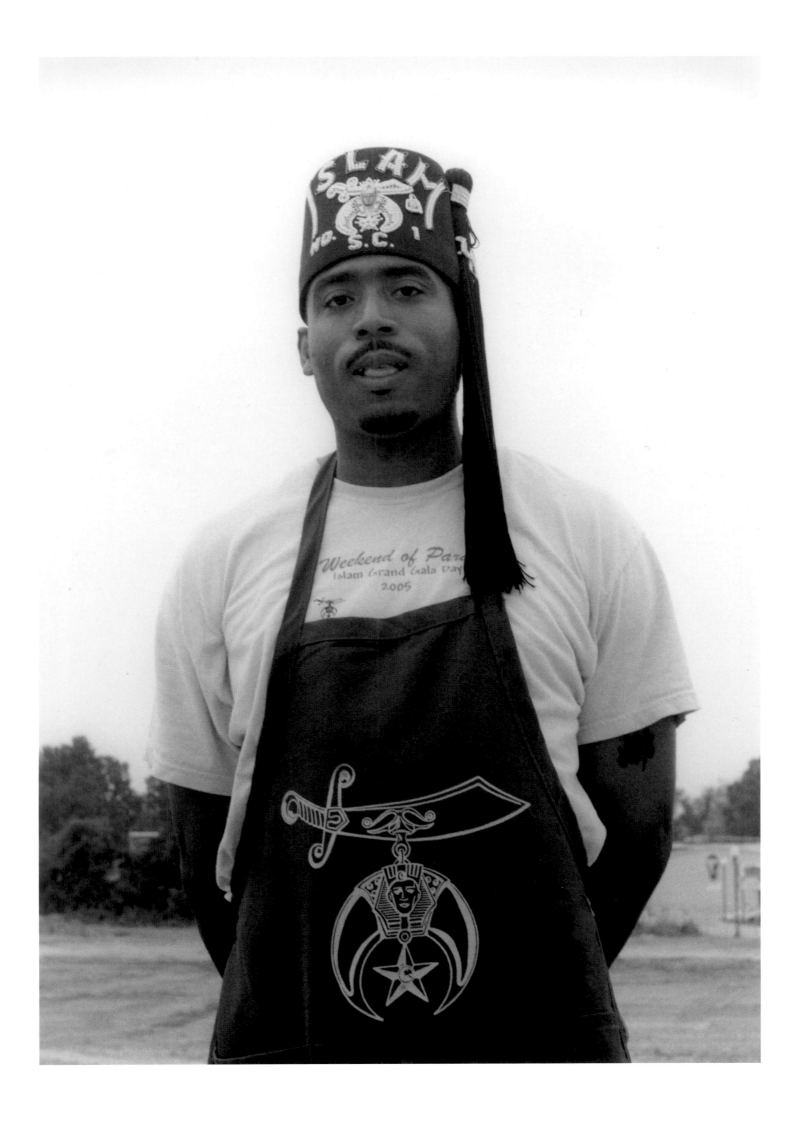

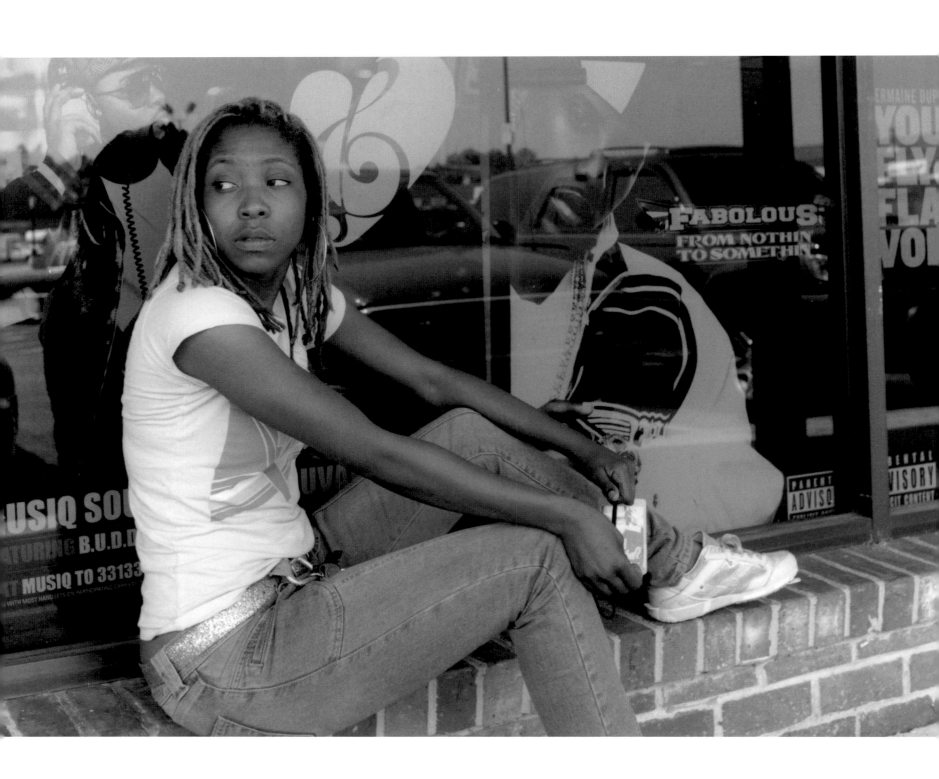

Brett Flashnick

I love life, people, adventures, and all things visual. I feel photography is so much more encompassing than what many people think it to be—just a snapshot of a moment in time, or a pretty place. To me, being a photographer, and, ultimately, a visual storyteller, is a constant evolution in the way that I see the world around me. I have been influenced by life lessons and personal growth, combined with a fascination for the changing and emerging technologies that allow me to capture the world I see in both still and moving images. To me, one of South Carolina's greatest assets is its people and their love for nature, history, the arts, and each other. Their warm-blooded southern passion drew me back to my home, and will keep me here for many years to come.

(P. 48–49) Brent McDonald, 2008. Eastover, SC.

(P. 50) Chris Darby, Surfboard Shaper and Owner of Darby Surfboards, 2009. Mount Pleasant, SC.

(P. 51 top) Scott Danskin, Forester, 2009. Wedgefield, SC.

(P. 51 bottom) Perry Dozier, Jr., Basketball Player for Spring Valley High School, 2009. Columbia, SC.

(P. 52–53) Nelson Garvin, Proprietor of Garbage Party Shop, 2009. Colleton County, SC.

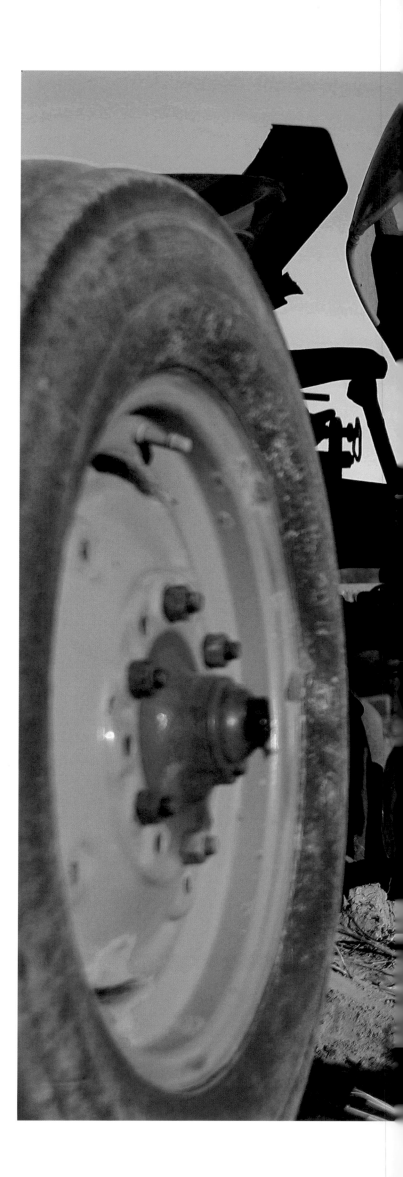

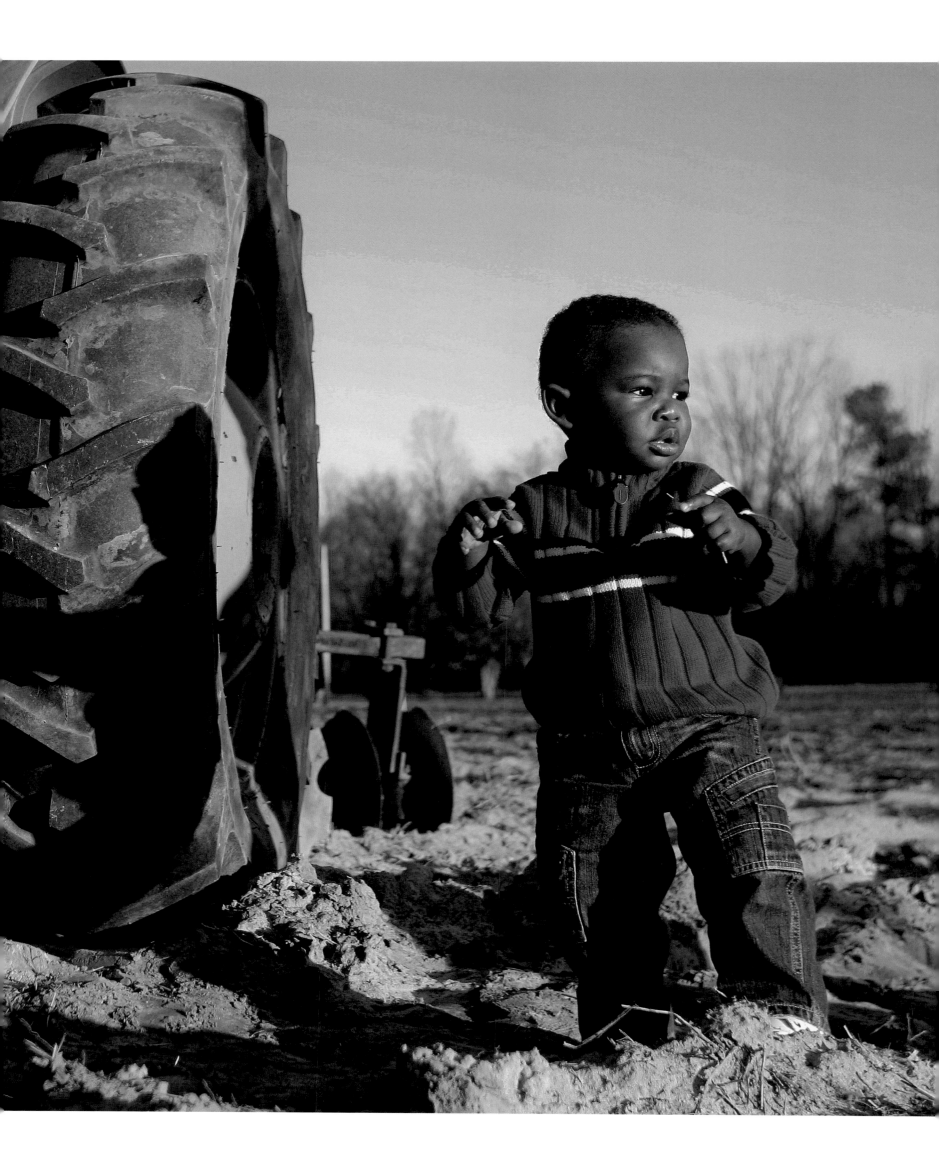

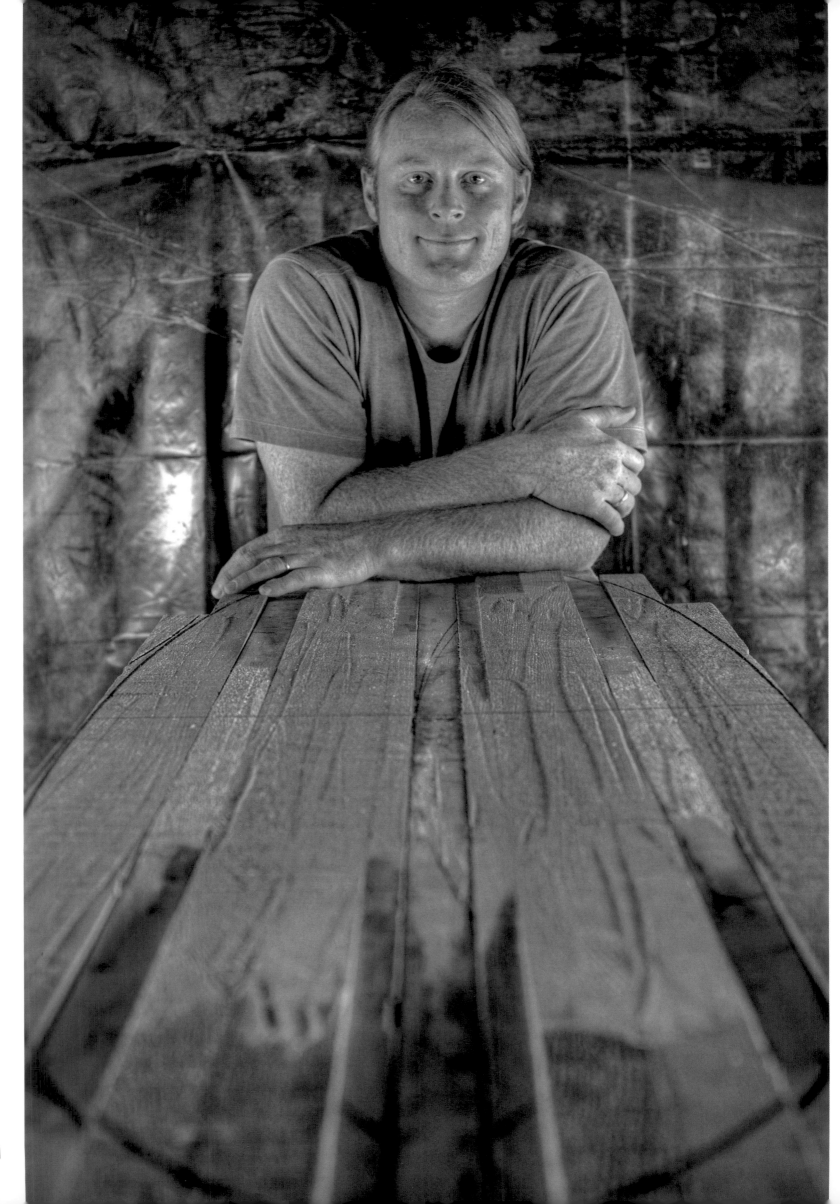

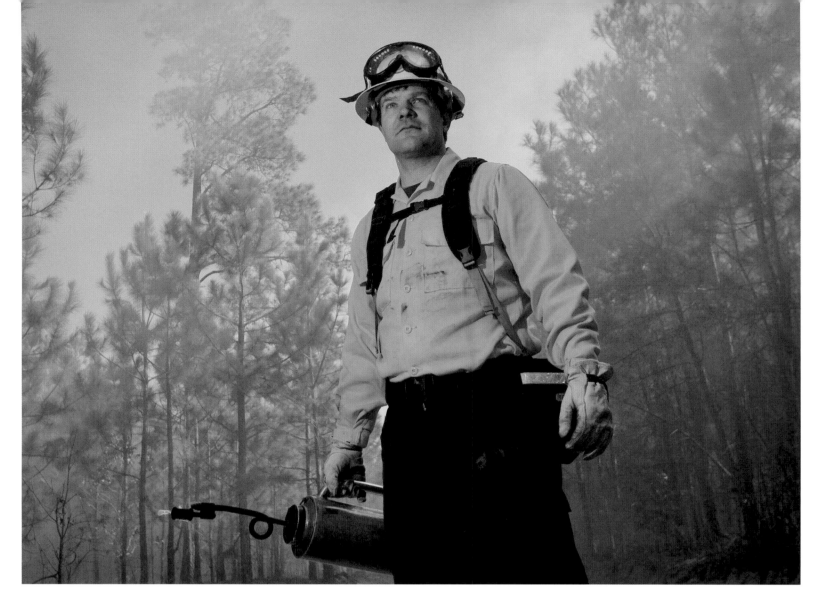

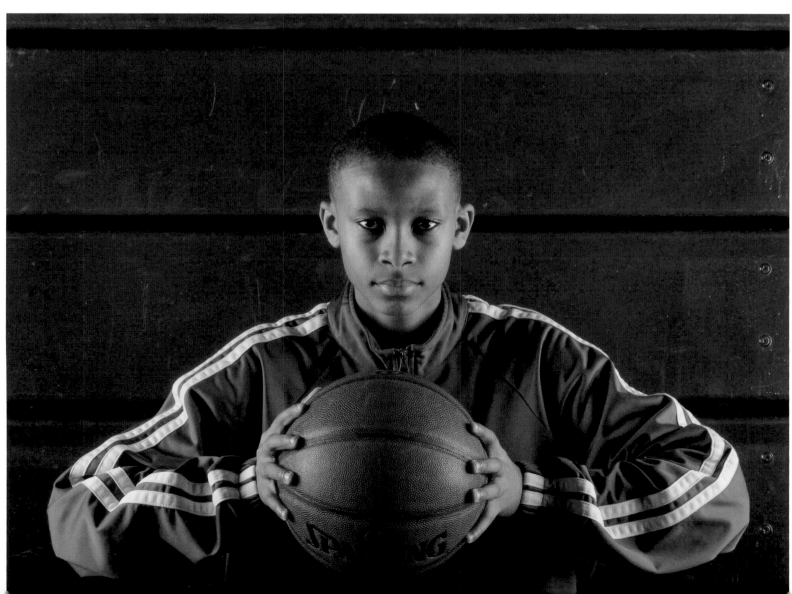

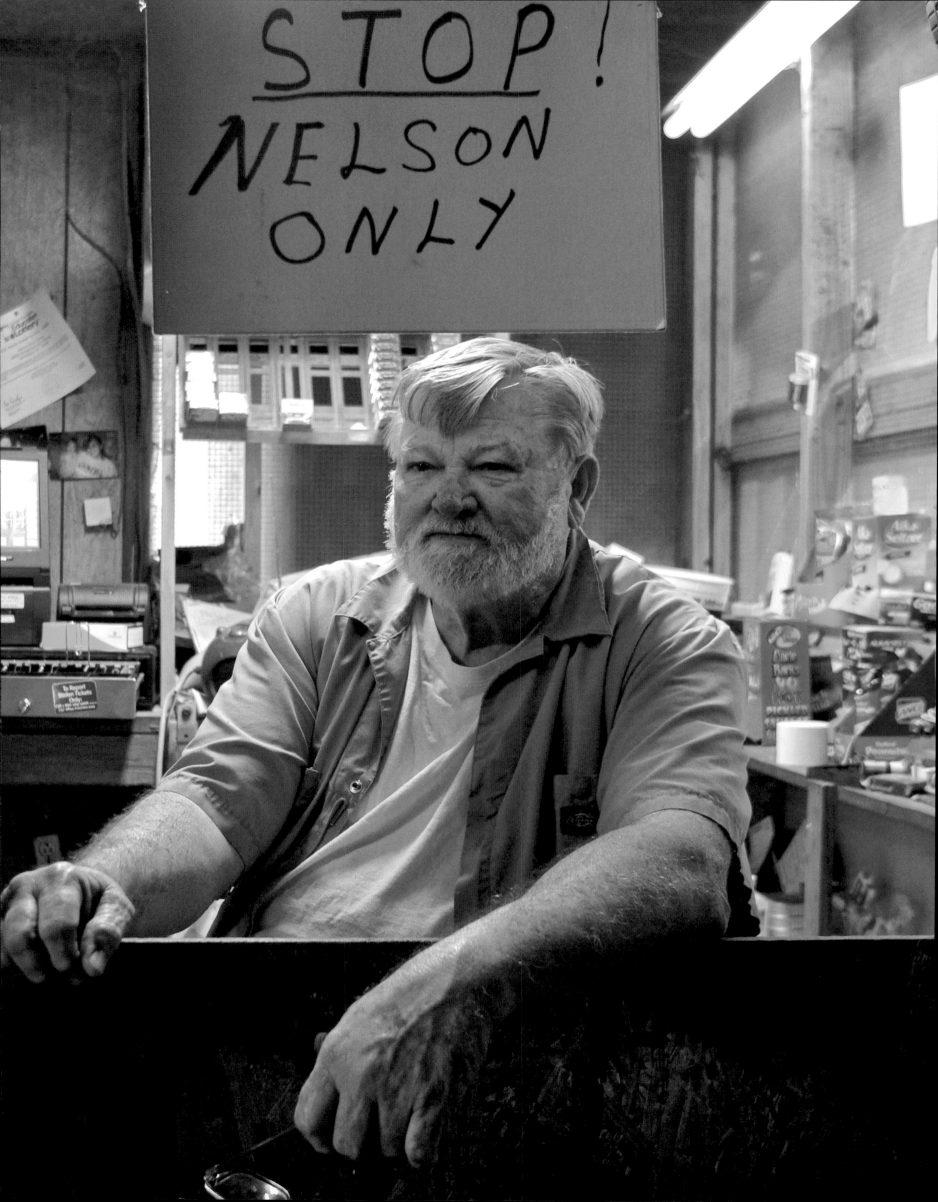

Squire Fox

Often, when I catch myself staring at someone's face, I want to go beyond the stare, beyond the look, to really see—from the lines on a person's face, worn like a warrior who has earned each one of them, to the smooth perfect skin of a child whose innocence shines forth, to the eyes that tell a story. This project captures each person of interest in a still frame, to be viewed over and over, to explore and see more deeply with each successive viewing.

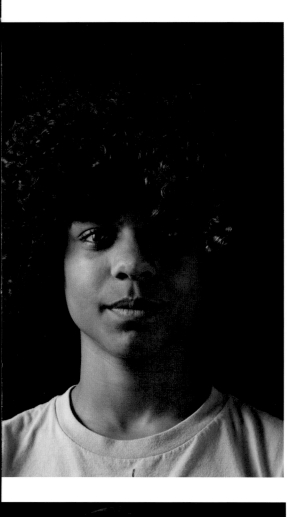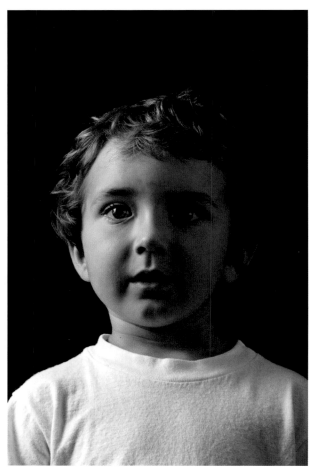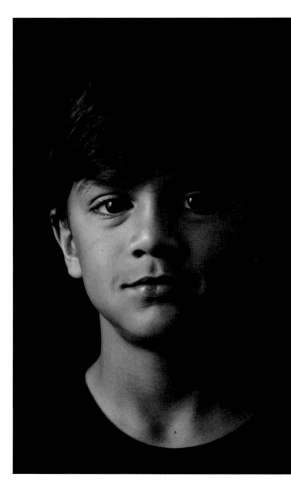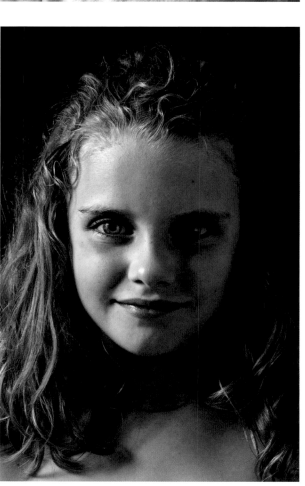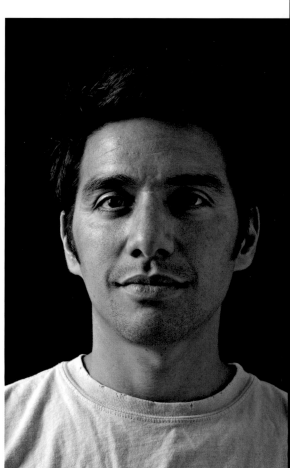

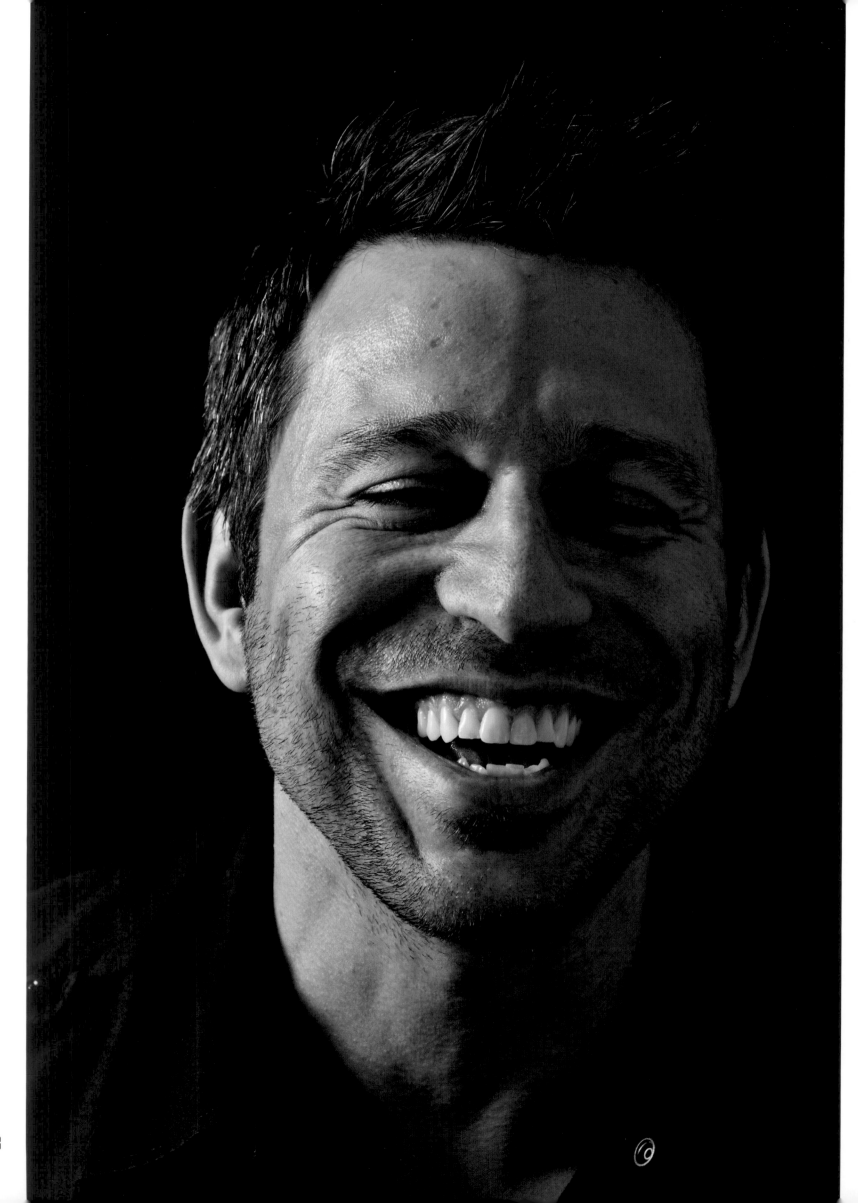

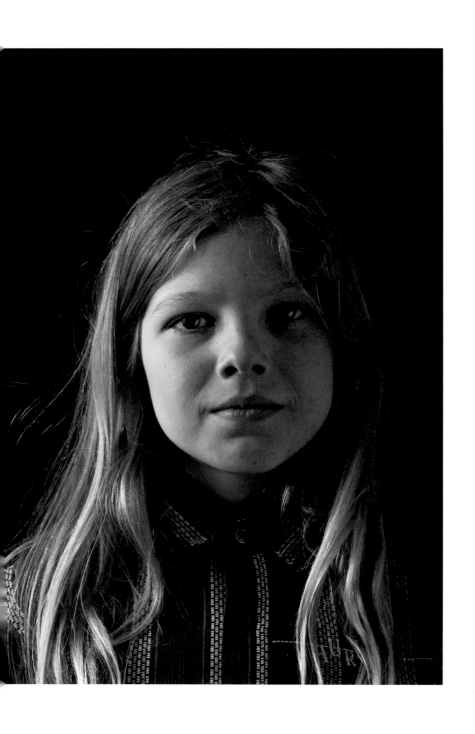

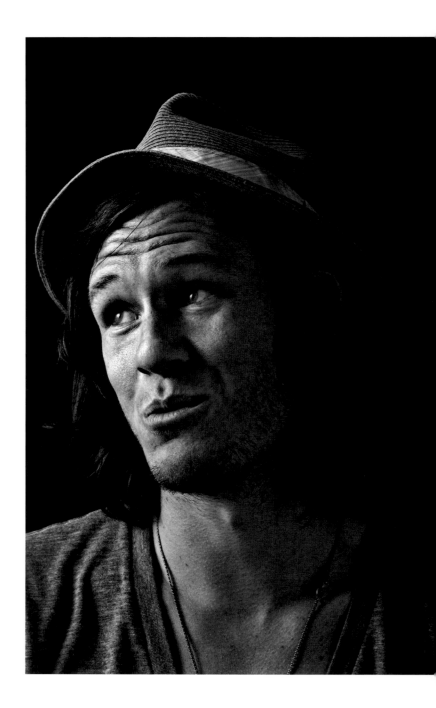

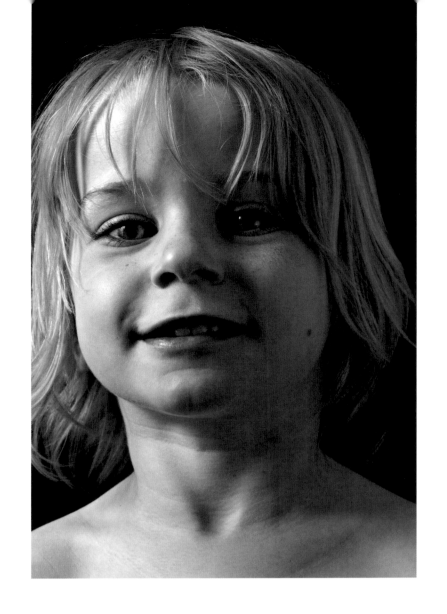

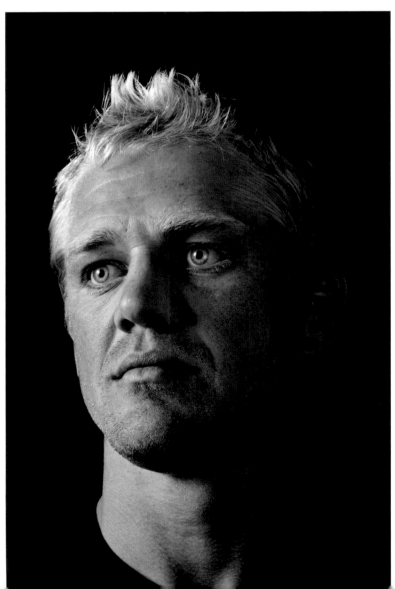

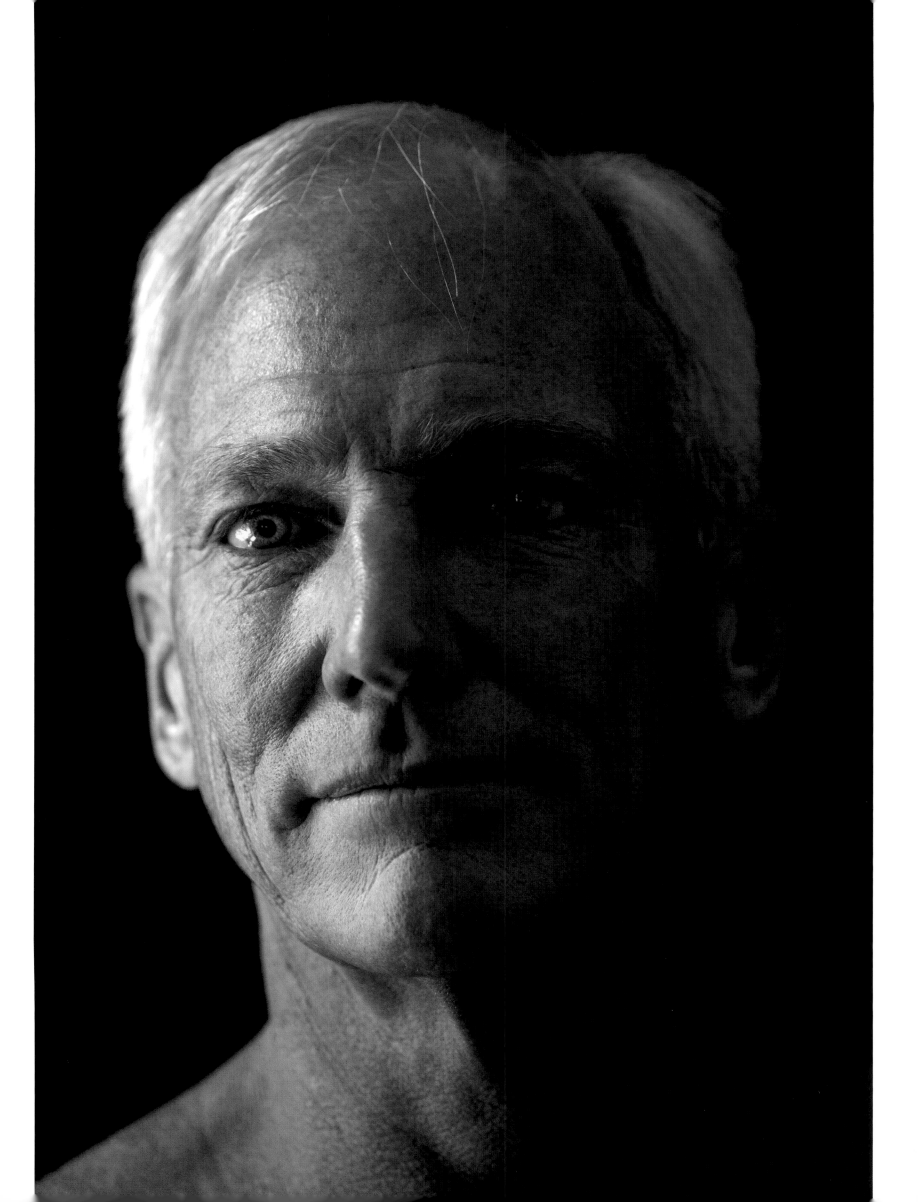

Andrew Haworth

I began the *Palmetto Portraits Project* by
revisiting Branchville, South Carolina, the
small town of my youth. The first photos
I created there set the tone for every
image that followed. I sought ordinary life
and everyday people, but instead found
myself fascinated by the element of the
unexpected that emerged as I developed a
rapport with my subjects.

My goal was to lead viewers into
the bucolic backcountry of the state's
midlands. Here, I attempted to create
tableaux that skirt the boundaries of
verisimilitude. I wanted to explore the
interests and occupations of people who
live in the rural areas that influenced me
as a child, while alluding to a dreamworld
somewhere between reality and the
subconscious. Occasionally, I amplified
this effect with colored lighting, bizarre
locations, and costumes; other photos,
though, are more straightforward
representations of the subjects as they
exist. Although I believe each image is
an accurate study of each person (if not
always literal), I hope viewers will allow
themselves a moment to craft their own
narratives, while enjoying the whimsy I
experienced when creating them.

(P. 60–61) "Tracker" Troy Ayer, Operator of Buck and Boar Hunting Lodge, 2009. Swansea, SC.

(P. 62) Julian Bair with son, Collin, Chicken Farmers, 2009. Bolentown, SC.

(P. 63 top) Paul Towns, Two-time Cancer Survivor, 2008. Elgin, SC.

(P. 63 bottom) Tony Grey, Owner of Sportsman's Taxidermy, 2009. Orangeburg, SC.

(P. 64 top) D. Murray Price, Wings of Freedom Volunteer, 2008. Columbia, SC.

(P. 64 bottom) Donella Wilson, Retired School Teacher, 2009. Columbia, SC.

(P. 65) Margaret Garris Frazee, Retired U.S. Census Worker and Caterer, 2008. Branchville, SC.

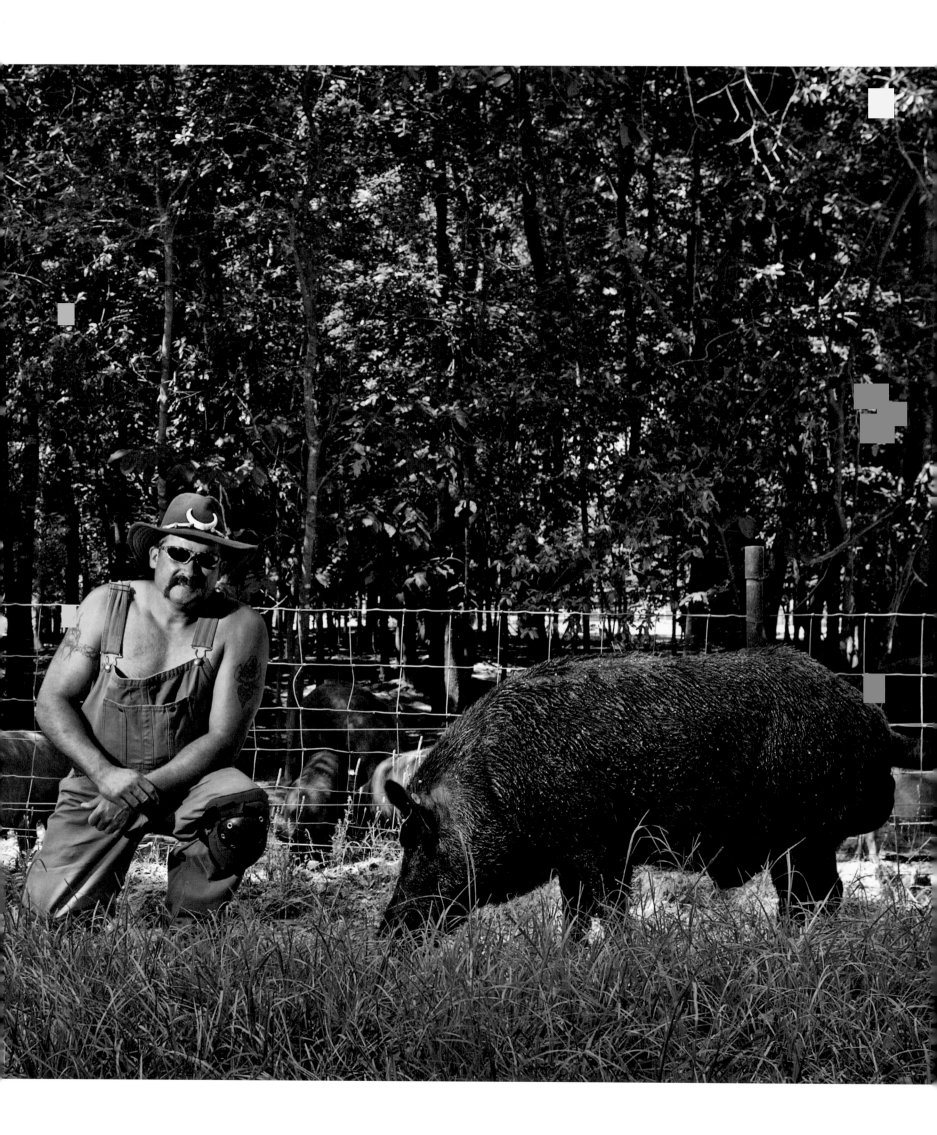

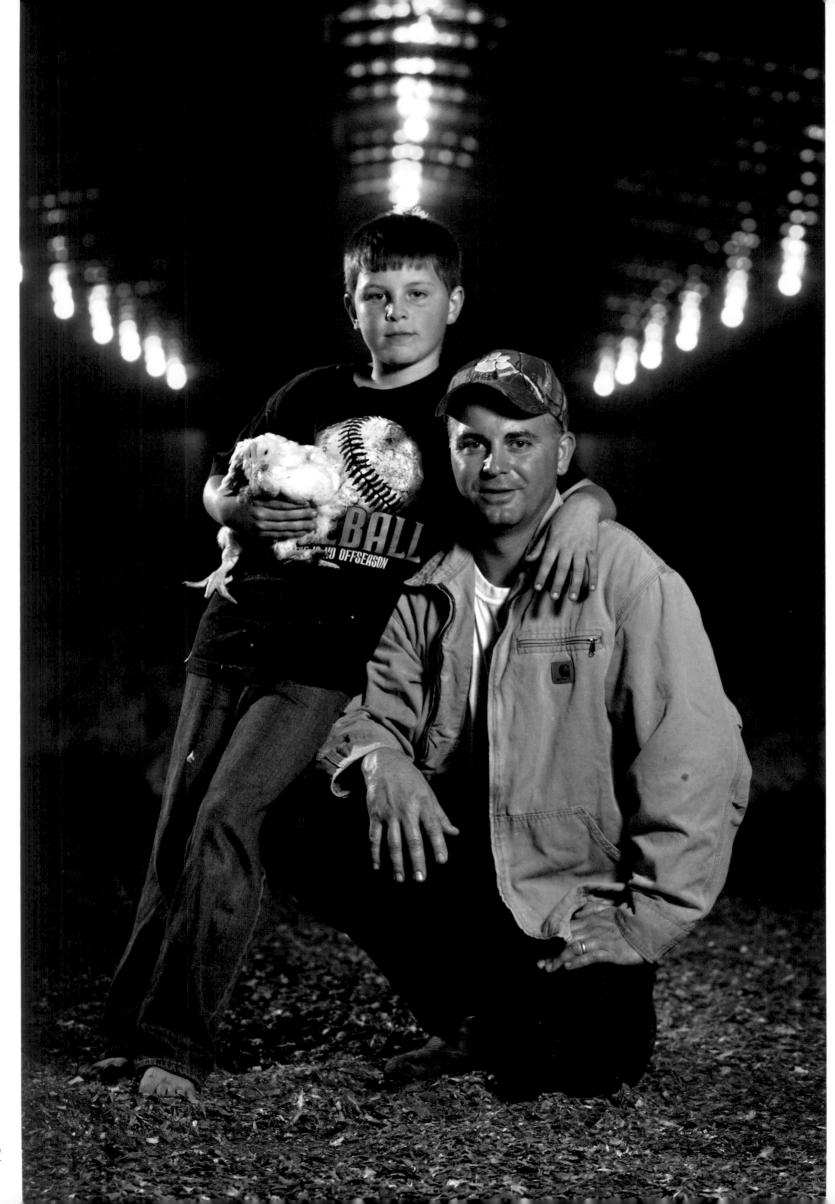

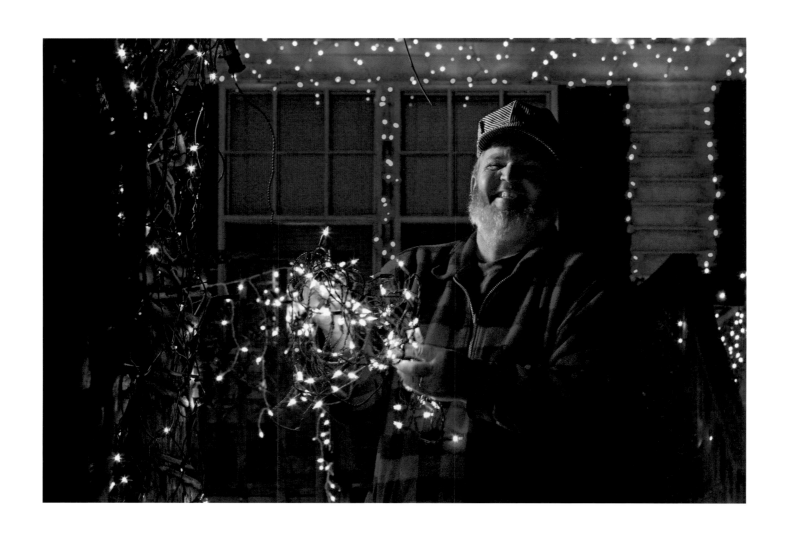

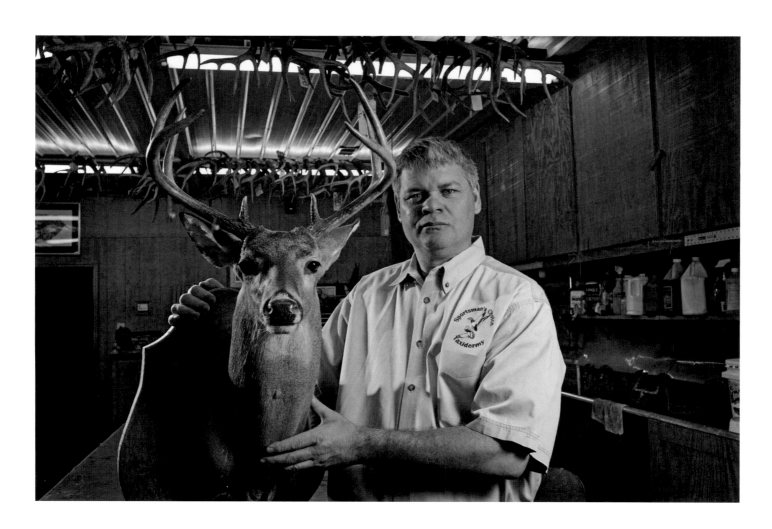

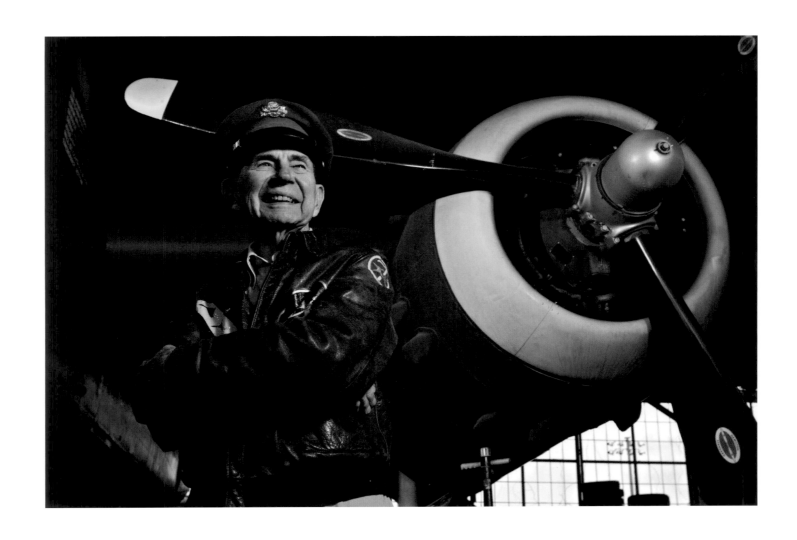

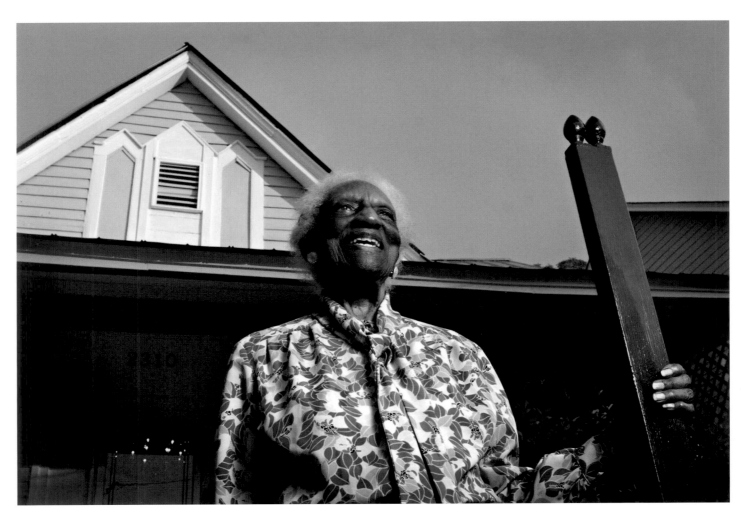

Molly Hayes

I've always been interested in photographing people in the act of doing what they love, especially when what they love is slightly out of the ordinary. Throughout my life, I've enjoyed watching and learning about the ways that people connect to their histories and families. My interest in the strong and deep-rooted connections that relate southerners to their cultural and family heritage has led me to the world of reenactors and to living-history enthusiasts of many types.

This portrait project, which I still consider to be in the early stages, examines a number of elements and questions. The social, cultural, political, theatrical, historical, and aesthetic aspects found in the reenacting/living-history world are a few of the themes I am dealing with in this work. As I grow increasingly involved in knowing these enthusiasts, the more I understand the complexity and diversity of the issues that concern their many and varied communities.

One of my favorite topics in this body of work (and others) is the relationship and clash between history and the present. I wanted to include contemporary elements in the portraits to illustrate the difficult challenge of separating the two worlds. These individuals have varying levels of commitment to the idea of historical accuracy, which are illustrated in the collection of portraits shown here.

A significant challenge with each subject was defining who is represented in the portrait. When photographing people who are "in character," it becomes difficult to ascertain whether the finished product is a representation of the "real" person being photographed or the character the subject is portraying. This blurred line between reality and theater fascinates me.

Beyond the social, historical, and cultural issues that engaged me, my goal was to make portraits that stand alone and above the themes that define them. Through meeting and photographing these people, I hope to show them as individuals, as well as to continue to learn about history and how we are defined by and connected to it.

(P. 67 clockwise top left) Vinson Miner, 2008. Camden, SC.

Kenny Davidson and Michelle Hopler, 2008. Mount Pleasant, SC.

Jim Blades Strong, Arlene MacKey, Robert A. McCann, Laura Gayle Ledford, Leonard H. Carter II, 2008. Camden, SC.

(P. 68) Lisa Q. Wilson, 2008. Mount Pleasant, SC.

(P. 69) Michael D. Burbage, 2008. Mount Pleasant, SC.

(P. 70 clockwise top left) Matt Vincett and Terry Wyman, 2008. Camden, SC.

Jeanne Elliott Weil, 2008. Mount Pleasant, SC.

Travis Poole, 2008. Camden, SC.

Sharon Murray, 2008. Mount Pleasant, SC.

(P. 71) Jim Blades Strong, 2008. Camden, SC.

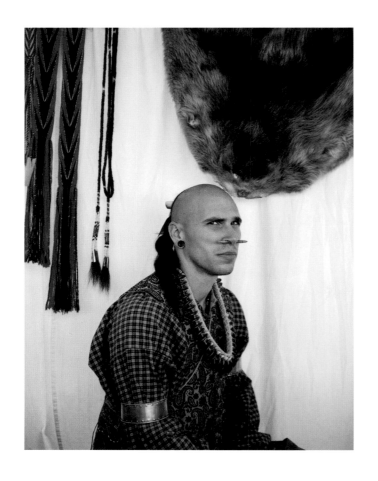
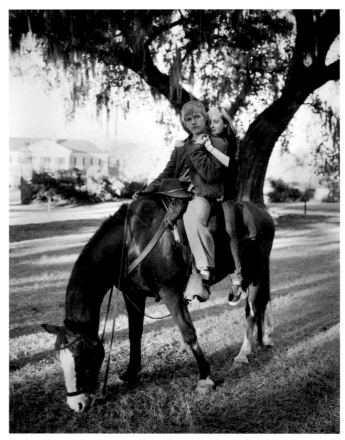
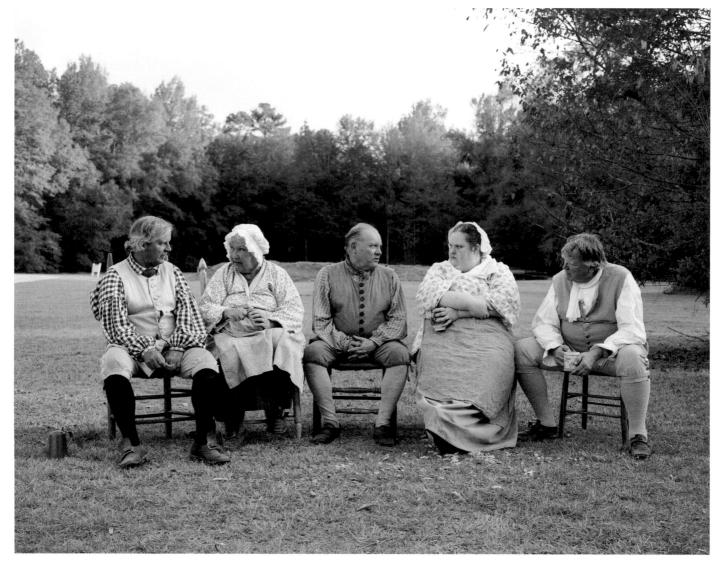

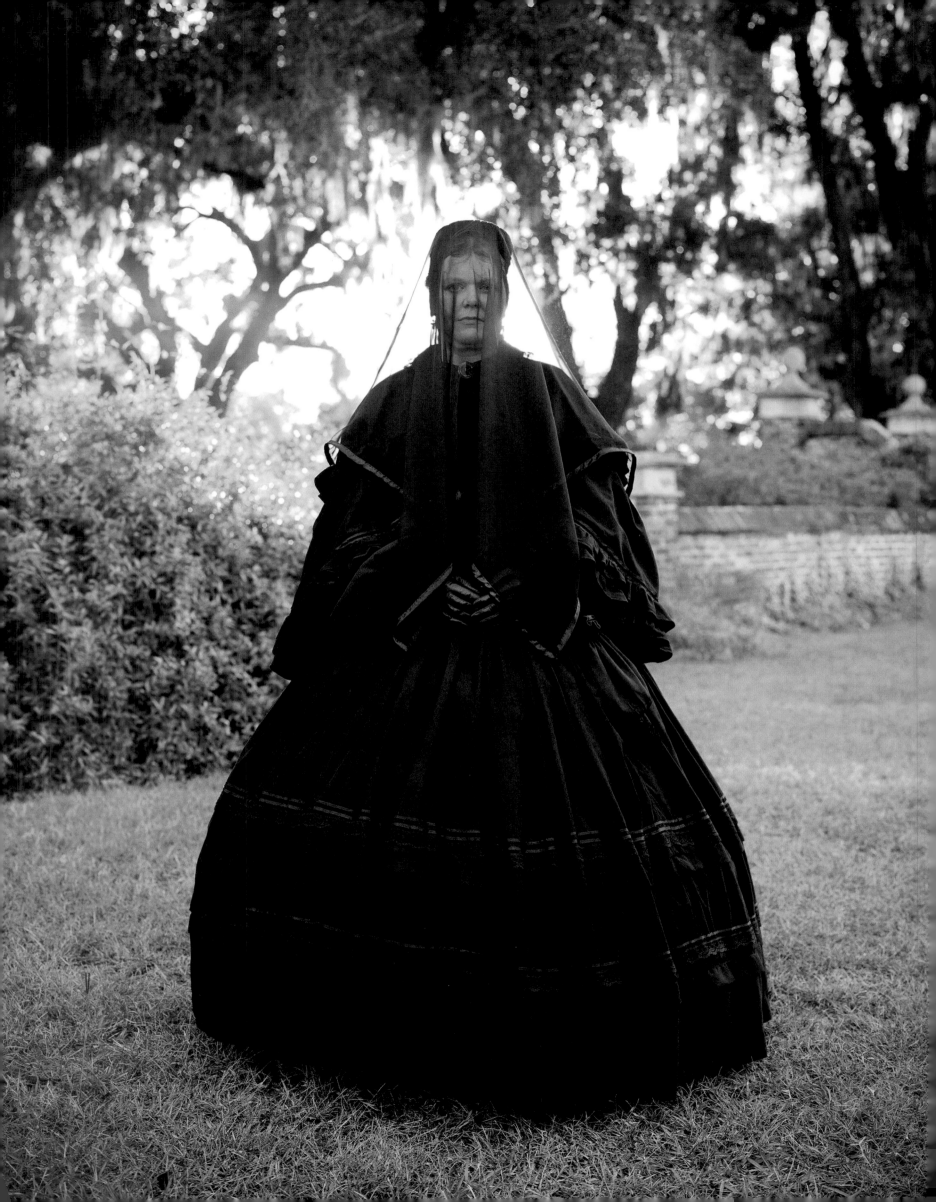

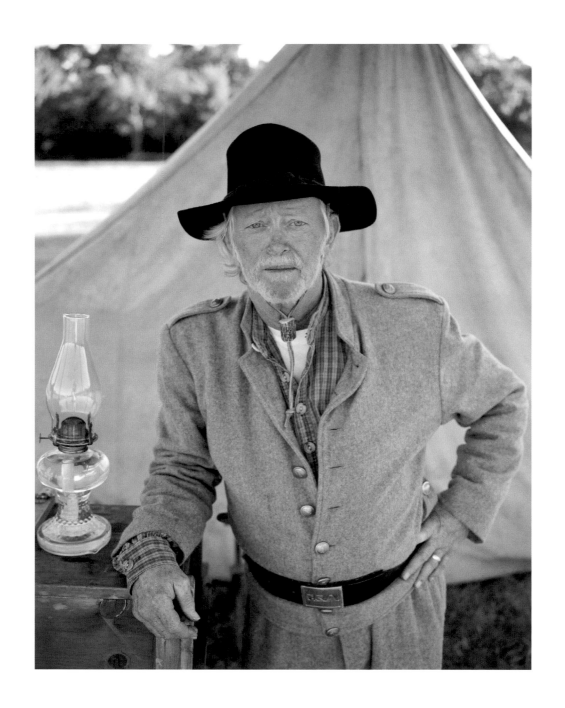

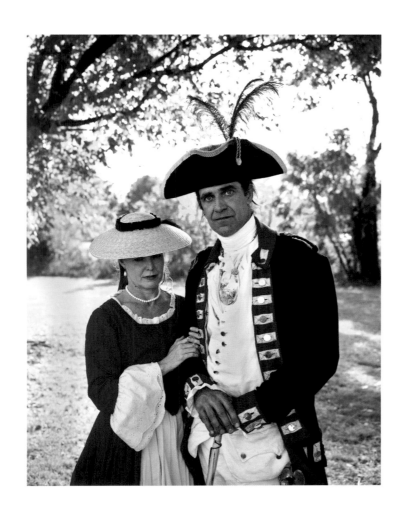

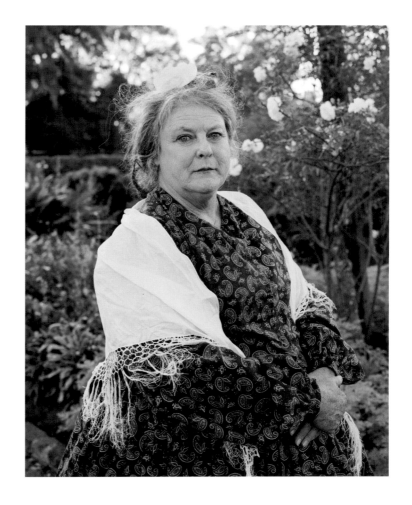

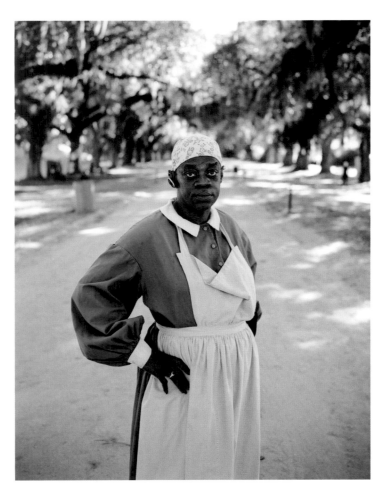

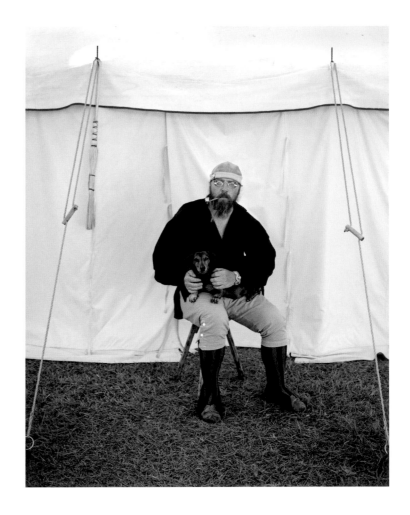

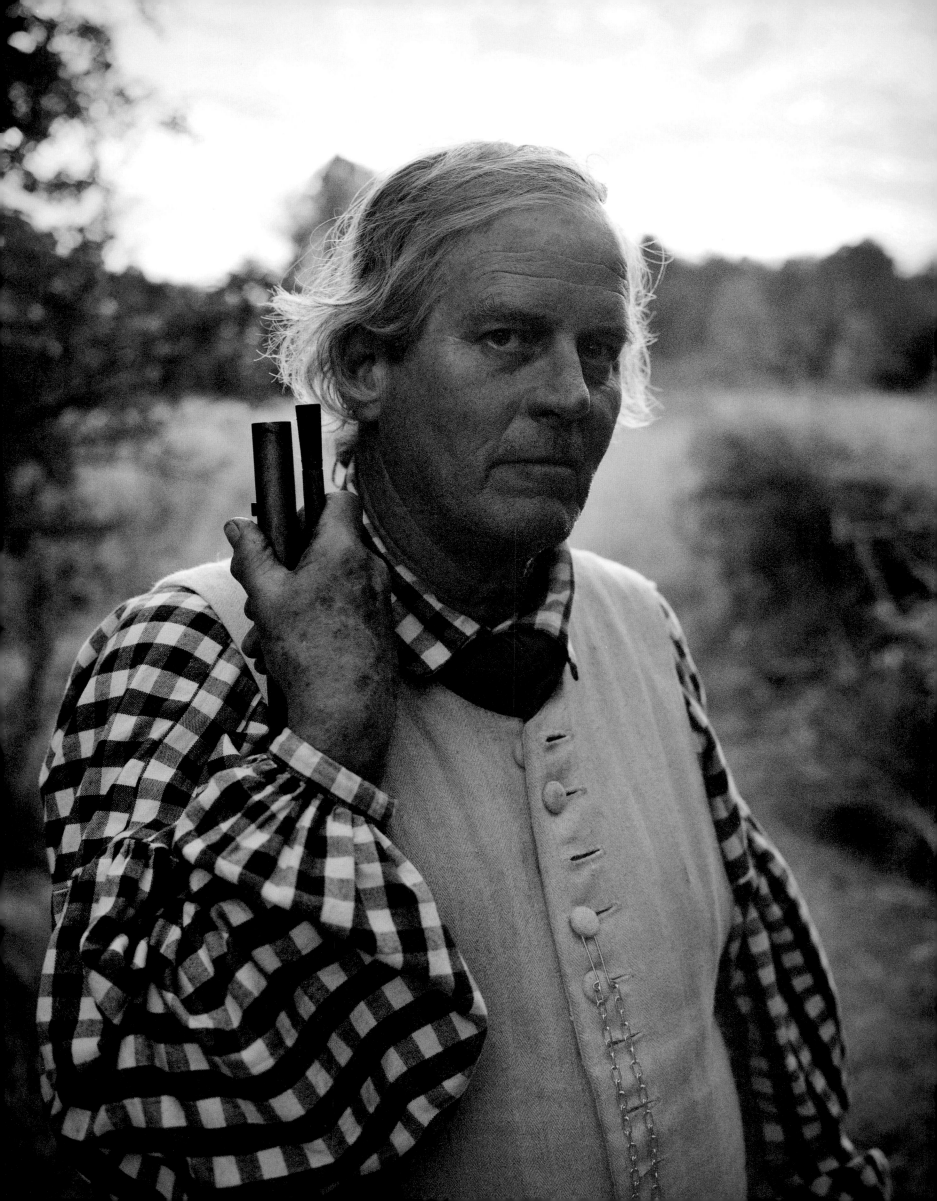

Jon Holloway

Too often in our society, we neglect
the importance of creating meaningful
connections with the world around us.
I believe that, as soulful beings, we are
made to share ourselves with each other.

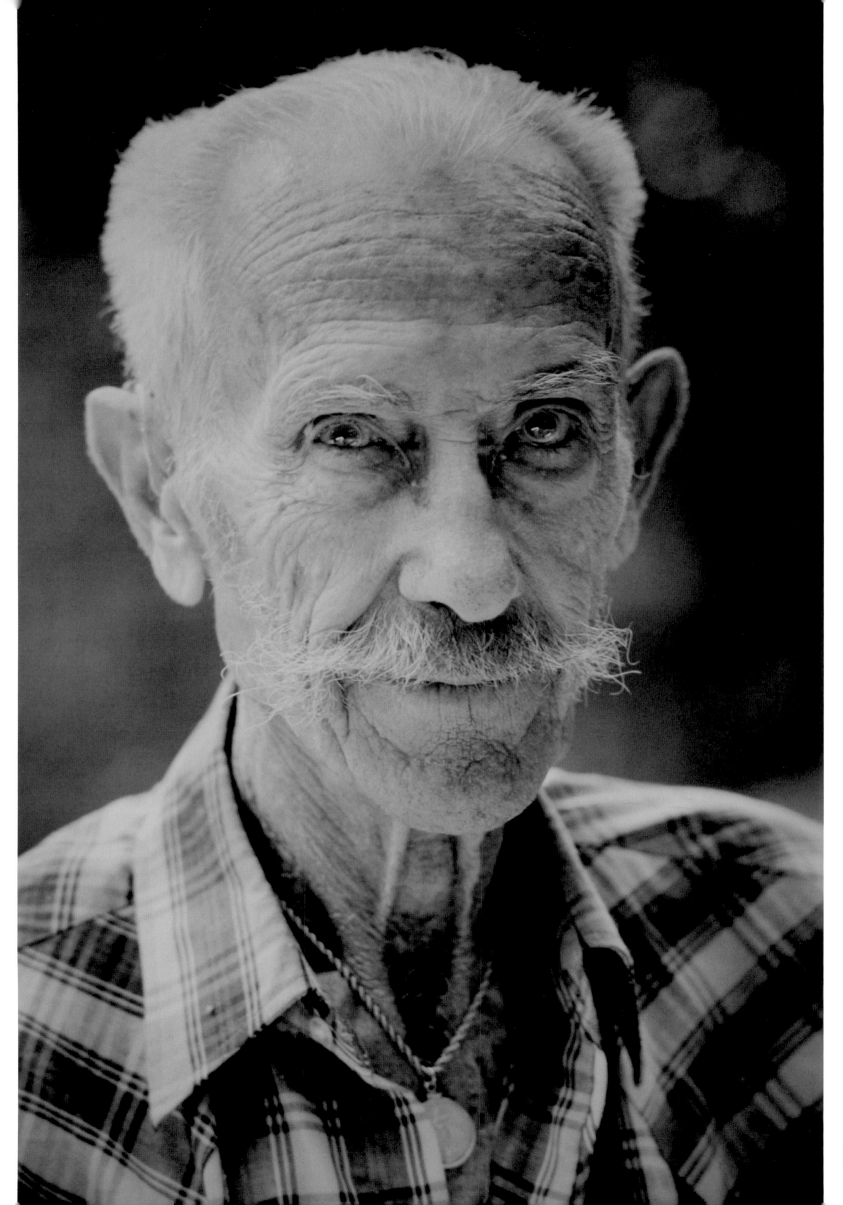

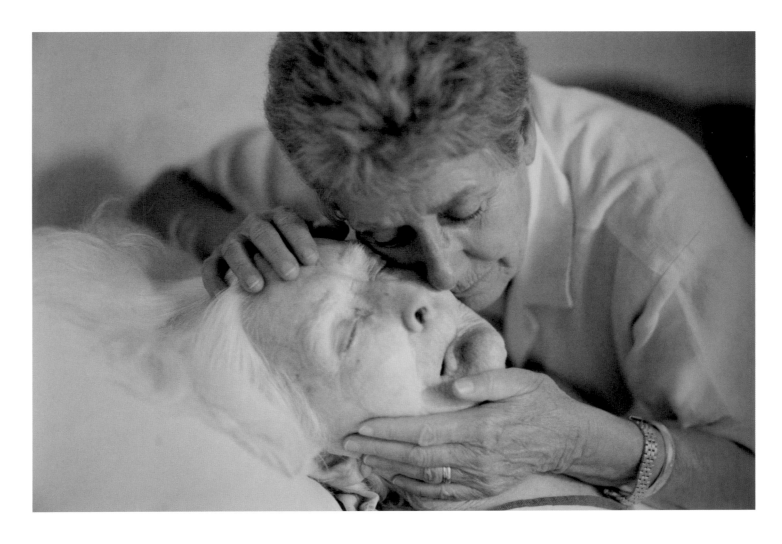

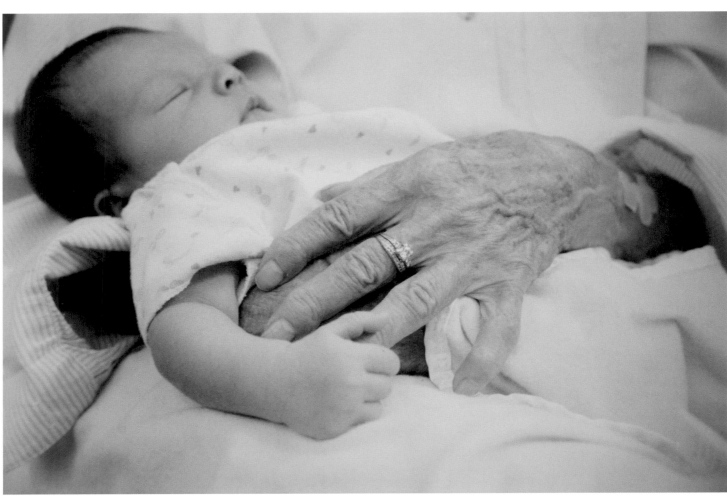

Caroline Jenkins

While shooting for this project, I was
continually amazed at the willingness of
people to be present and available to the
lens. Their openness and generosity of
spirit was inspiring to me as an artist and
encouraging as a witness to humanity.

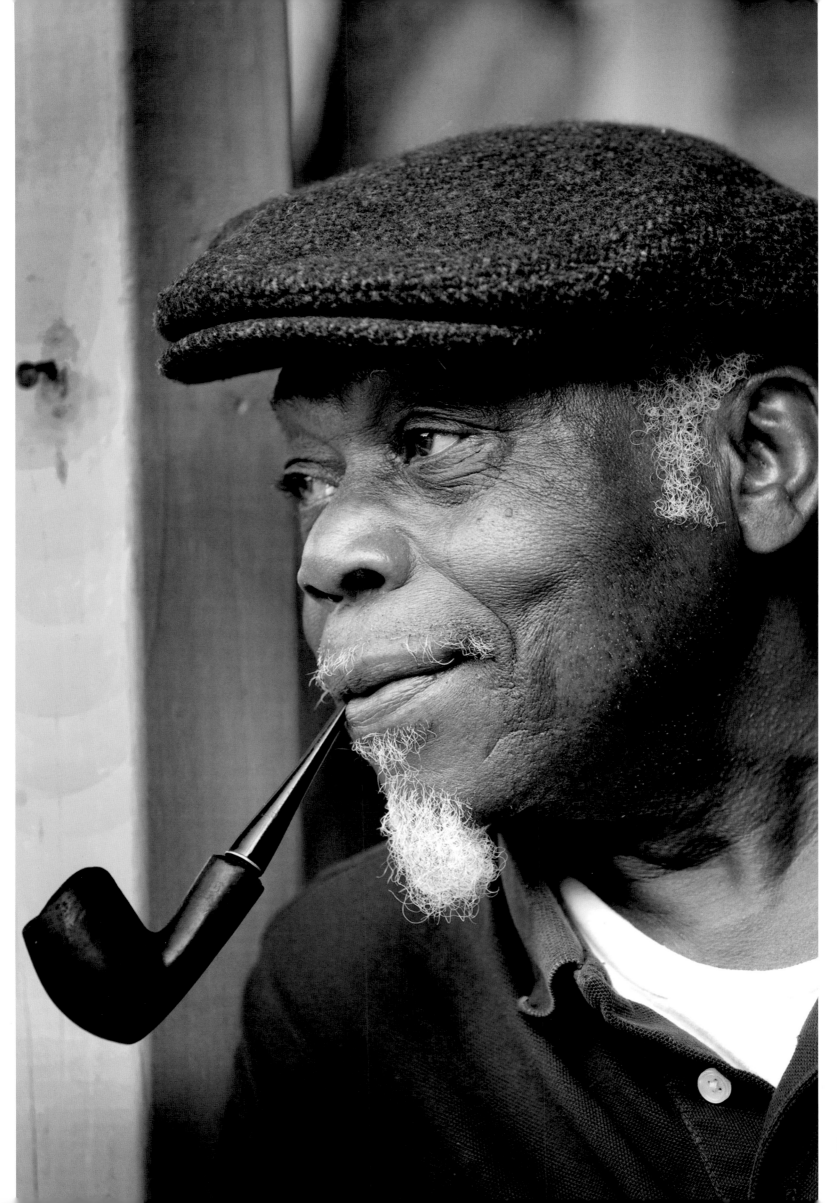

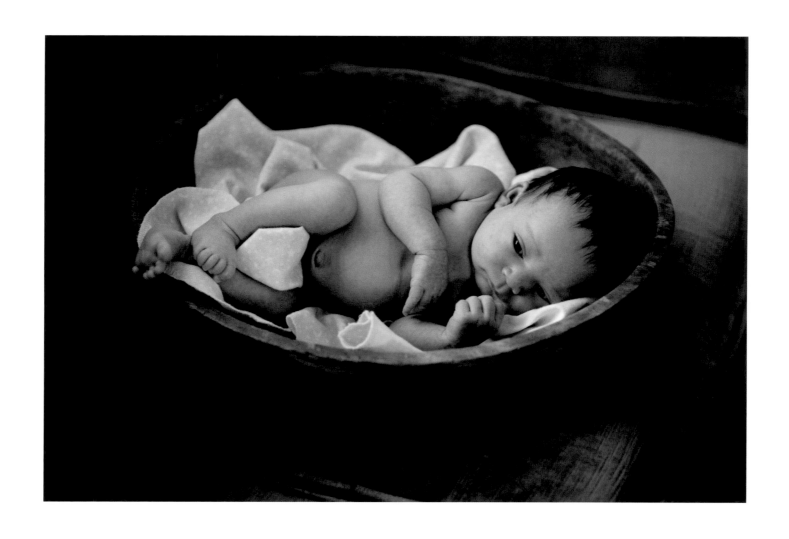

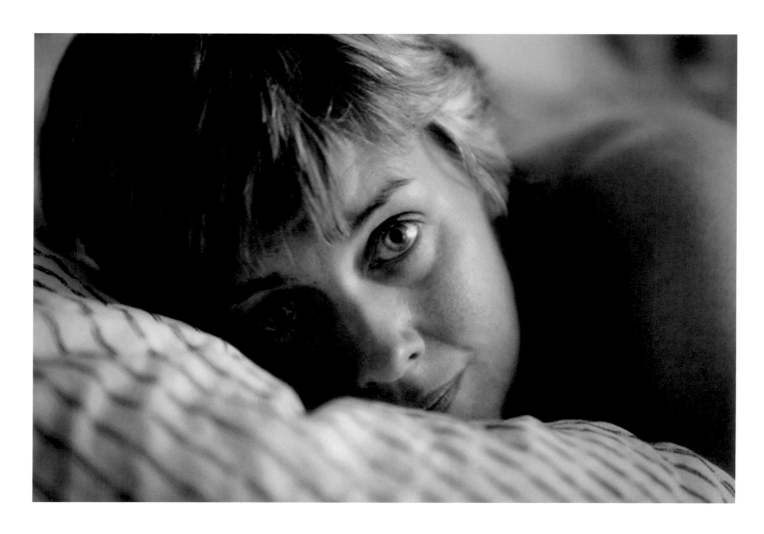

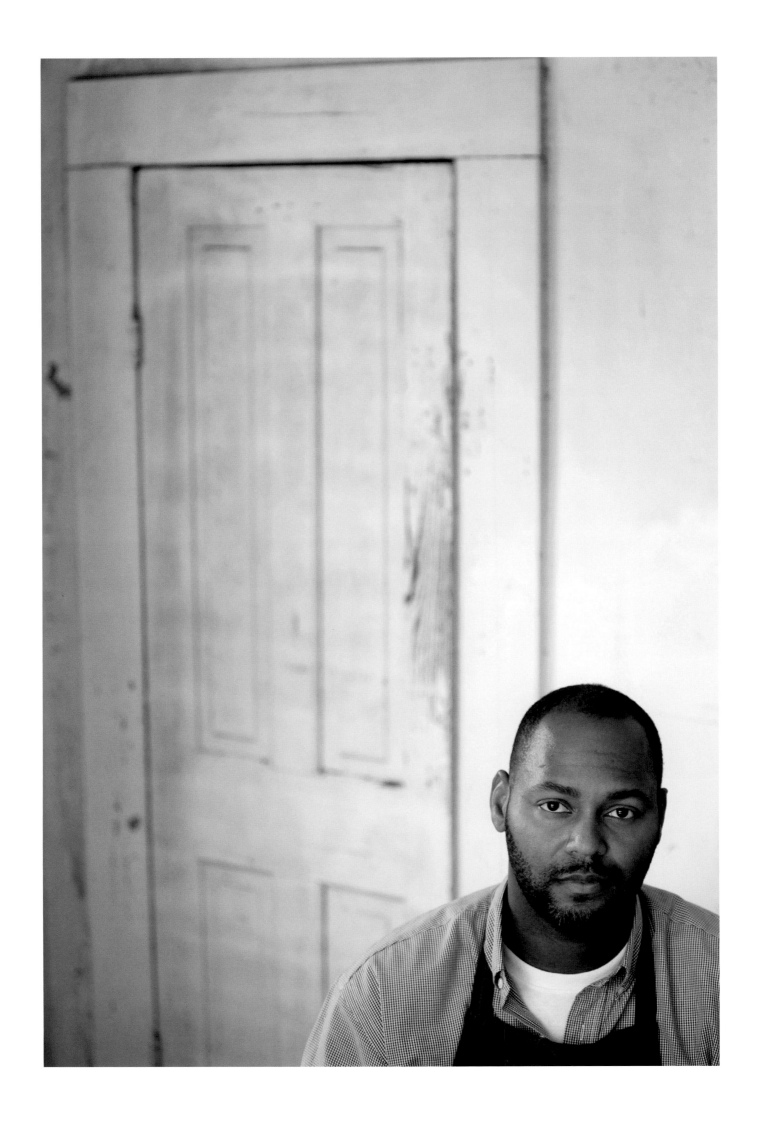

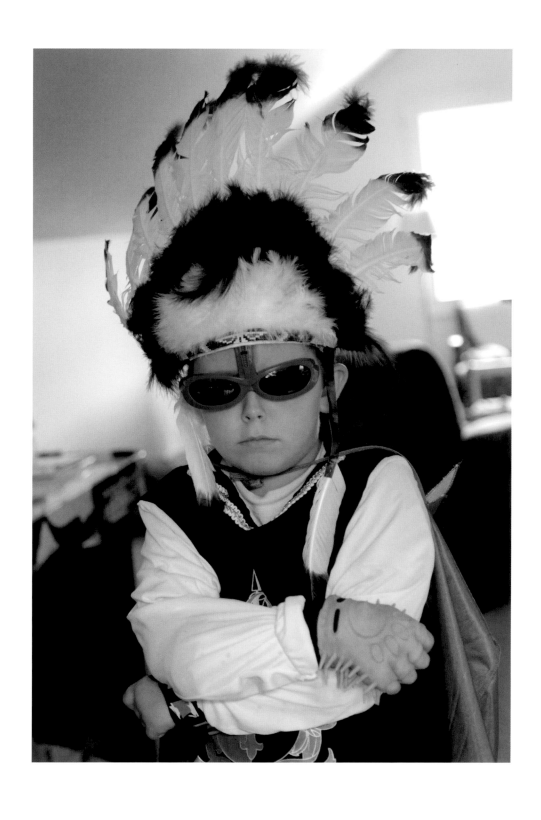

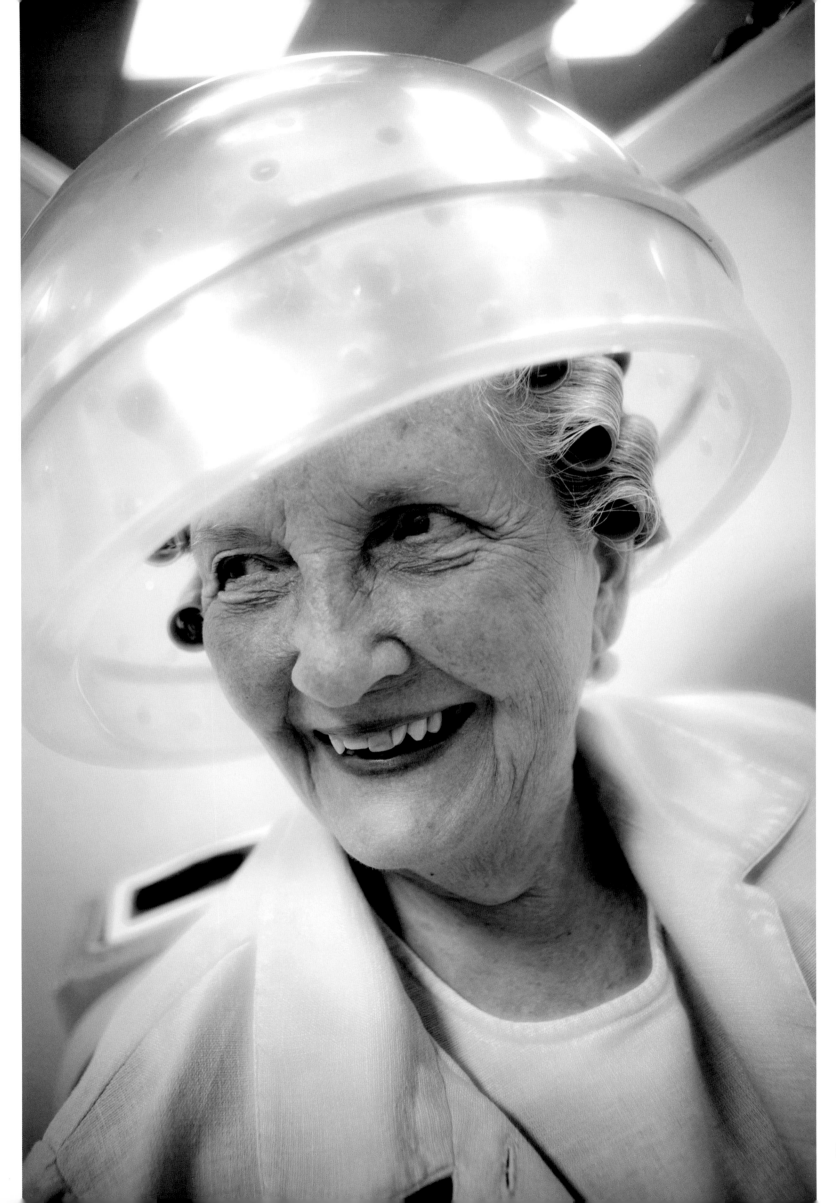

Julia Lynn

I chose interesting characters who are a part of South Carolina history. I was particularly fascinated by people who are a part of a fading era. I wanted to capture the timeless quality of the people in these places.

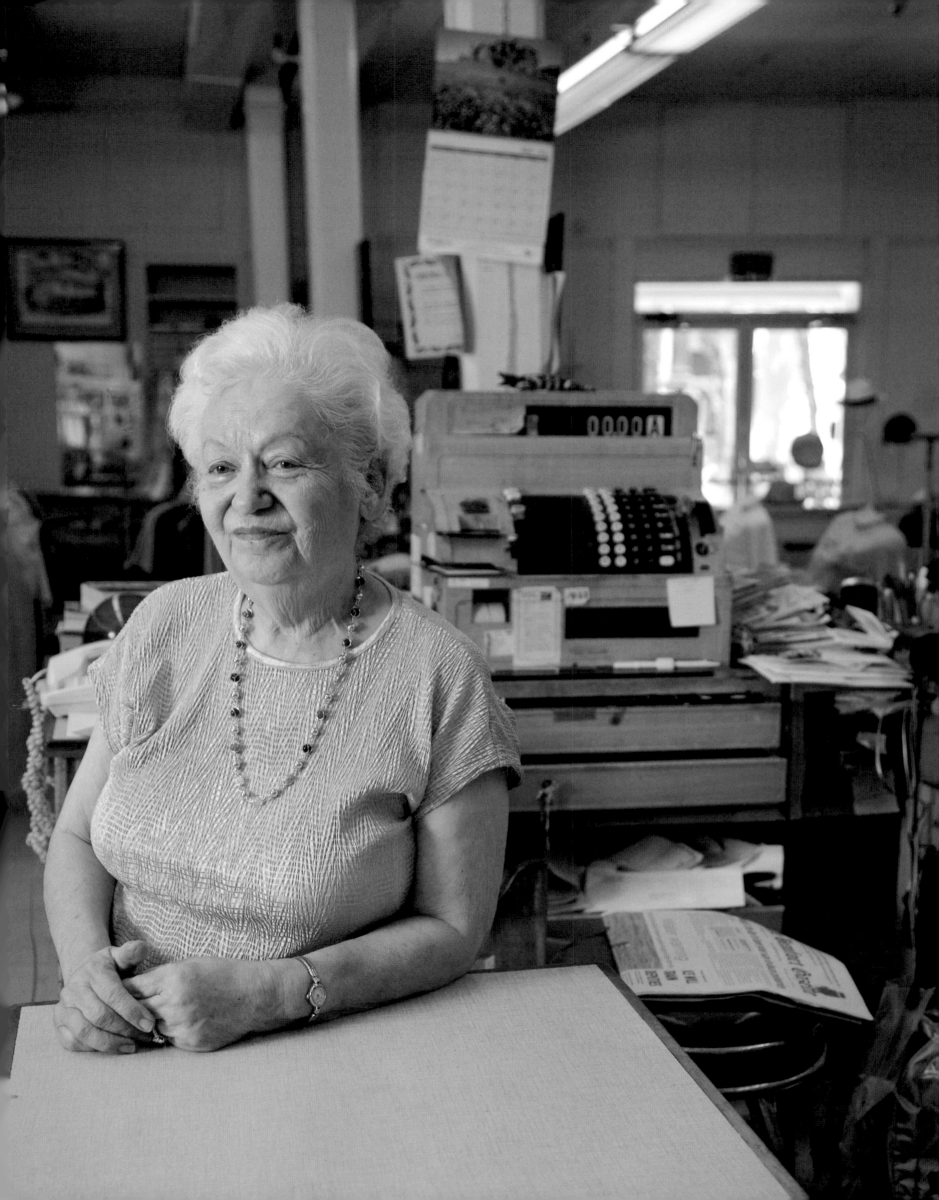

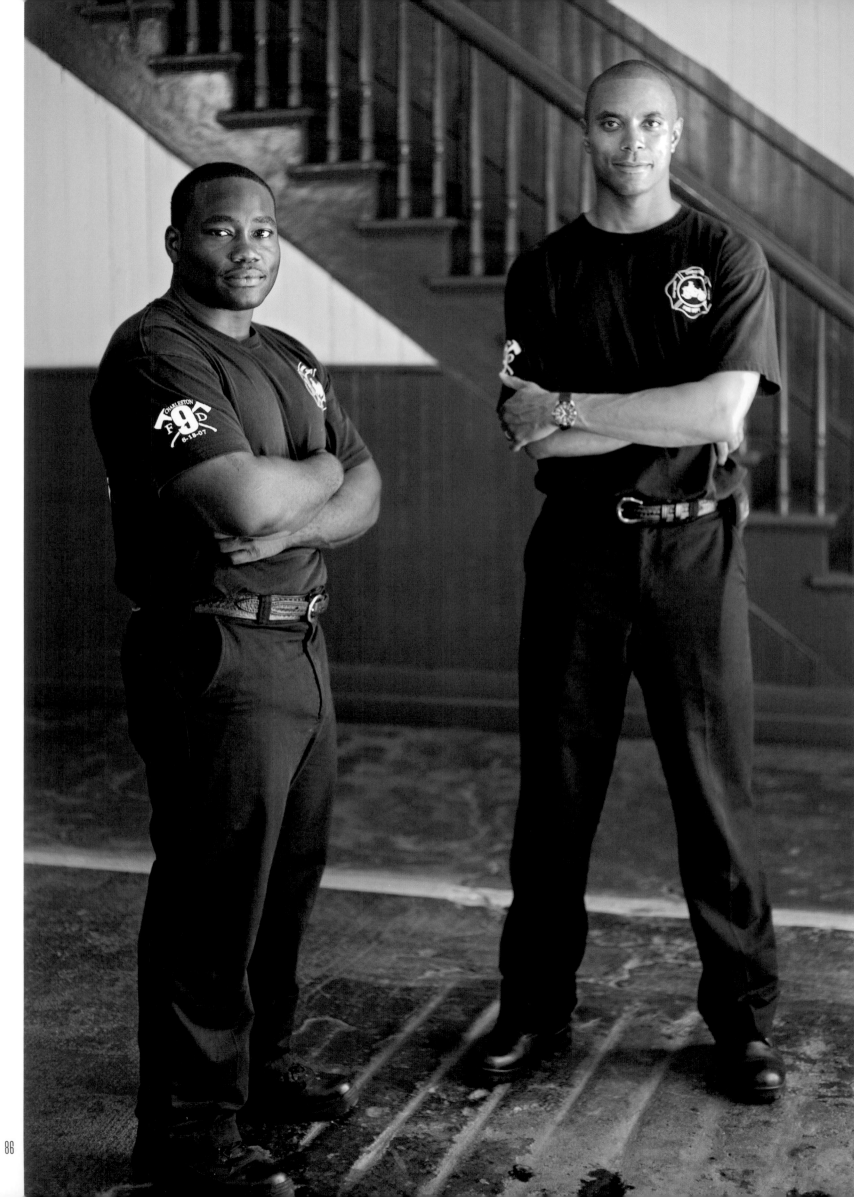

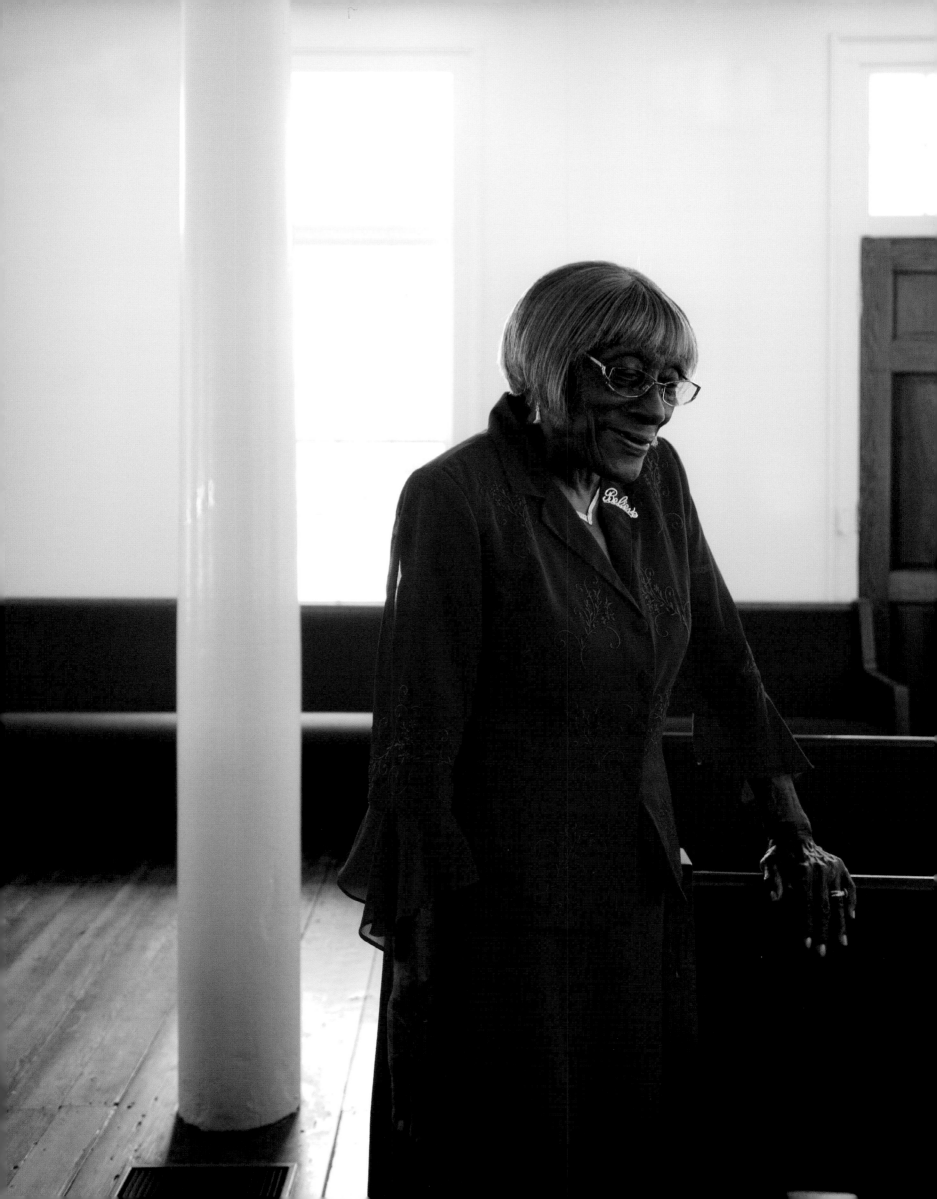

Nancy Marshall

These portraits are of people I know well, who have come in and out of my intimate circle over time. I've known some of my subjects all of their lives and have photographed them over the years. I'm looking for the individual qualities of mystery and beauty that are unique to each person; I also wish to reveal how time and events change both me and the people I photograph.

The photographs are made with an 8x10-inch wooden-view camera. This way of working slows everything down. The camera produces a big negative that I then print on platinum papers I prepare myself. For me, the resulting photograph then becomes a unique object.

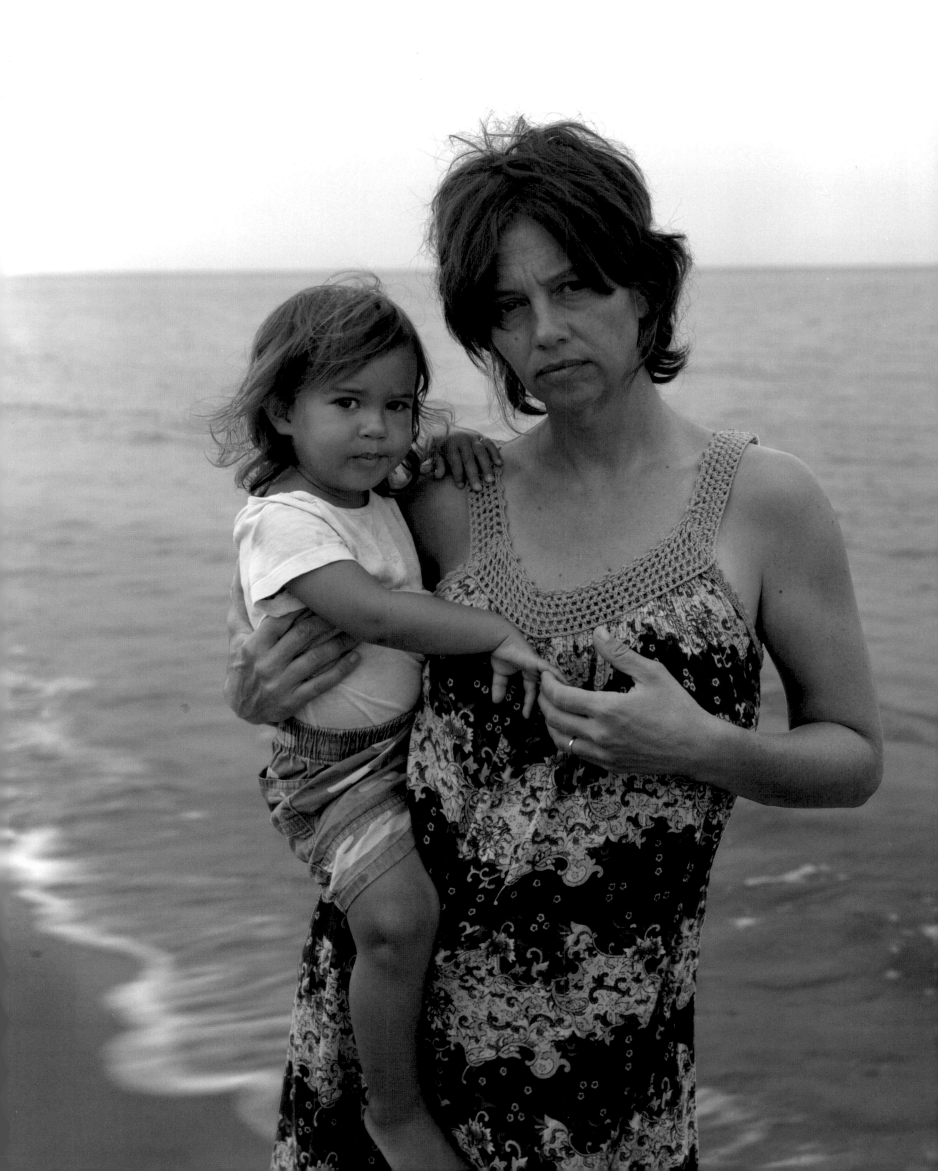

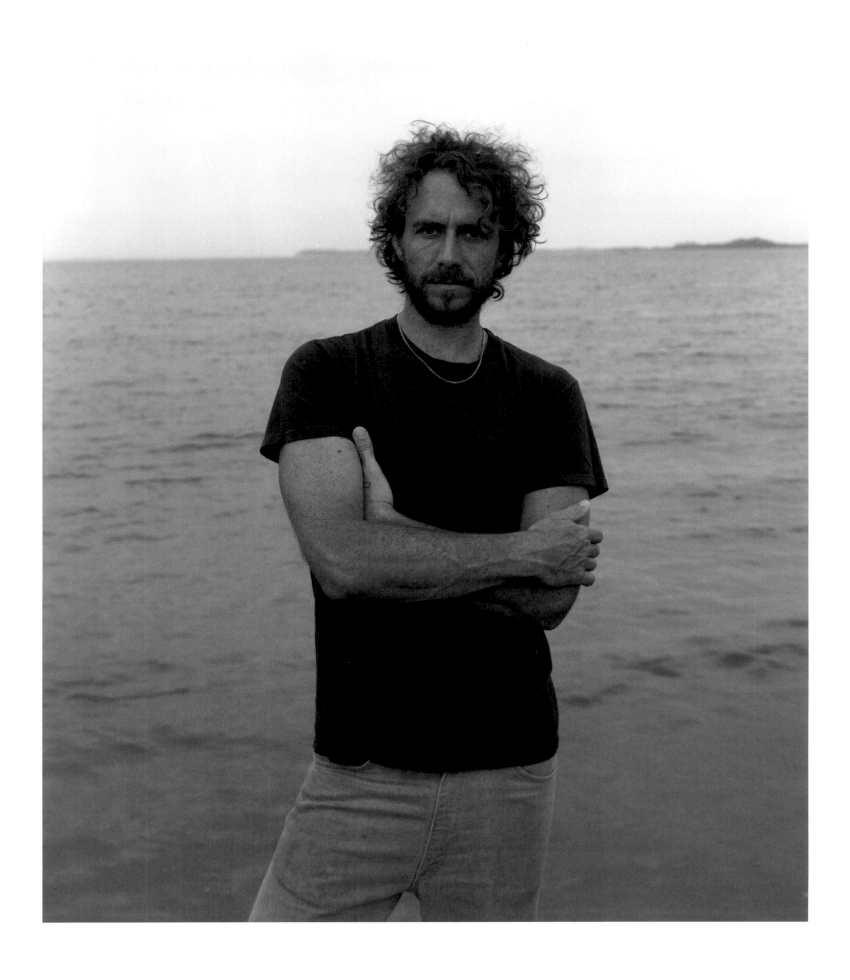

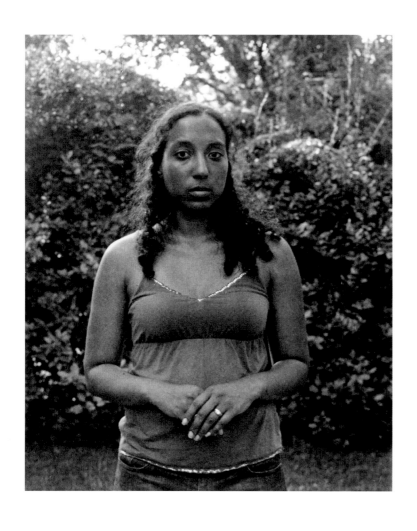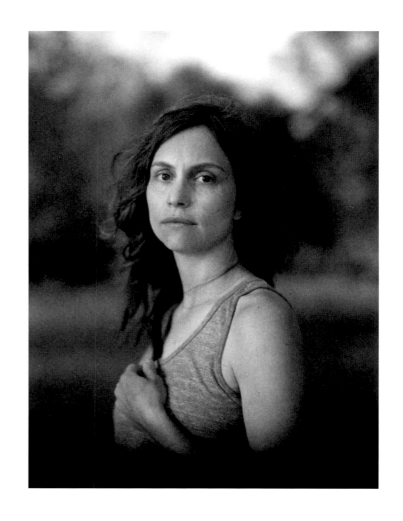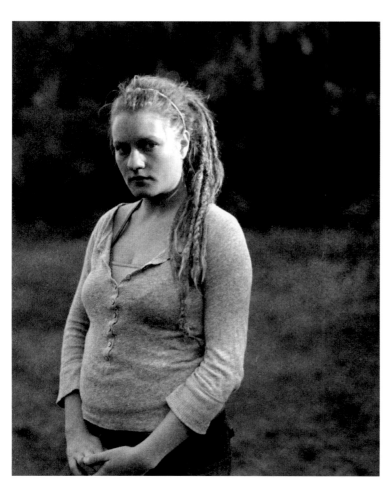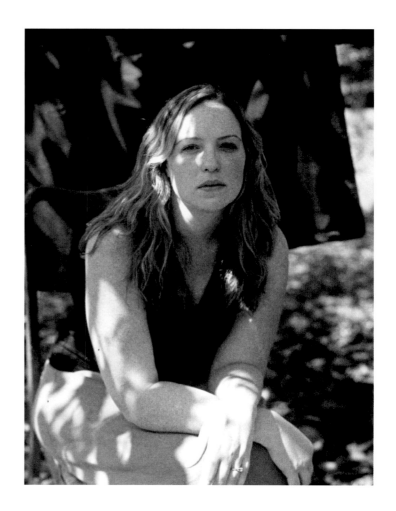

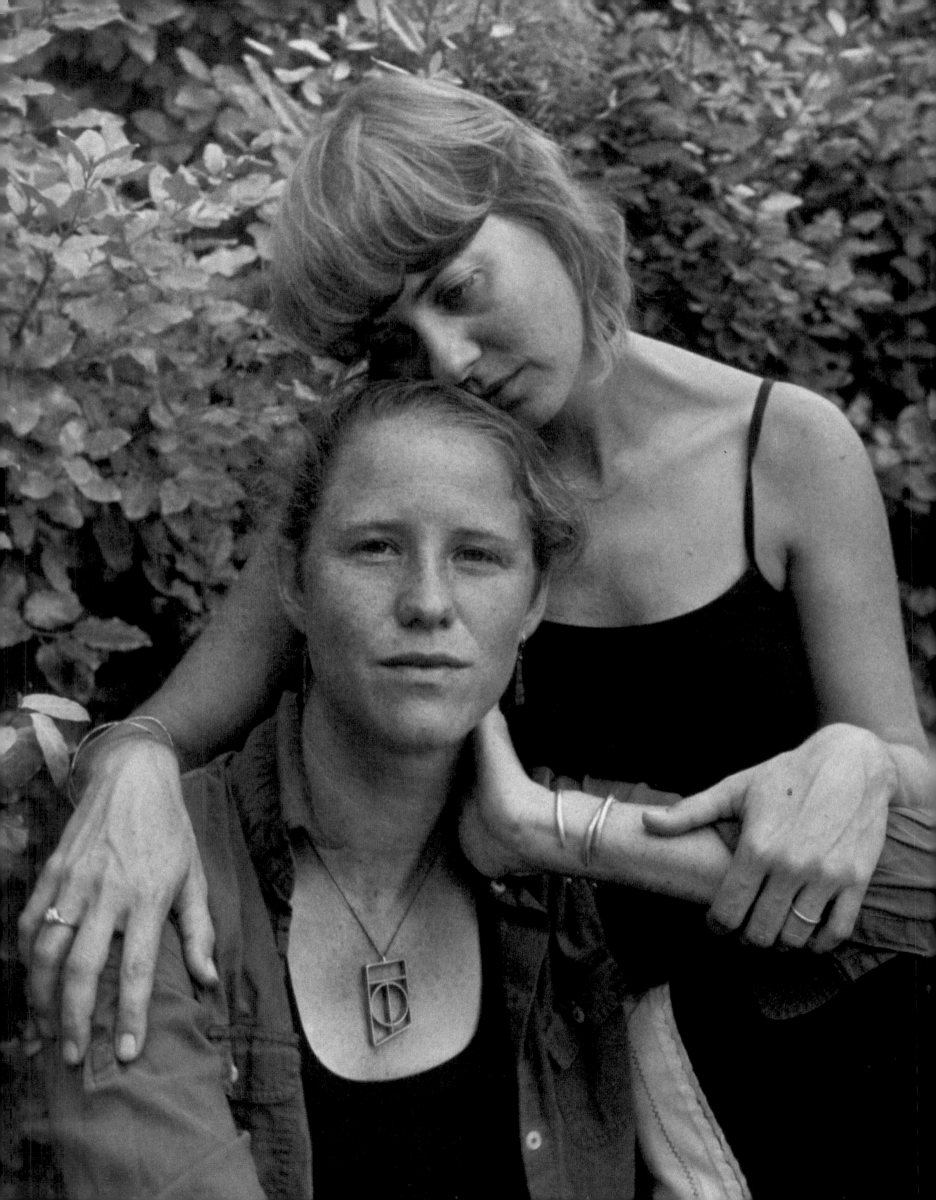

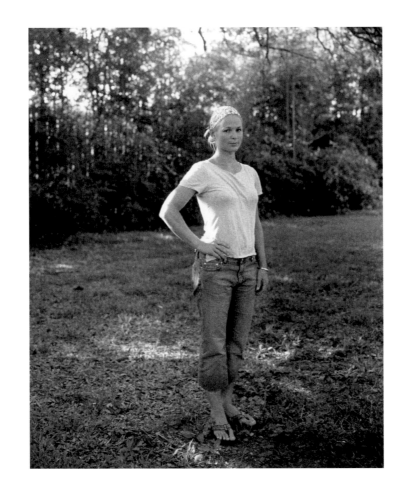

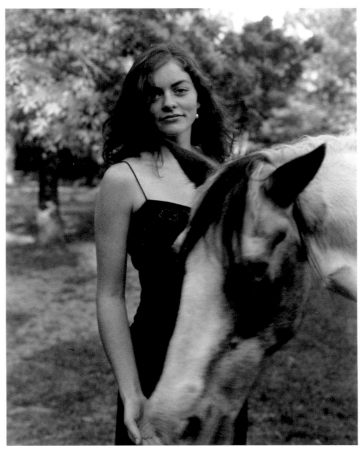

Phil Moody

I have always been interested in
photographing the working environments
of ordinary people, and my work is still
motivated by their stories.

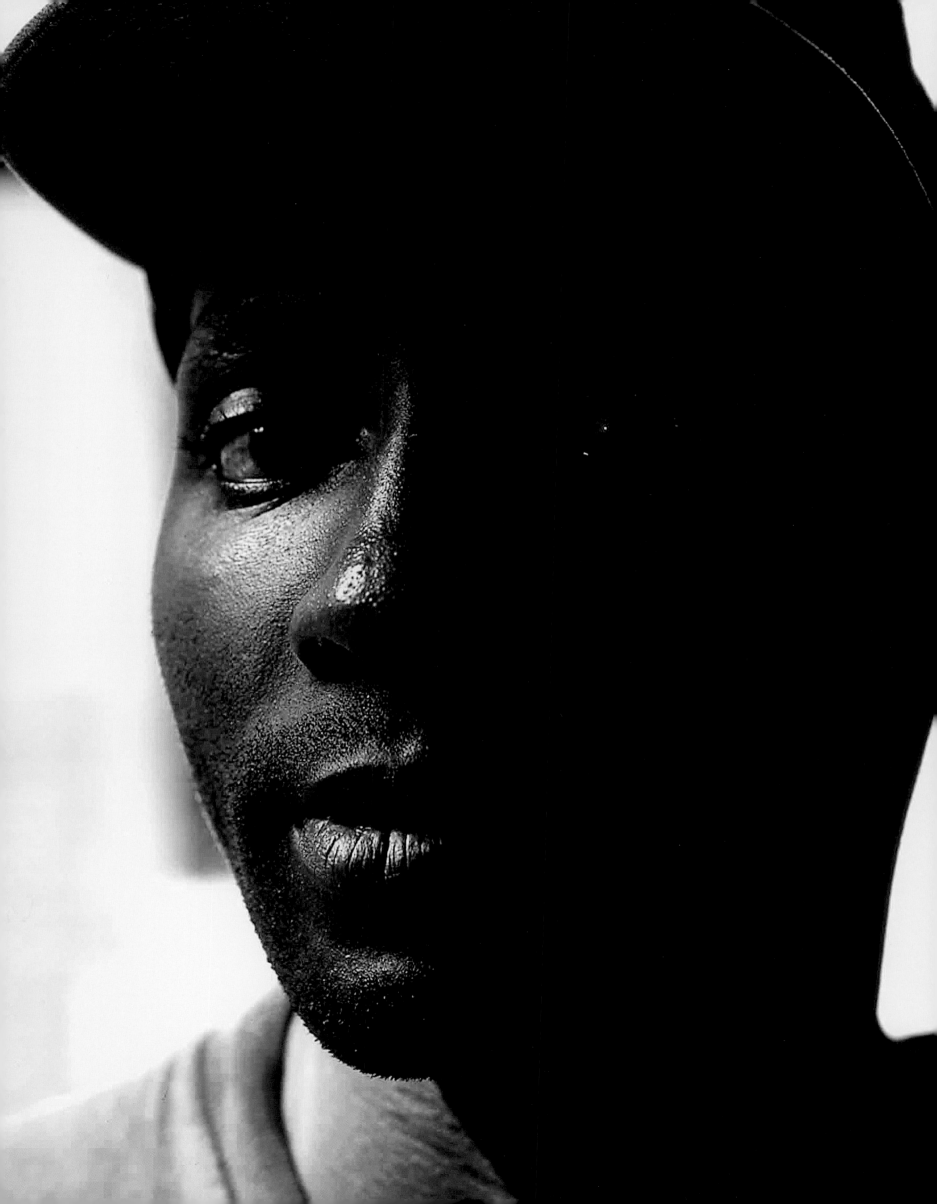

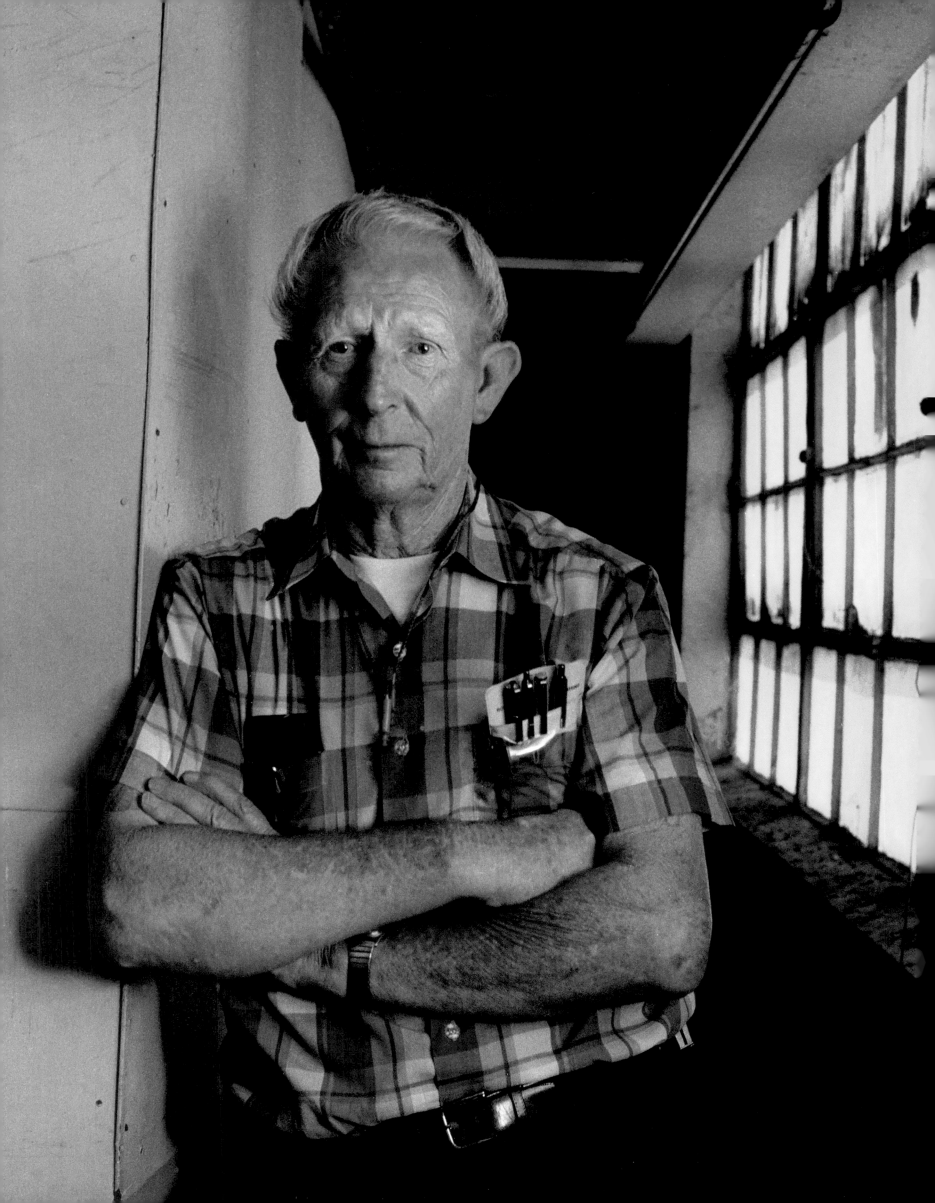

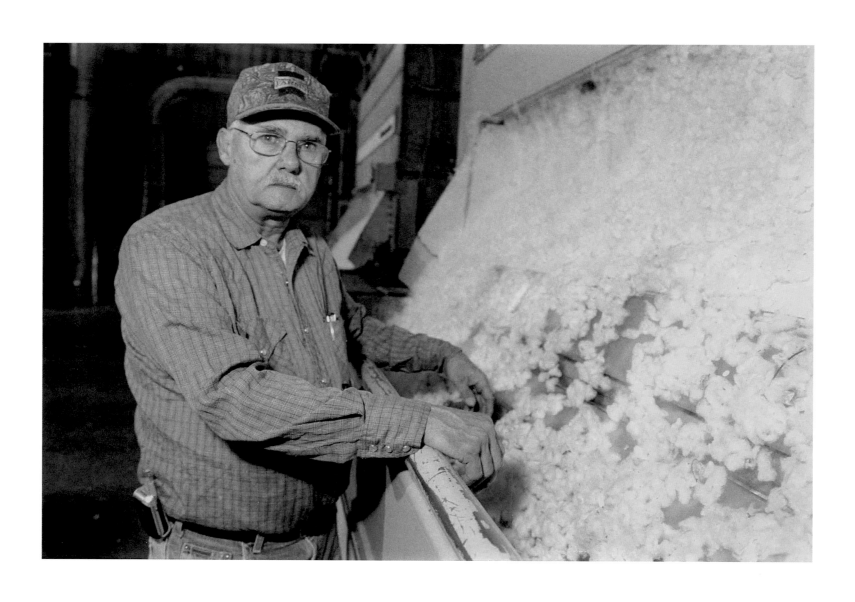

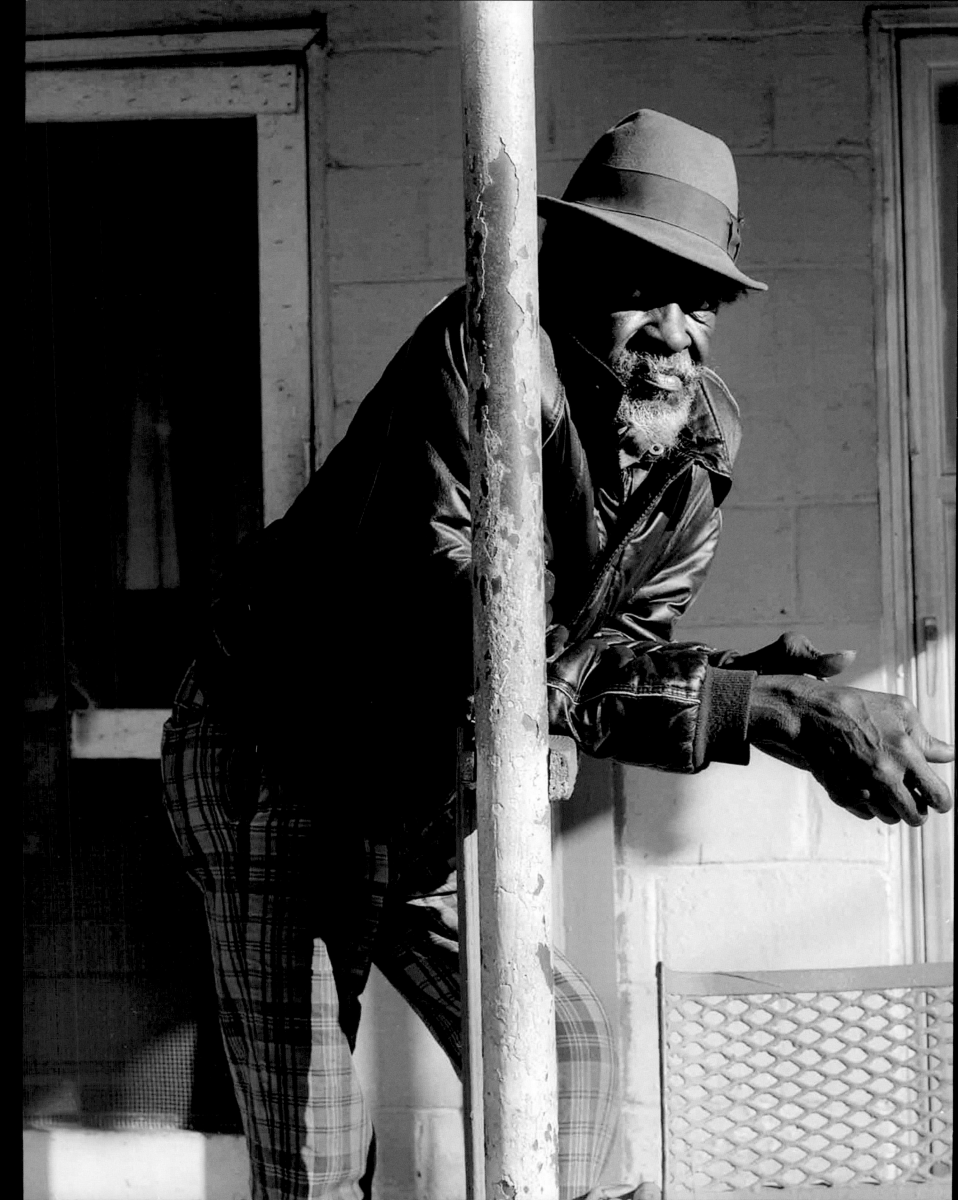

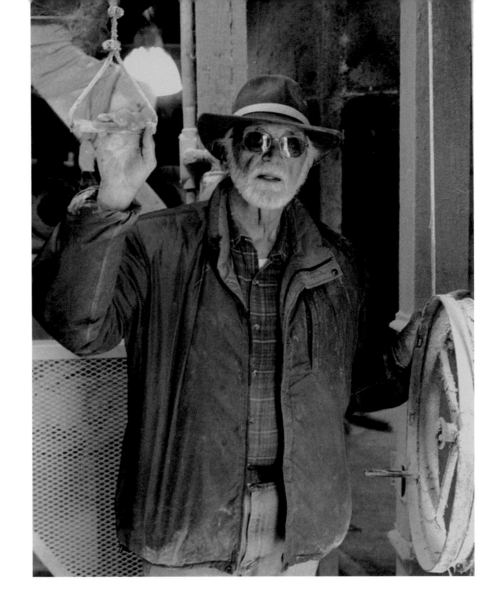
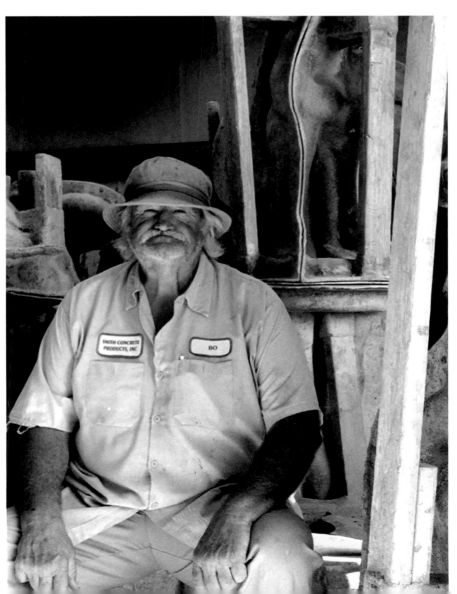

Milton Morris

I have always had a passion for creating portraits, especially on large-format film. The *Palmetto Portraits Project* was a wonderful opportunity to produce a series of images with my large-format cameras—an 8x10 Horseman and an 11x14 Deardorff. I prefer using these cameras because they allow me to work in a studied manner.

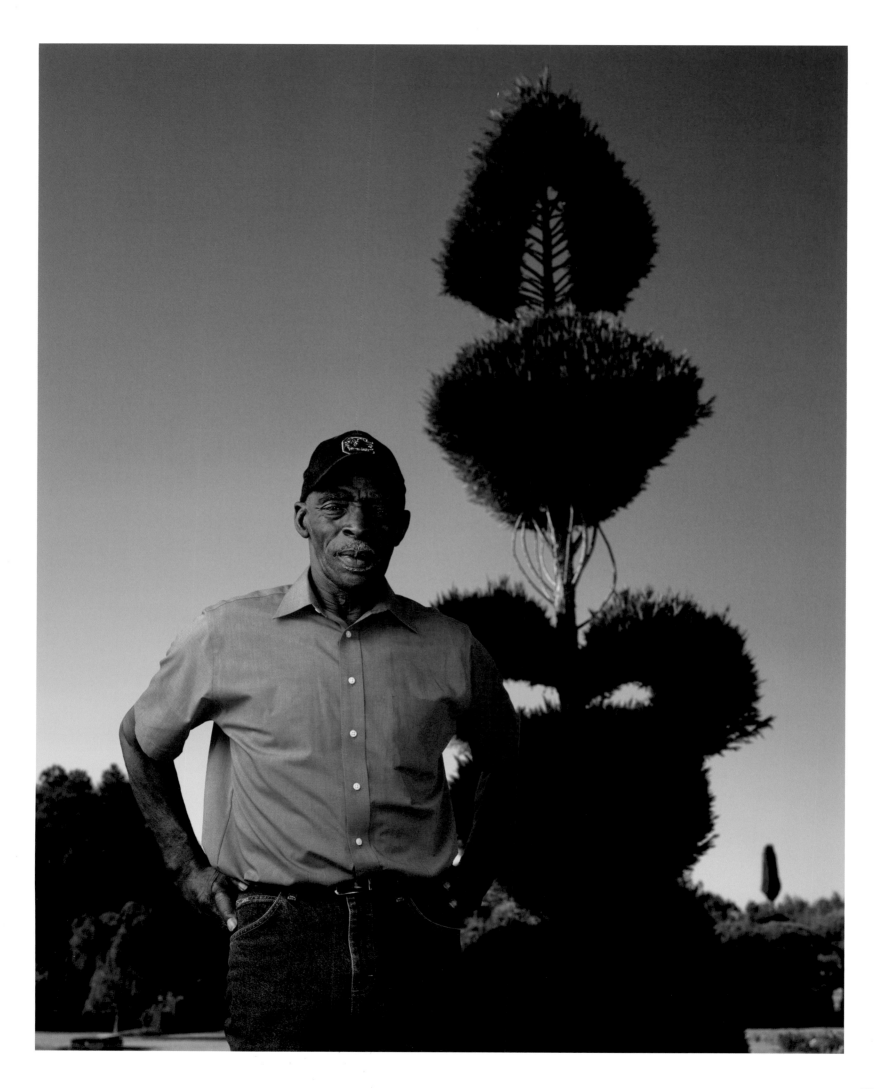

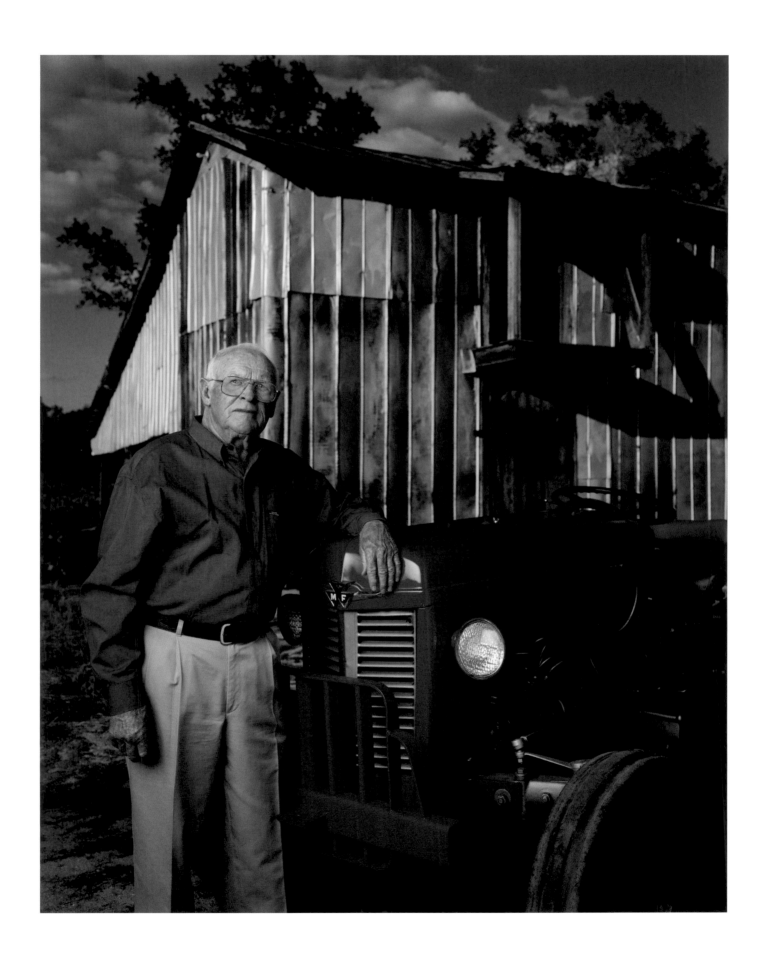

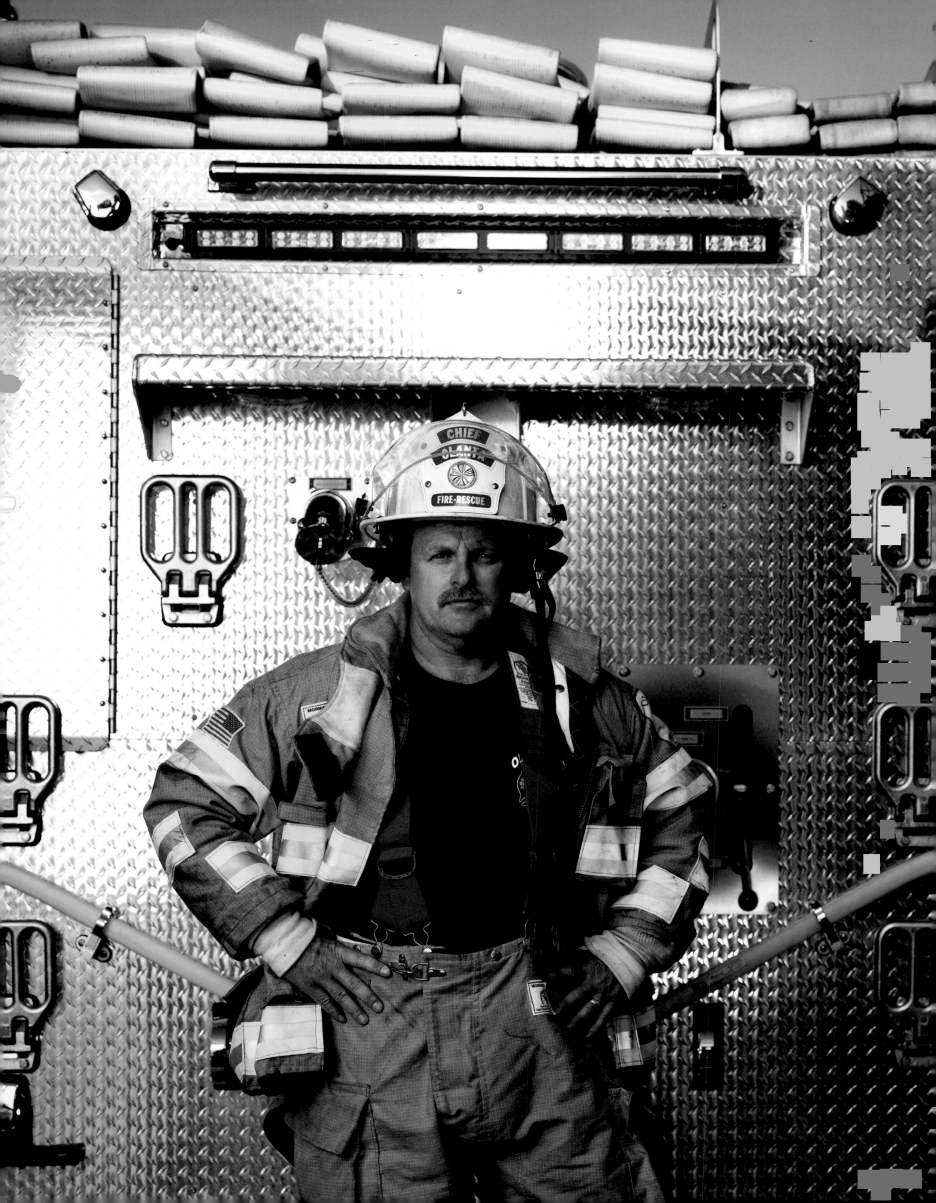

Stacy L. Pearsall

I spent many memorable years in the military, and there is nothing more honorable than serving one's country. I came to live in Charleston because I was stationed at the First Combat Camera Squadron, located at Charleston Air Force Base. South Carolina hosts every branch of service: Army, Air Force, Navy, Marines, and Coast Guard. Given my military history and connections to each of the state's bases, I decided to make them my focus.

I traveled to Fort Jackson, Charleston Air Force Base, Charleston Naval Base, Marine Corps Recruit Depot Parris Island, and Coast Guard Sector Charleston. Each base and each face made my minimission worthwhile. From those kooky military-issued glasses (aka birth control glasses) right down to their muddy boots, South Carolina's military men and women make me so very proud to be a veteran.

(P. 109) Jose Delgado, U.S. Marine Corps Recruit, Marine Corps Recruit Depot, 2007. Parris Island, SC.

(P. 110) Aya Hussein and Julia Yamrose, U.S. Army Privates, Fort Jackson, 2007. Columbia, SC.

(P. 111) Joseph Wessick, U.S. Marine Corps Recruit, Marine Corps Recruit Depot, 2007. Parris Island, SC.

(P. 112 top) Sean Flury, U.S. Marine Corps Recruit, Marine Corps Recruit Depot, 2007. Parris Island, SC.

(P. 112 bottom) Johnathan Frank, U.S. Army Private, Fort Jackson, 2007. Columbia, SC.

(P. 113) David Briones, U.S. Marine Corps Recruit, Marine Corps Recruit Depot, 2007. Parris Island, SC.

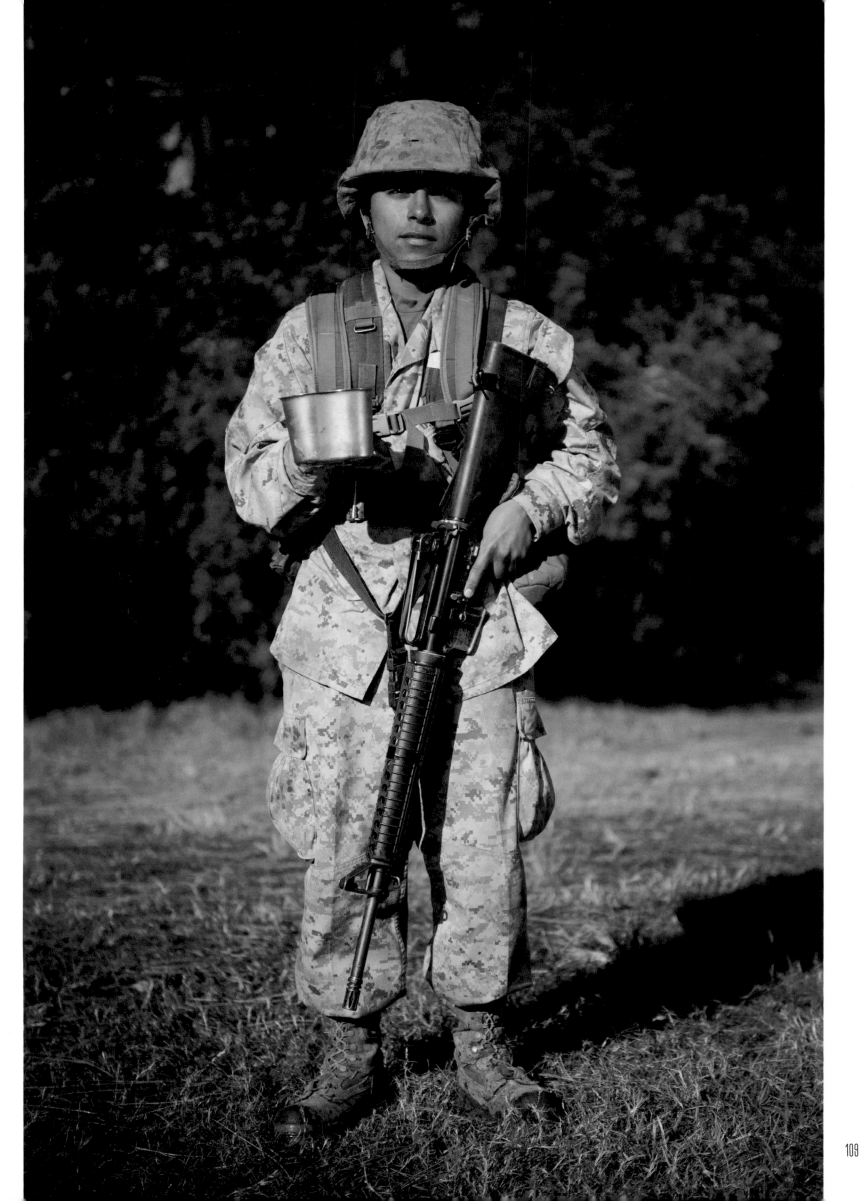

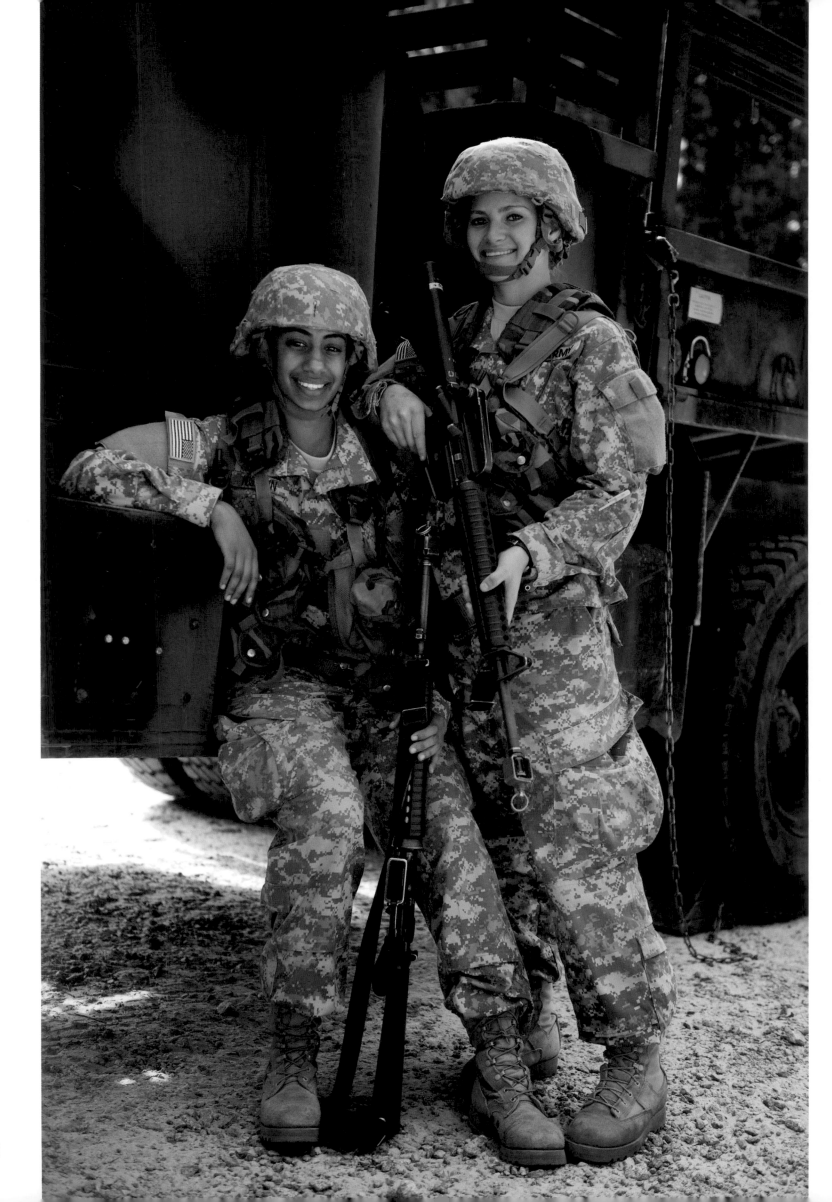

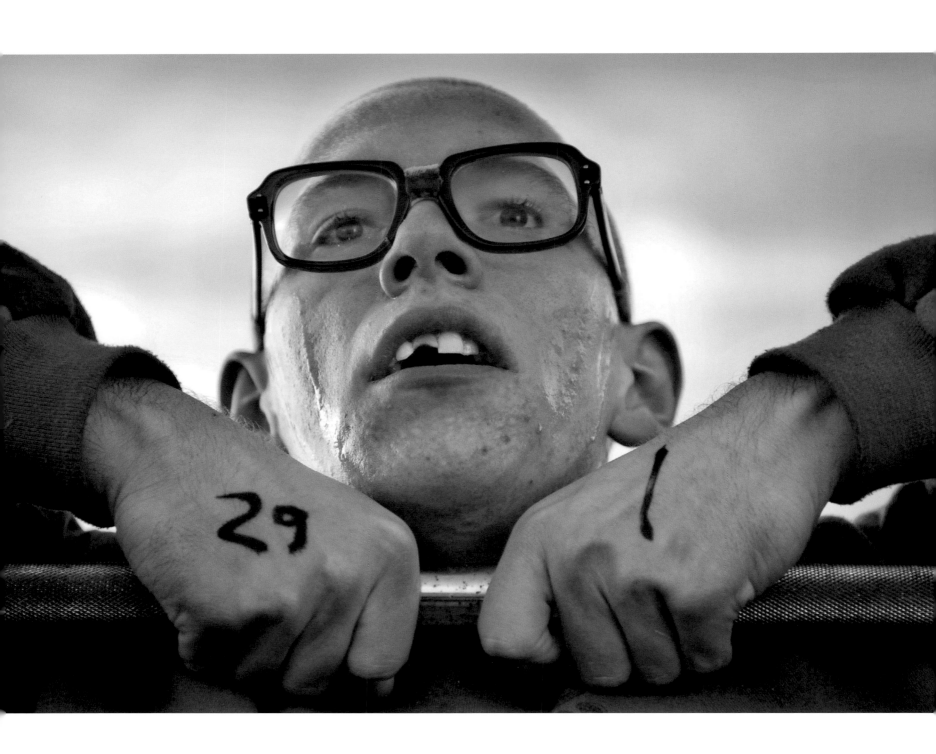

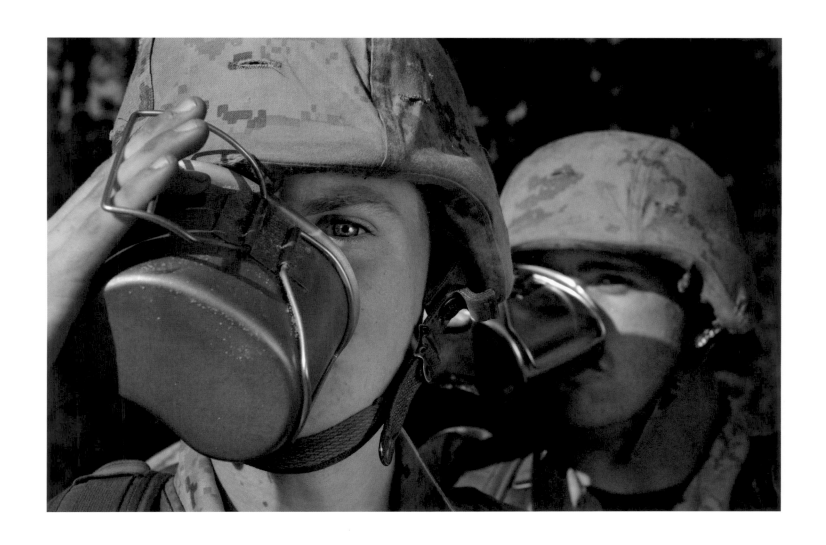

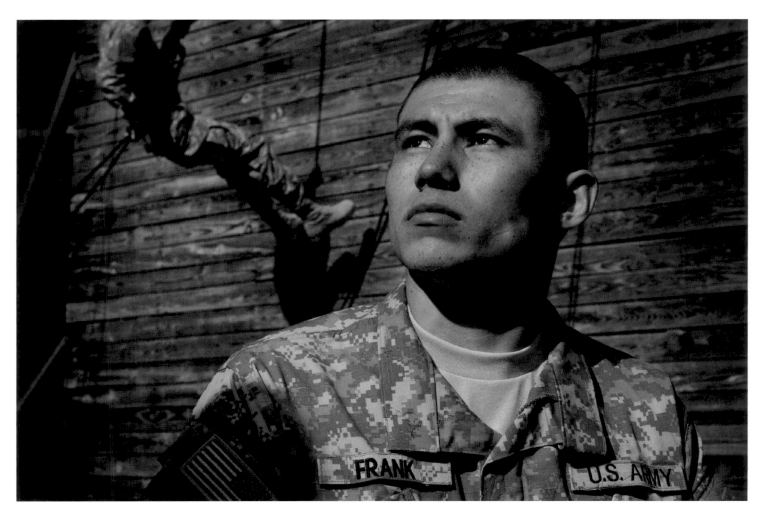

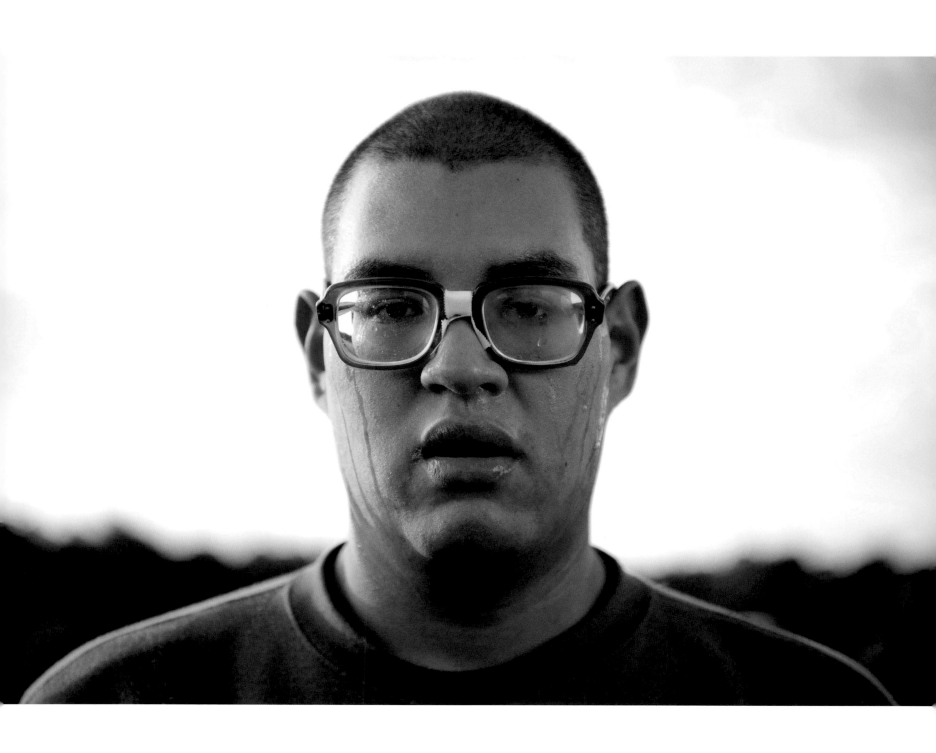

Blake Praytor

My contribution to the *Palmetto Portraits Project* includes portraits that are participatory in nature. The subjects participated in selecting the location and assisting in the composition by including or excluding information about themselves. I used a large-format camera mounted on a tripod to establish a formal approach to the subject, and to allow for studying the composition and content of each image.

(P. 114–115) William T. Thompson, Glassway Mansion Studio, 2008. Greenville. SC.

(P. 116) Brad Wyche, Walker Shoals, Reedy River, 2008. Greenville, SC.

(P. 117 clockwise top left) Remmie Wayne Boxx, 2008. Greenville, SC.

Jeffery J."Jeff" Zaglin, The Army Store, 2008. Greenville, SC.

Hargrove "Skipper" Bowles, Fucawee Pass, 2008. North Greenville County, SC.

Billy Mitchell, 2008. Greenville, SC.

(P. 118) Maxie M. Eades, 2008. Dacusville, SC.

(P. 119) Herman Thompson, 2008. Jenkinsville, SC.

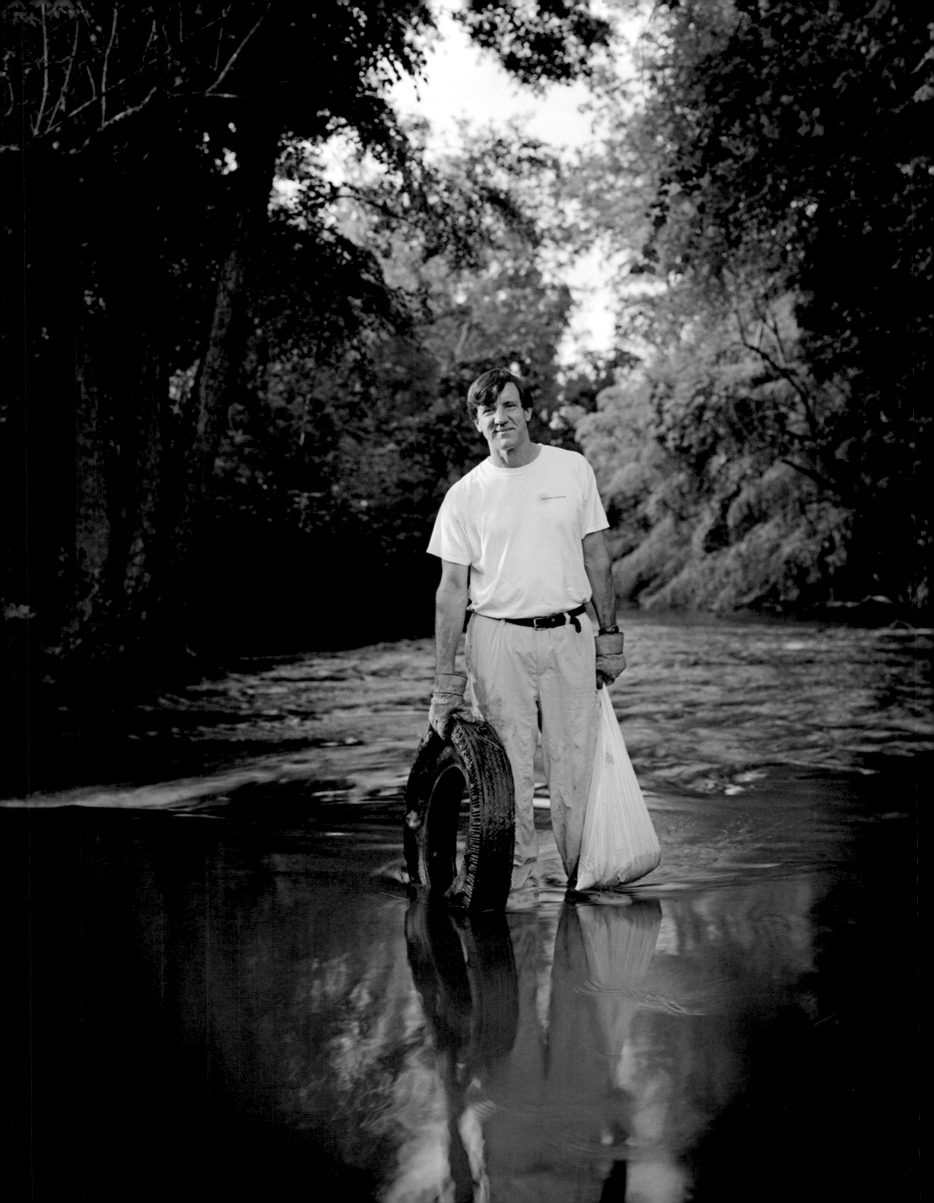

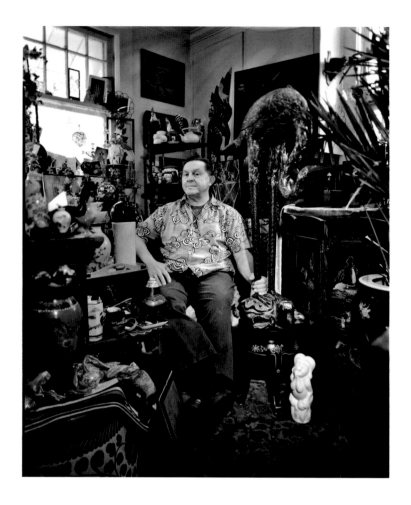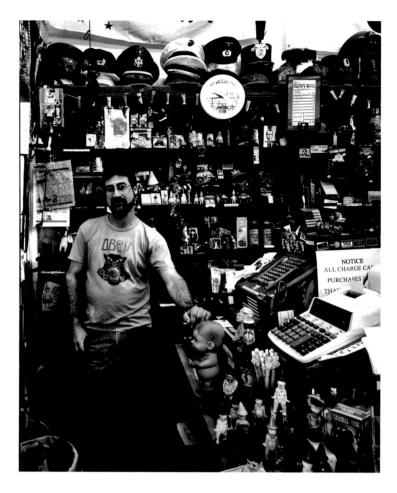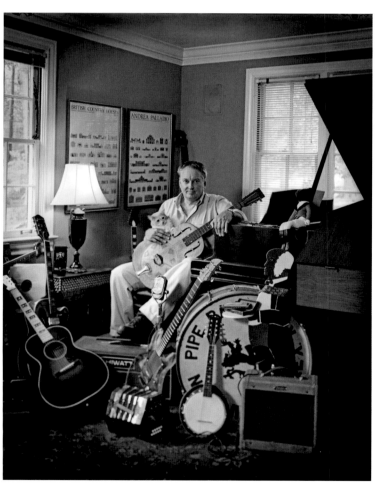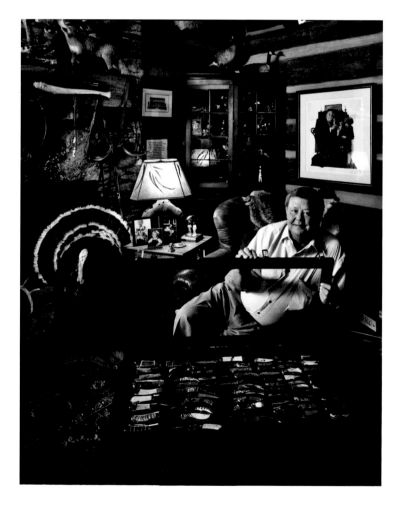

Ruth Rackley

Being given the opportunity to show portraits of South Carolina, I wanted to probe deeper into the subjects' lives than the typical portrait allows and, at the same time, tell a short story. I began the project thinking I would focus on the disappearing agriculture of South Carolina, but I soon realized that it wasn't just agriculture that was disappearing, it was the culture of simpler life.

(P. 121 top) Mr. Wagler, 2008. Laurens County, SC.

(P. 121 bottom) Party of Three, 2008. Richland County, SC.

(P. 122–123) Lee, 2008. Cherokee County, SC.

(P. 124 top) Jake Desmaroux, 2008. Cherokee County, SC.

(P. 124 bottom) Don Rackley, 2008. Laurens County, SC.

(P. 125) Will, 2008. Laurens County, SC.

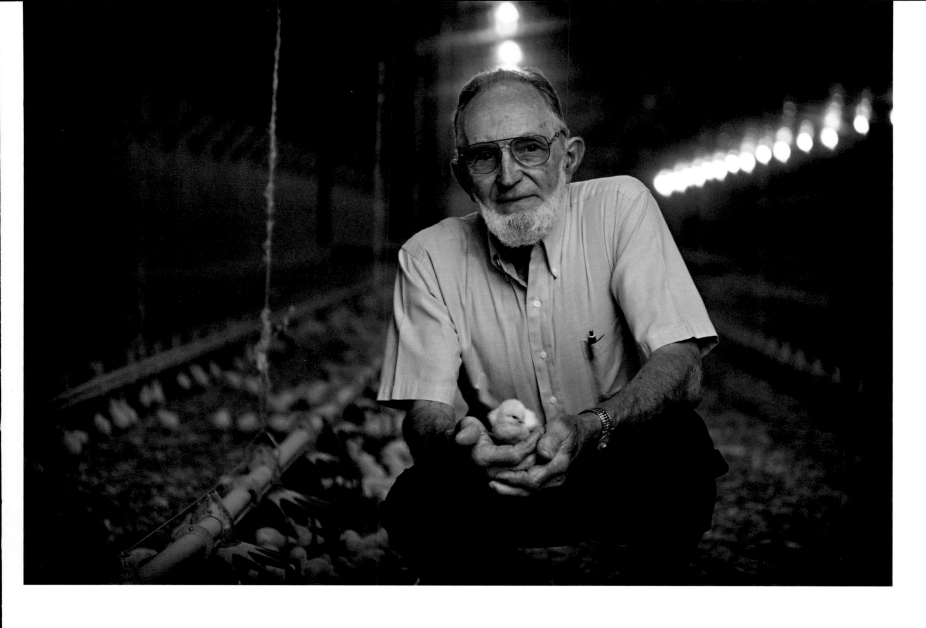

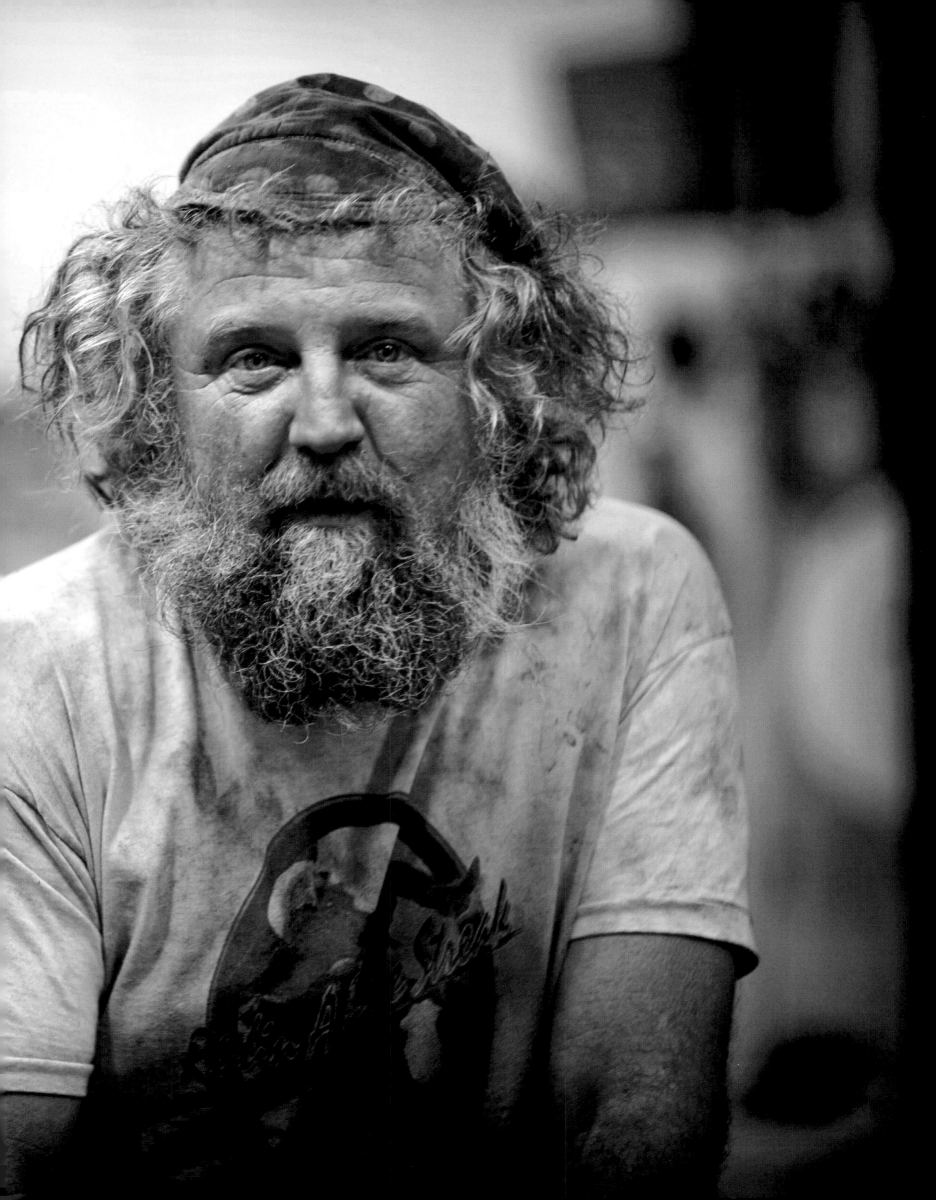

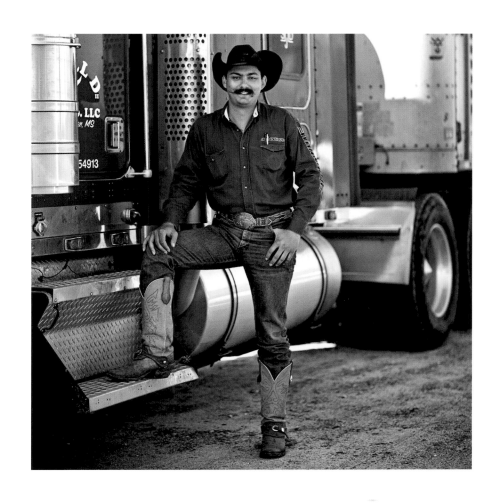

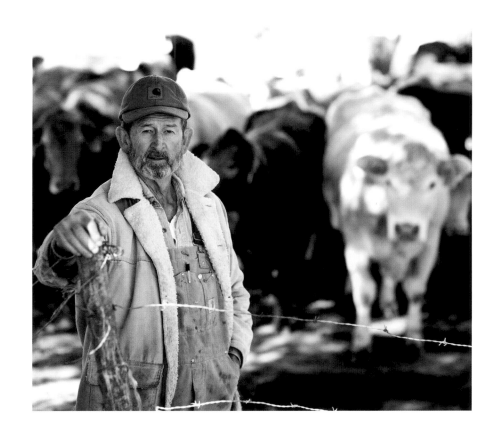

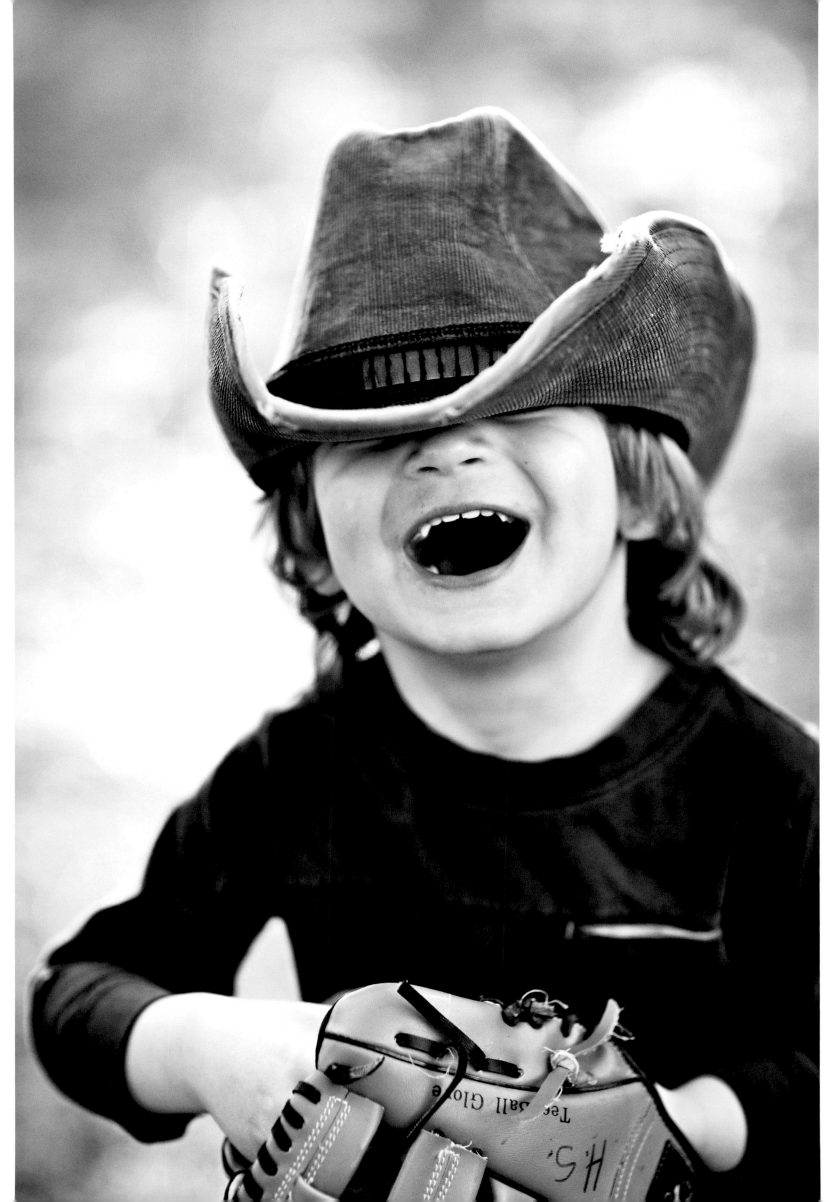

Kathleen Robbins

In 2003, I moved to Columbia from my family's farm in the Mississippi Delta to take a teaching job at the University of South Carolina. It was here that I met my husband, Ben. We bought a home together, our first, in a downtown neighborhood, Hollywood Rose Hill. In contrast to the isolated landscape of Mississippi, I am ensconced in a vital community, where my neighbors are like family. In the summer of 2007, I used the *Palmetto Portraits Project* as an opportunity to explore my relationship with my new community. *Self-portrait with Apple Pie* depicts my initial attempt at neighborliness. That summer, I walked the streets of Hollywood Rose Hill with my dog, Finn, and my Hasselblad. The remaining images are portraits of my in-laws, my new husband, and our neighbors.

(P. 126–127) Christina and Genevieve Altaman, 2007. Columbia, SC.

(P. 128 top) Robbie Kalish, 2007. Columbia, SC.

(P. 128 bottom) George Gordon, July 4th Goodale State Park, 2007. Columbia, SC.

(P. 129) Jeffrey Day, 2007. Columbia, SC.

(P. 130) Self-portrait with Apple Pie, 2007. Columbia, SC.

(P. 131 top) Gabe and Seema Madden, 2007. Columbia, SC.

(P. 131 bottom) Gabe and Laith Madden, May 24th, One-Day Old, 2007. Columbia, SC.

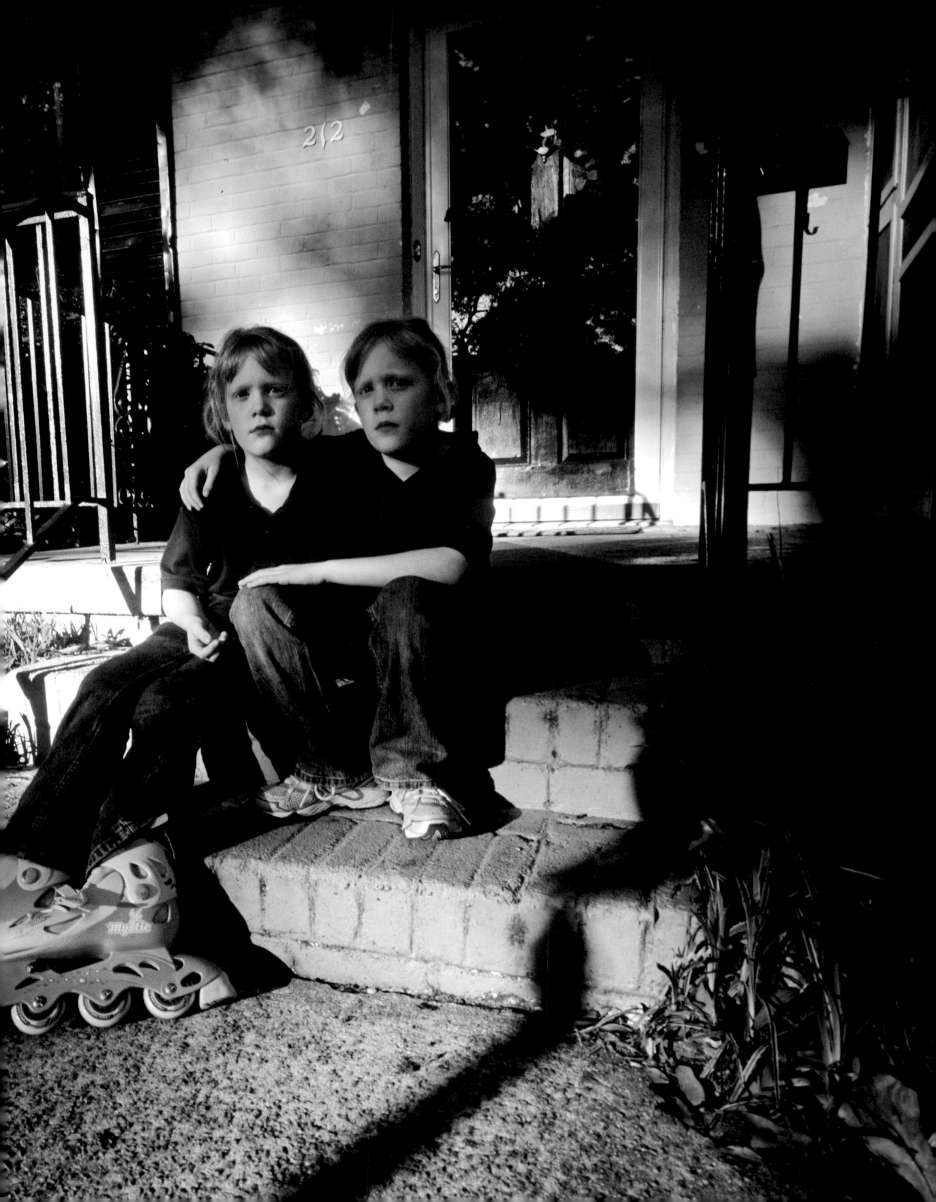

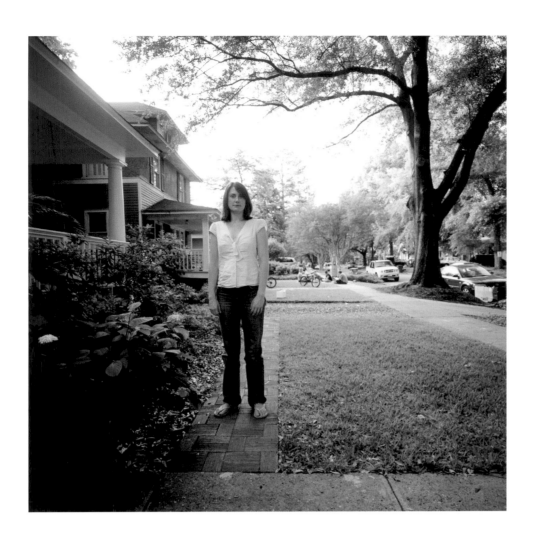

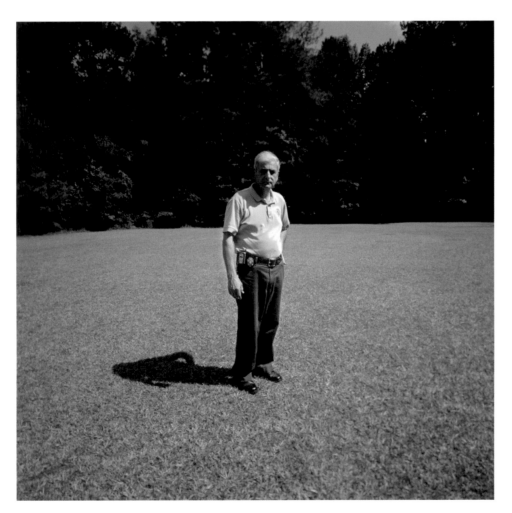

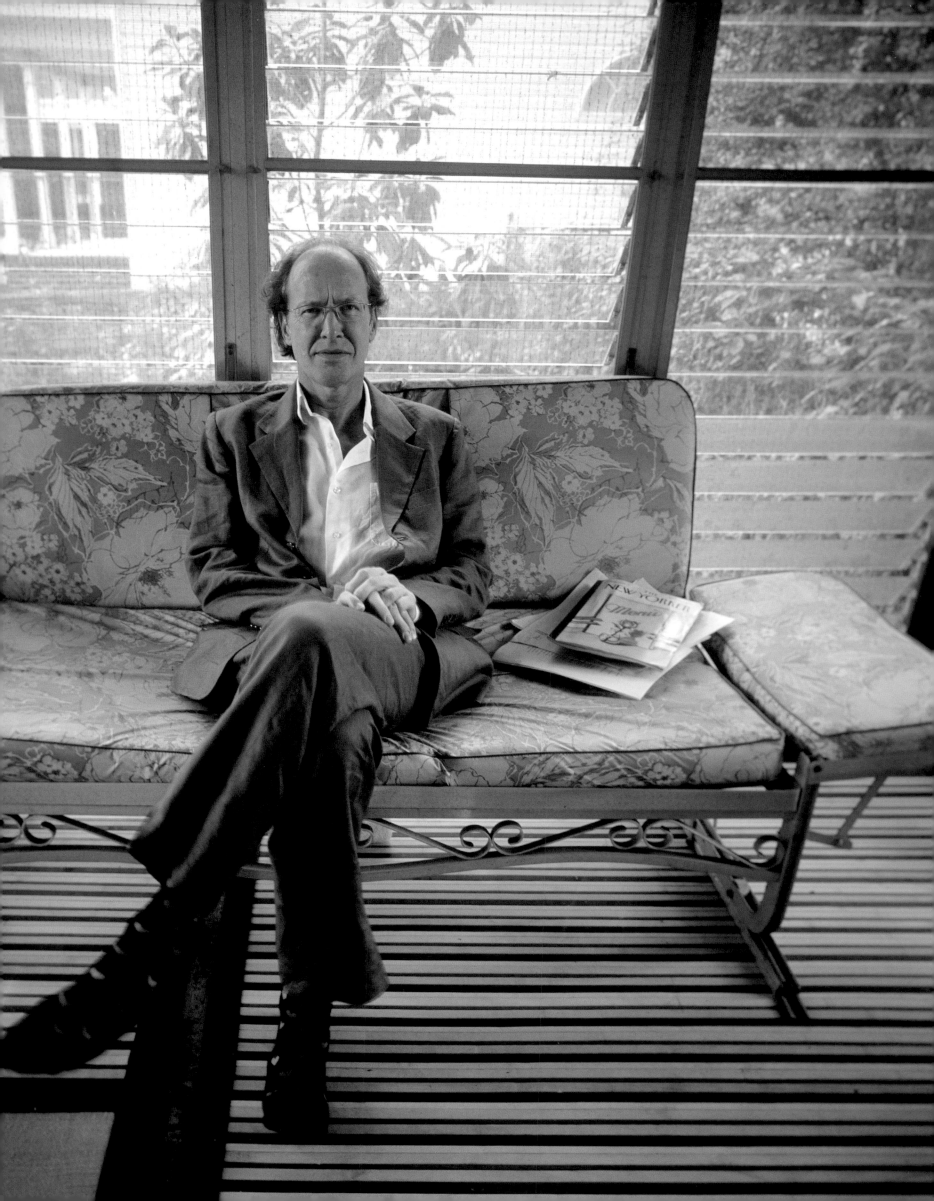

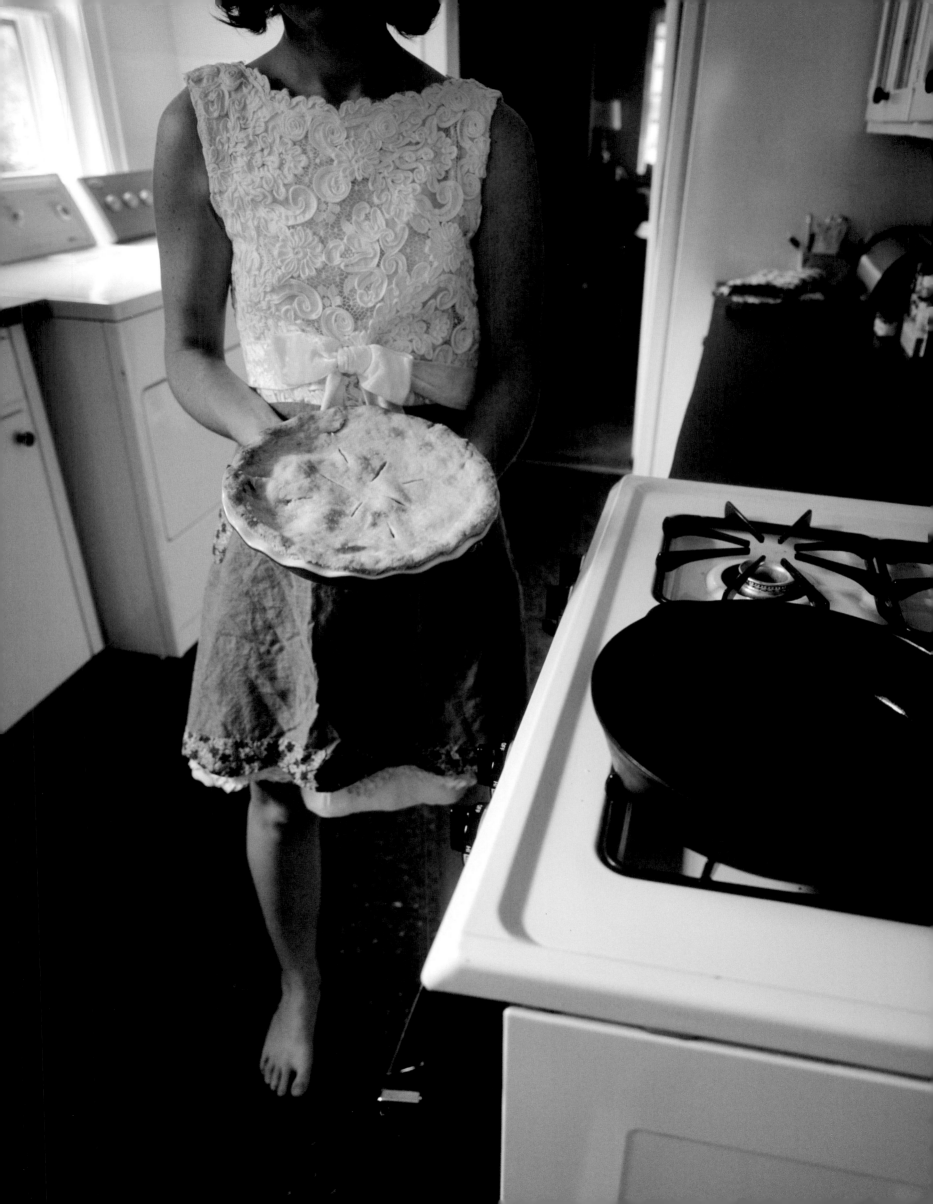

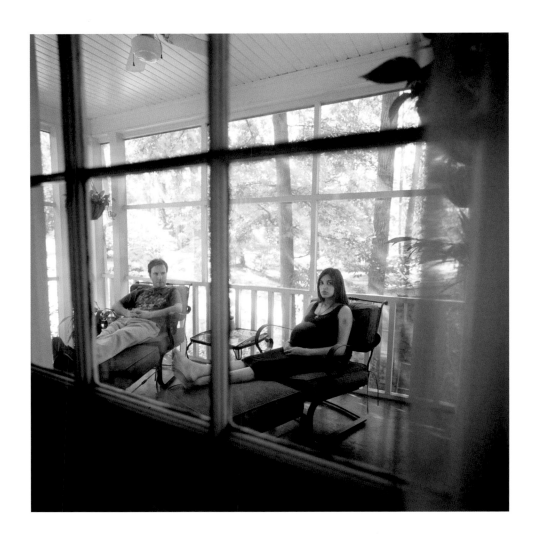

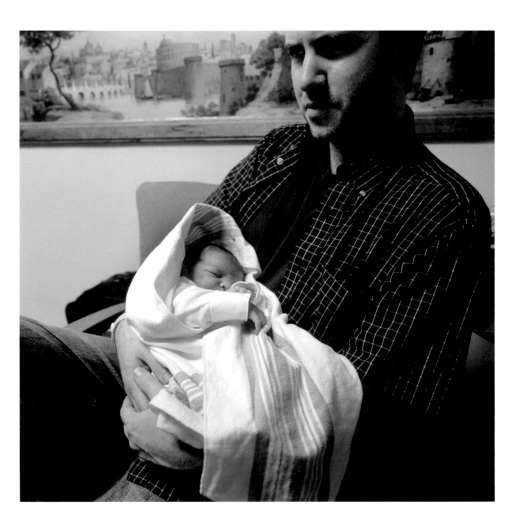

Chris M. Rogers

Portrait photography is about an immediate connection between two human beings— the subjects are willing to offer themselves, and the photographer is willing to capture their essential humanity and character with his camera. A good portrait is actually a good connection. I've wanted to do a project like this since I moved to Johns Island. I've driven past the Greater St. John African Methodist Episcopal (AME) Church countless times, often wishing I had a reason to visit a Sunday service and meet these amazing people, listen to their singing, and hear their families' stories. I'm honored that they invited me into their church and their lives, and especially honored that they allowed me to take their portraits for the *Palmetto Portraits Project*.

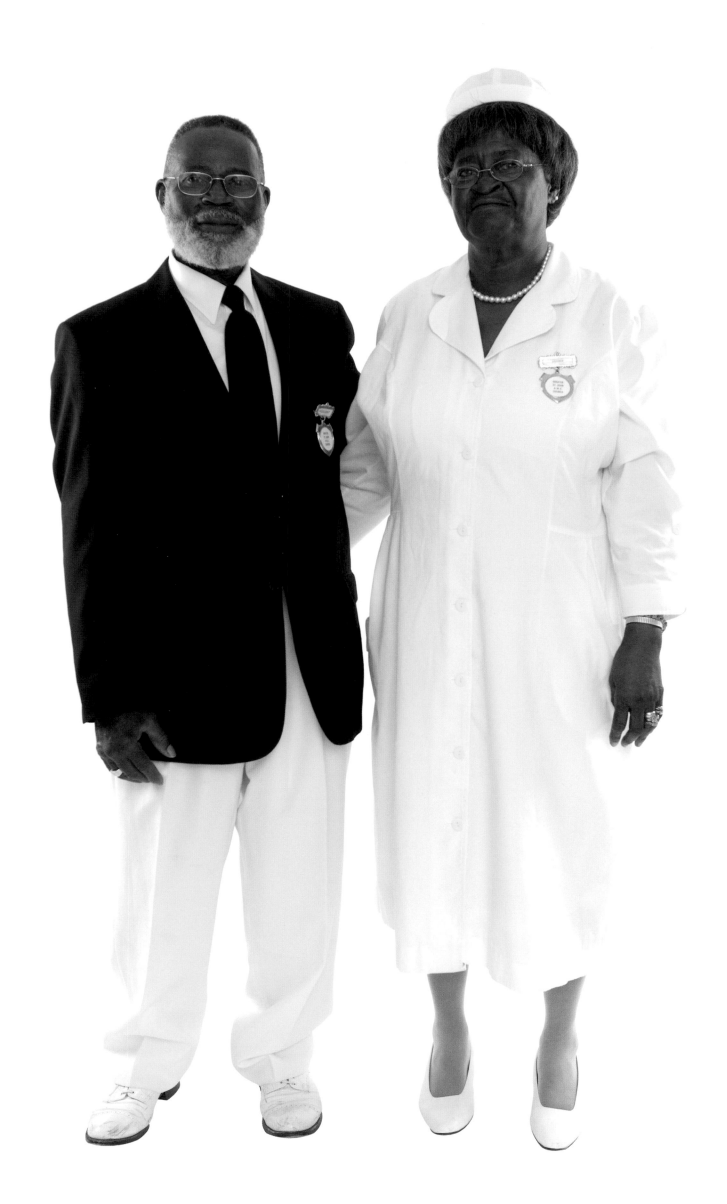

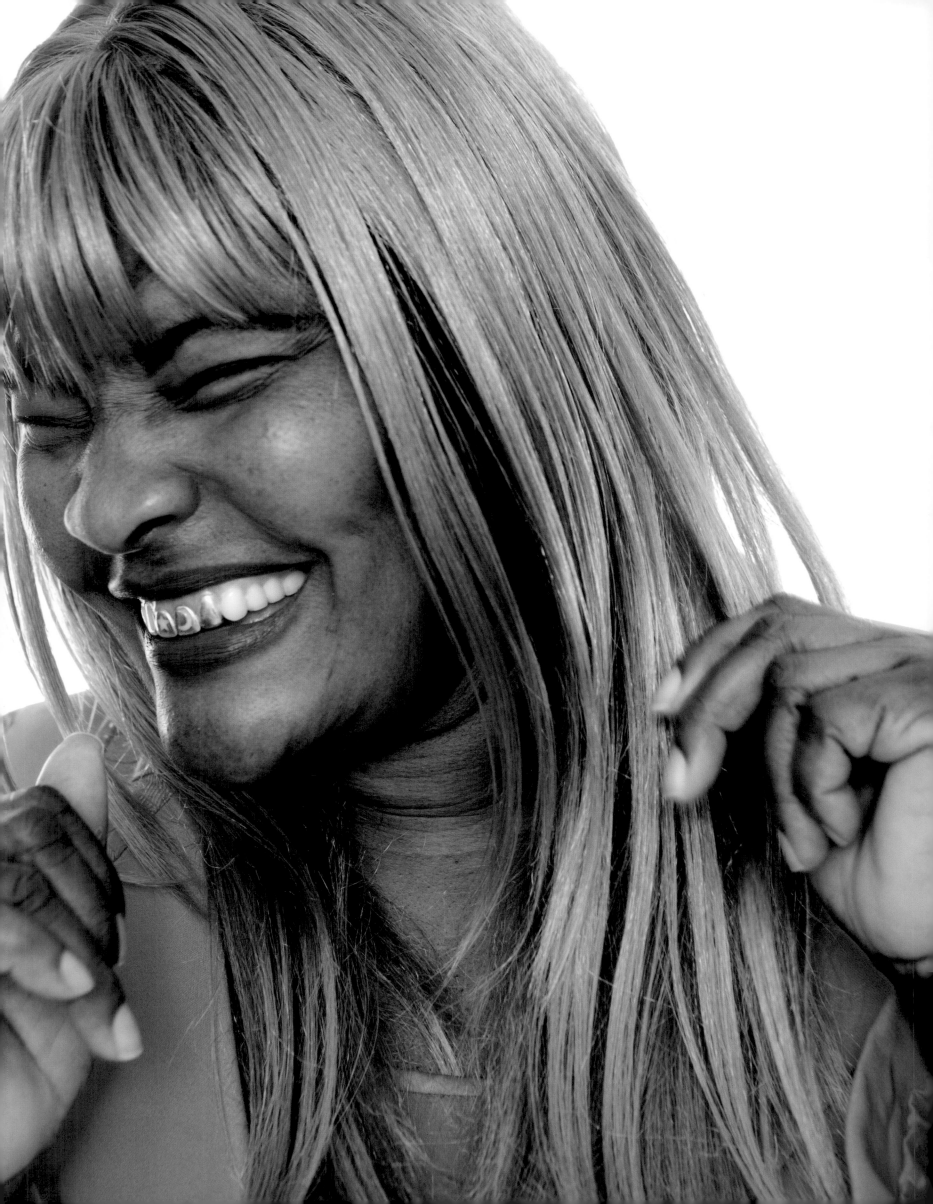

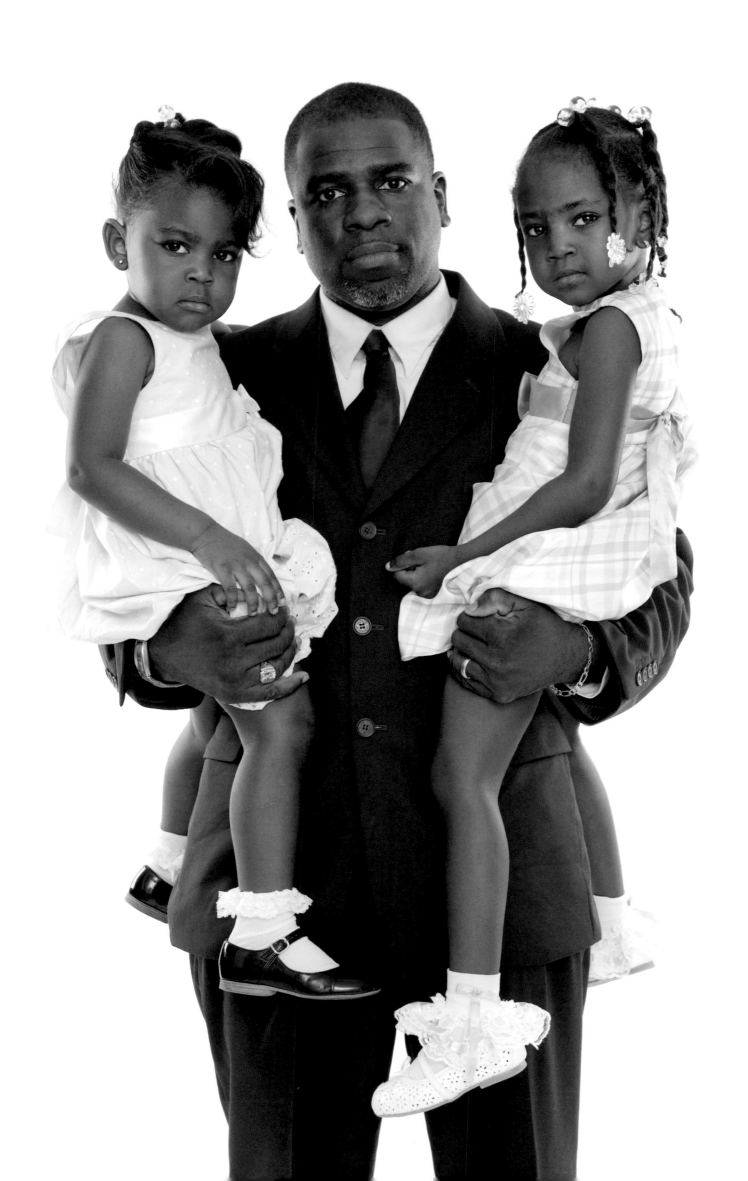

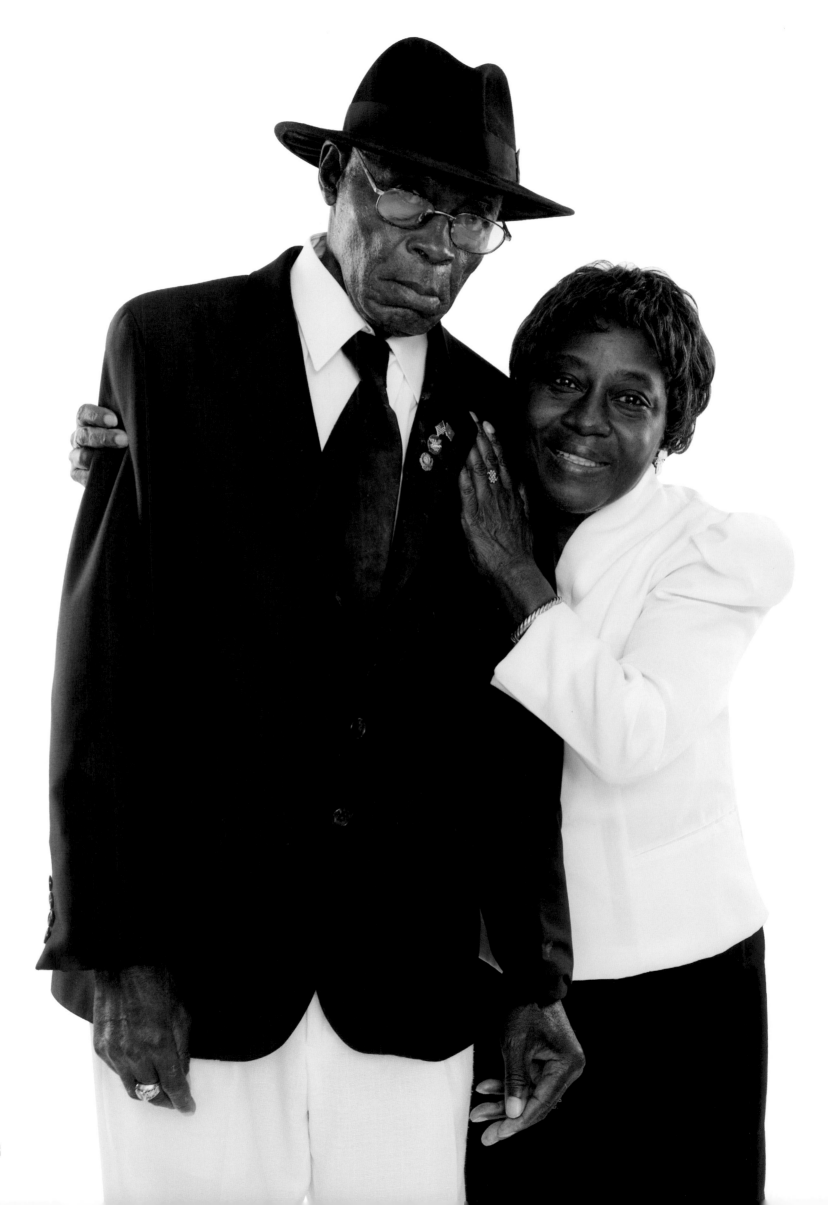

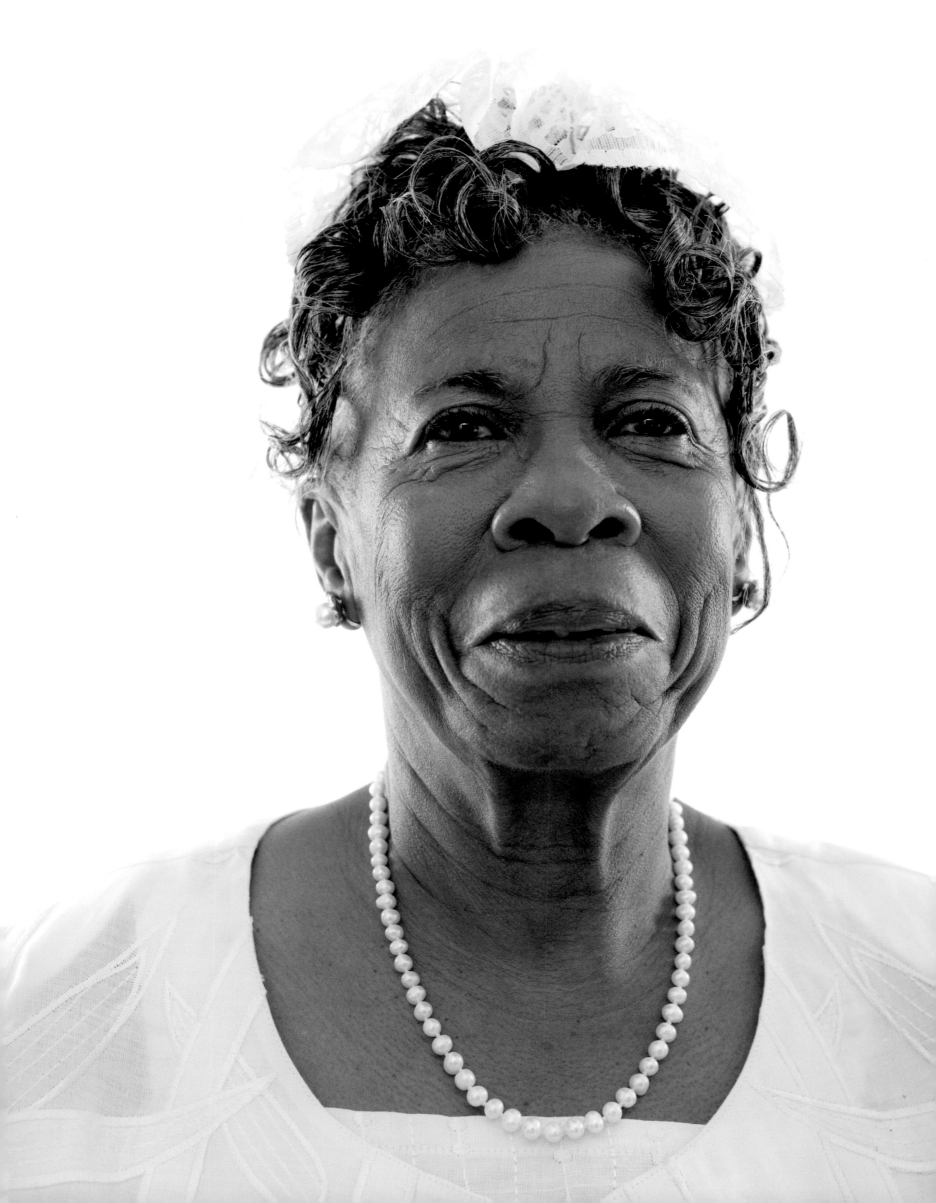

Nancy Santos

The people of the Lowcountry fascinate me.
Their lives are rich with southern flavor.
I am thrilled to get this opportunity to
document and honor them in the *Palmetto
Portraits Project*.

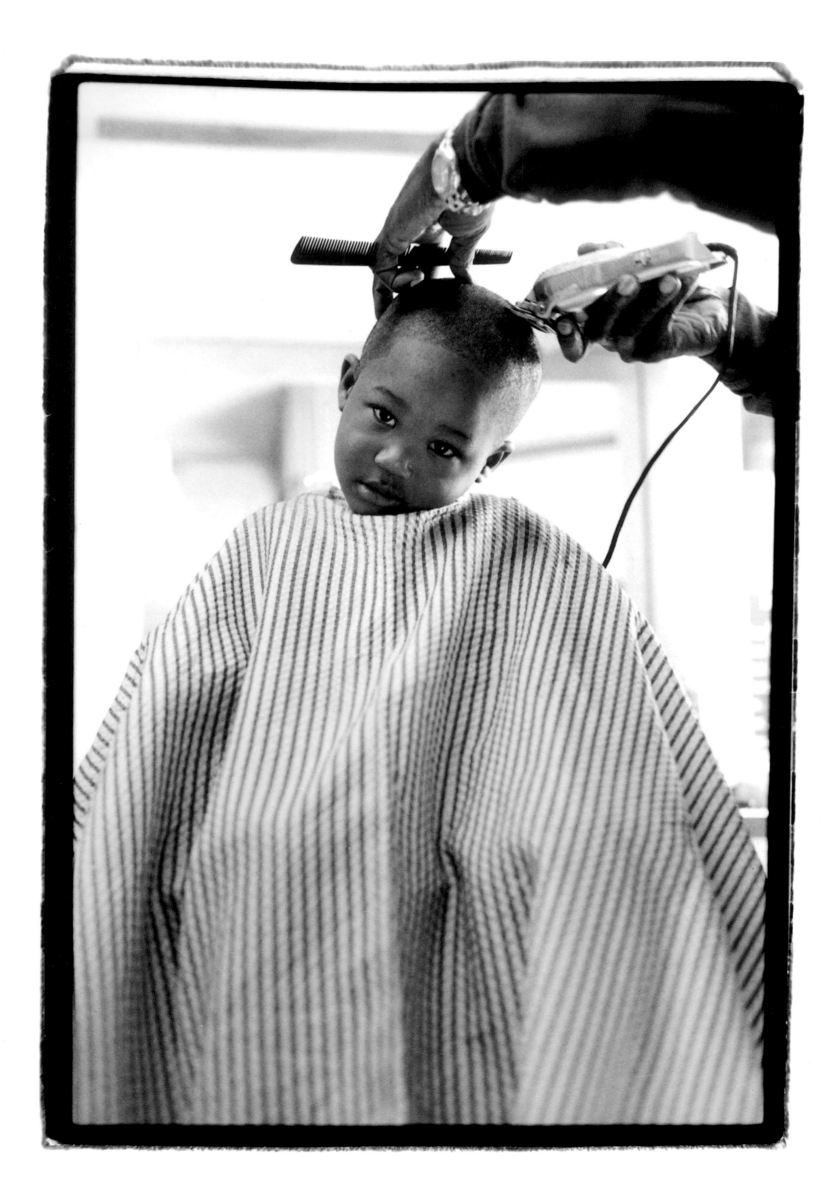

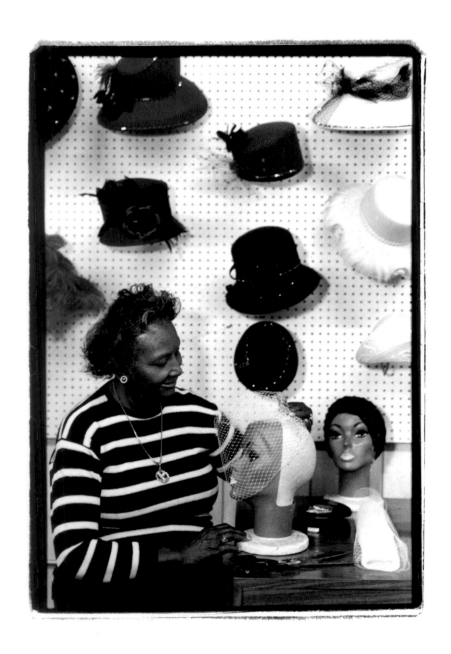
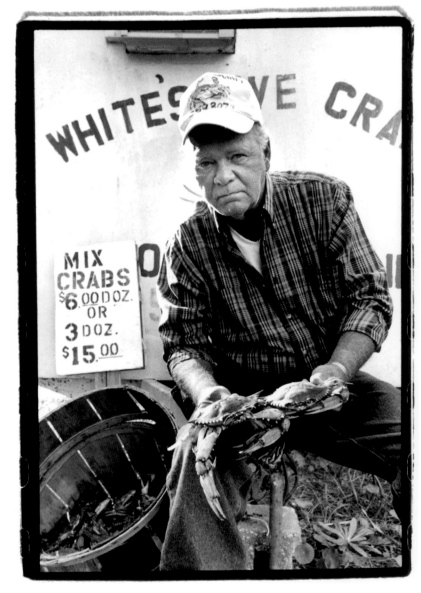

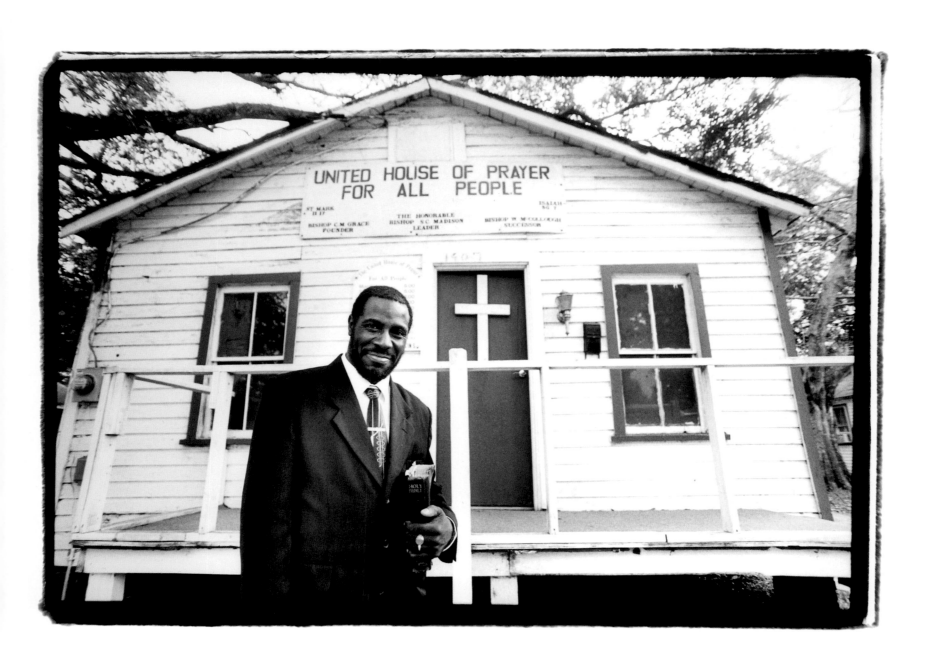

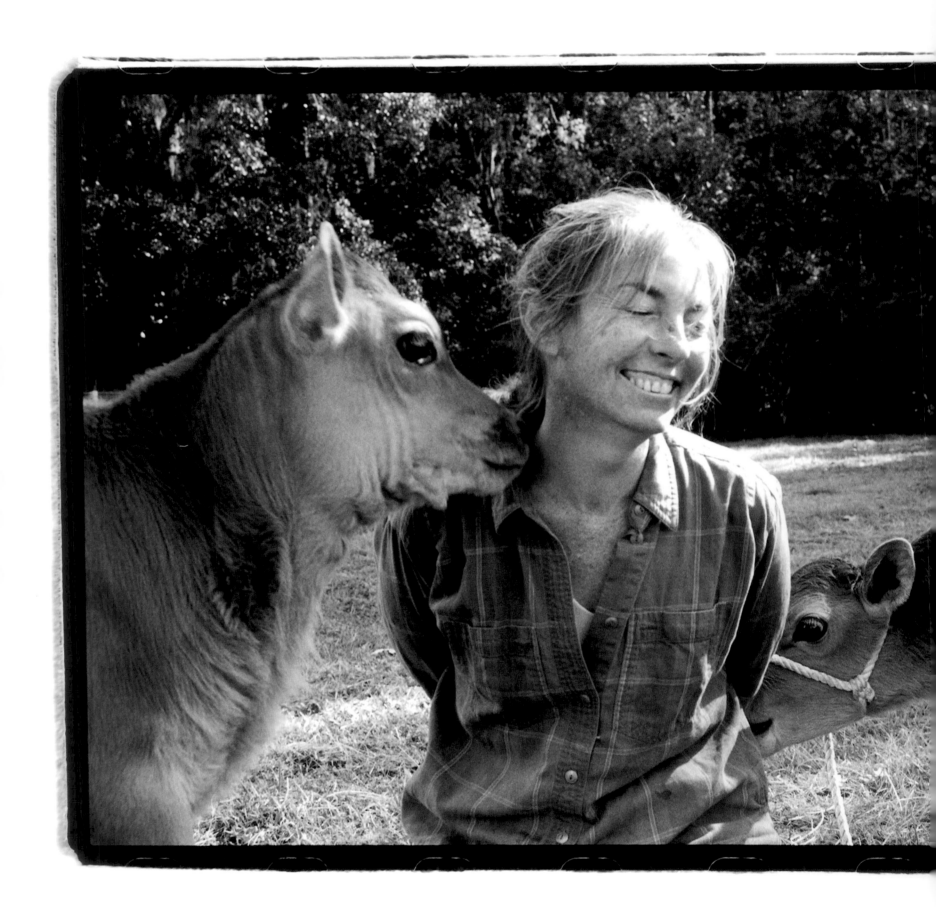

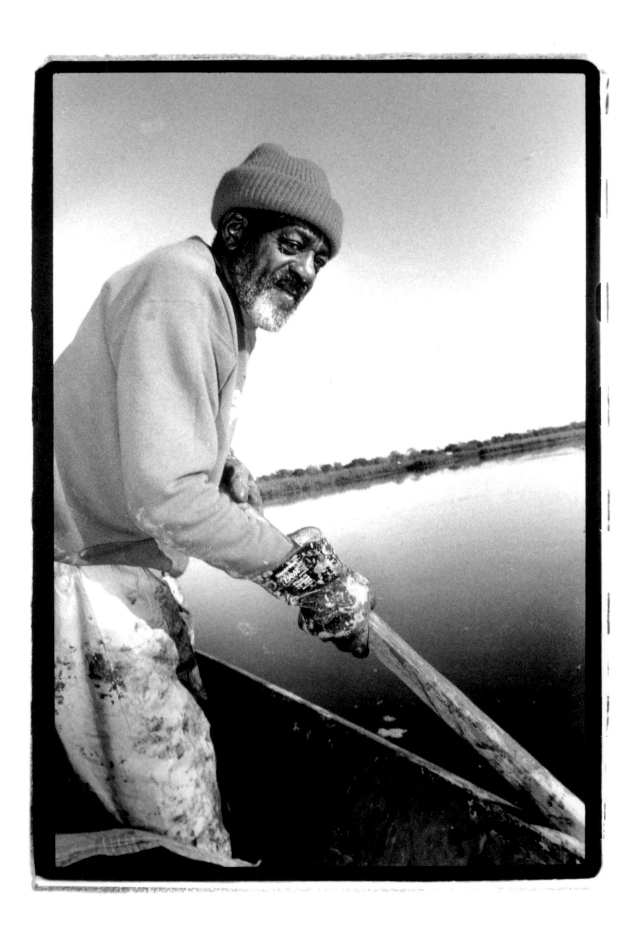

Mark Sloan

My father had a drugstore on Franklin Street in Chapel Hill, North Carolina, and all of the other business owners on the street were a tight-knit family, of sorts. For *Palmetto Portraits Project,* I set out to photograph independent King Street merchants in Charleston, as I wanted to see what sort of camaraderie existed there. Not surprisingly, it was much the same as the Franklin Street of my youth. With this project, I'm interested in showing the range of business types, the ethnic and cultural mix of merchants, and the contrast between older and newer businesses. I plan to continue this project, chronicling the shifting fates of this historic main street.

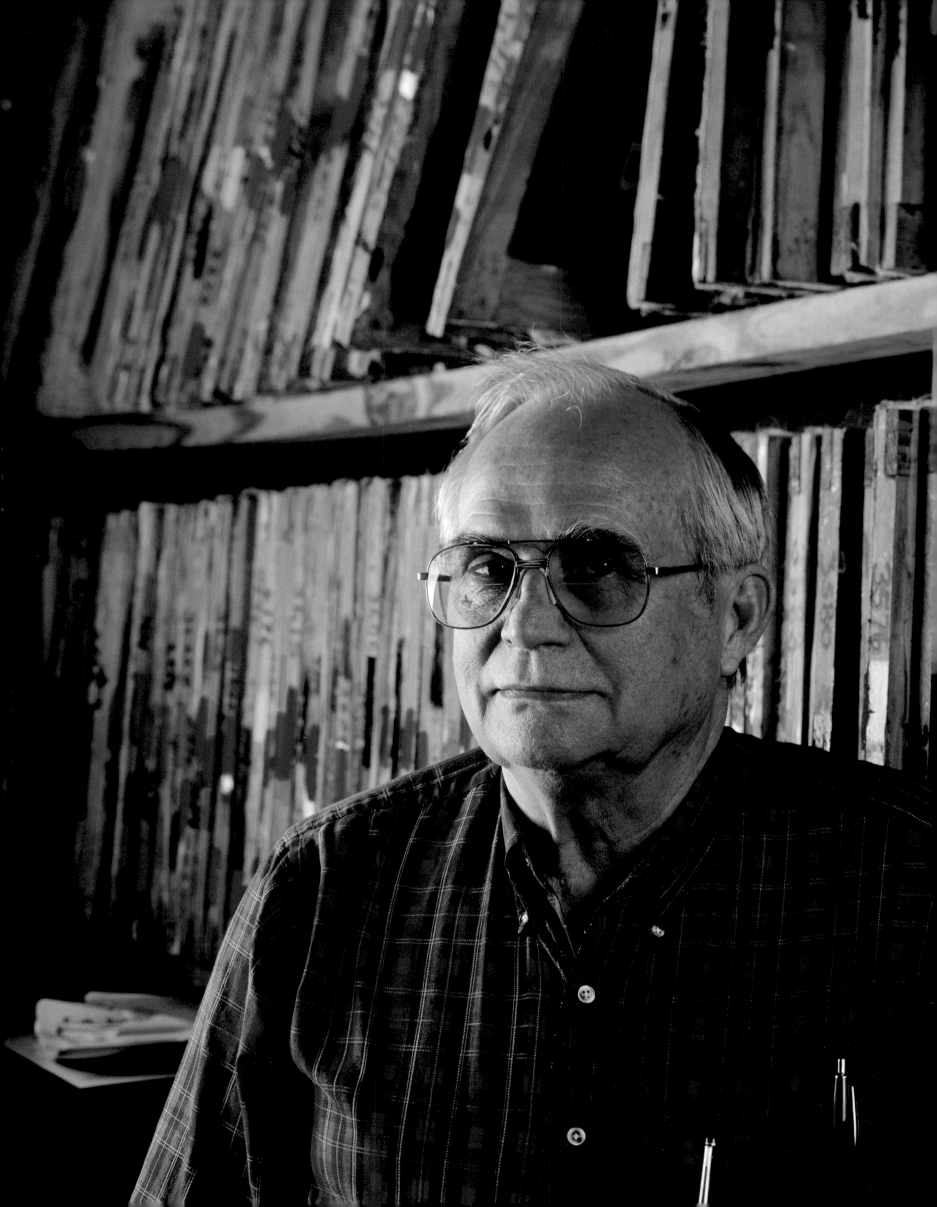

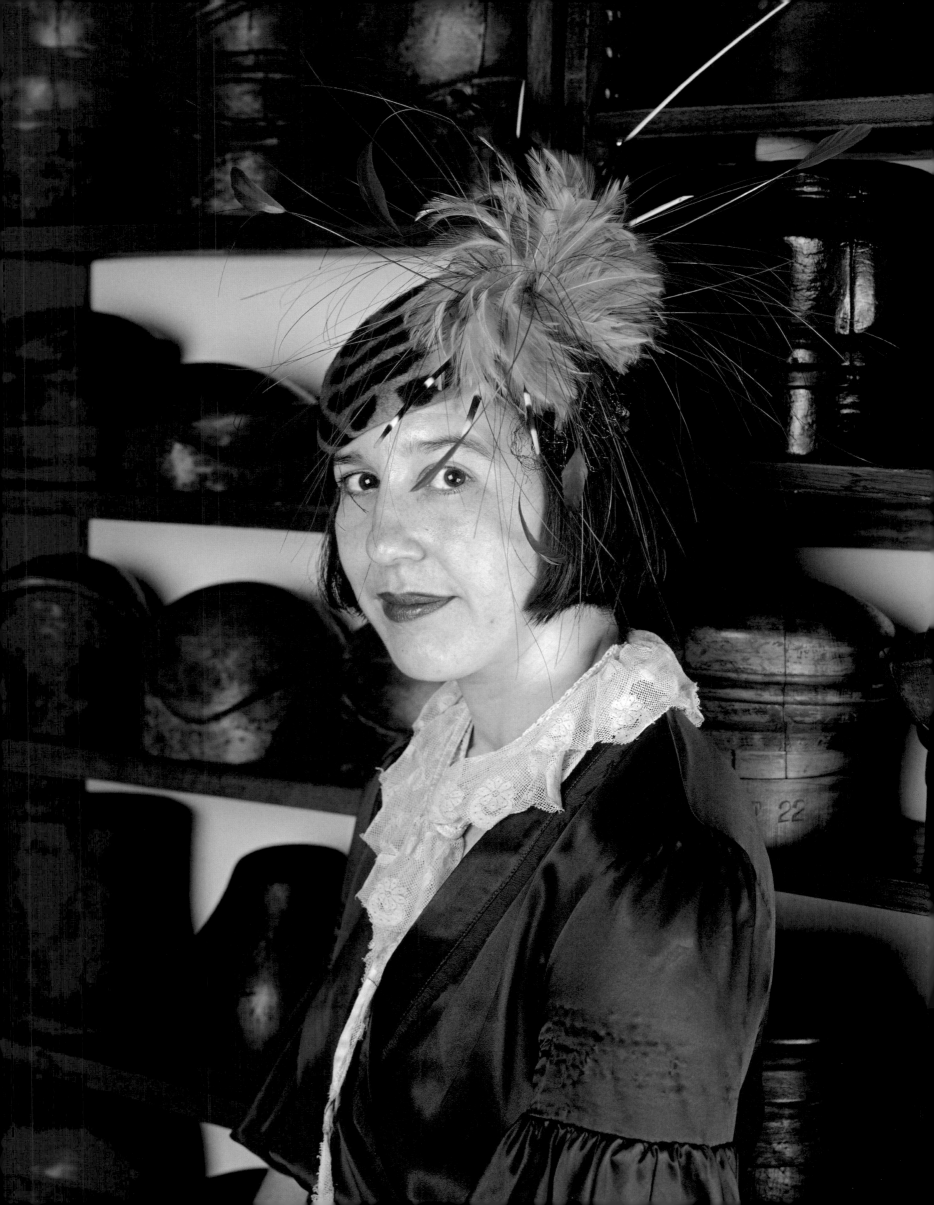

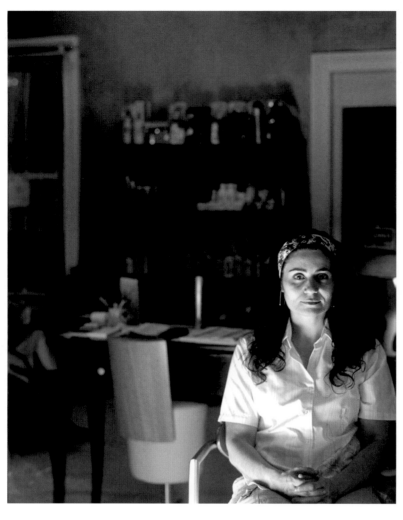

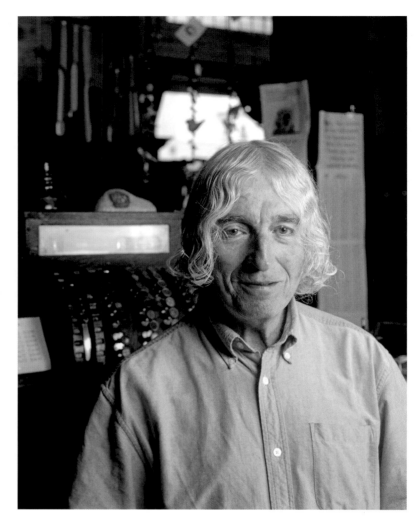

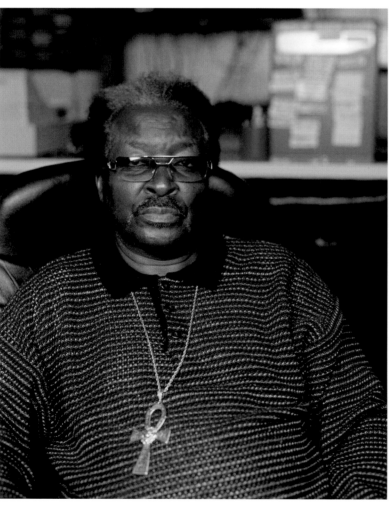

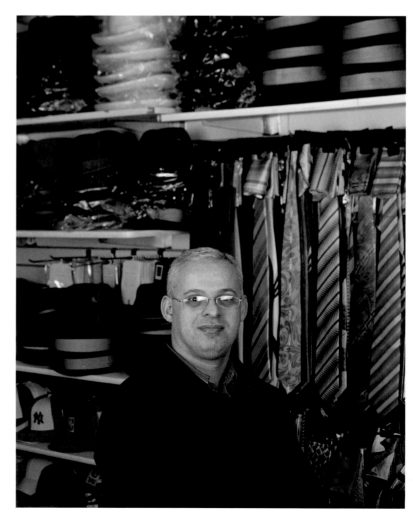

Michelle Van Parys

For this project, I stayed close to home. I looked at my immediate circle of friends and acquaintances and saw the rich, diverse community of people that surrounded me. In my selection of portraits, I was interested in capturing the diversity of individuals in the Lowcountry. The subjects of my portraits represent a broad community of people, and each person is pictured within an environment that supports his or her place in life.

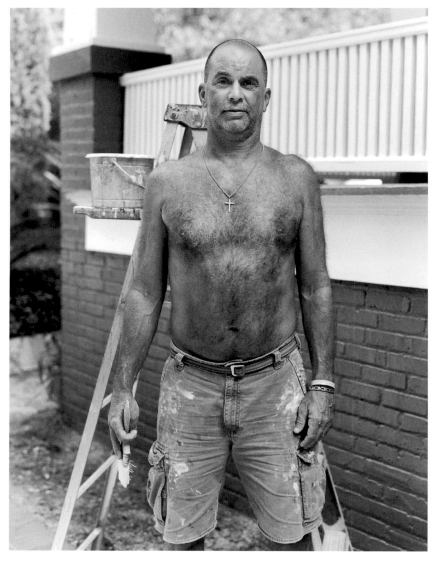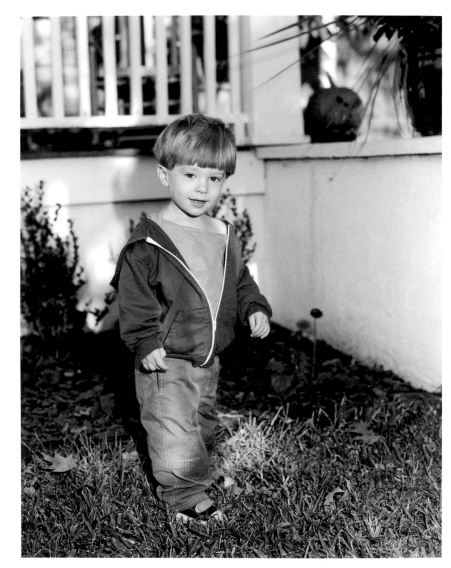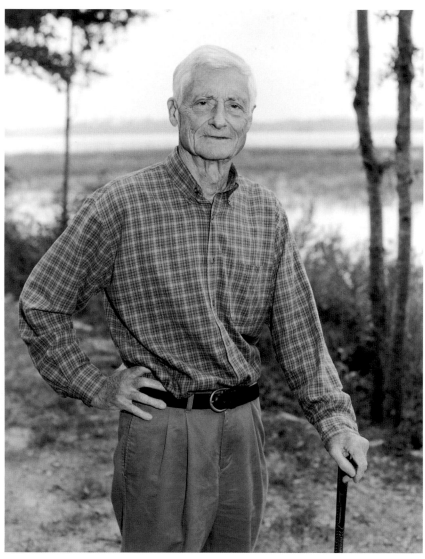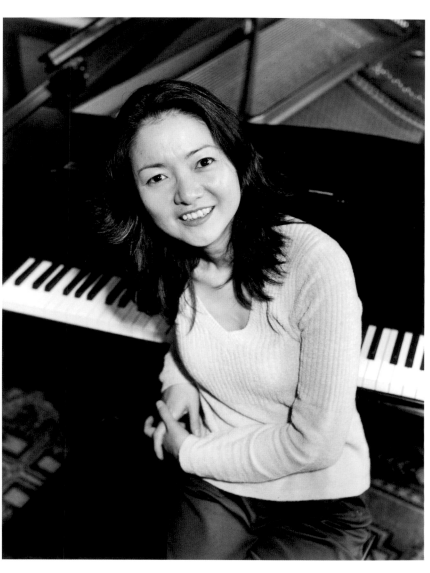

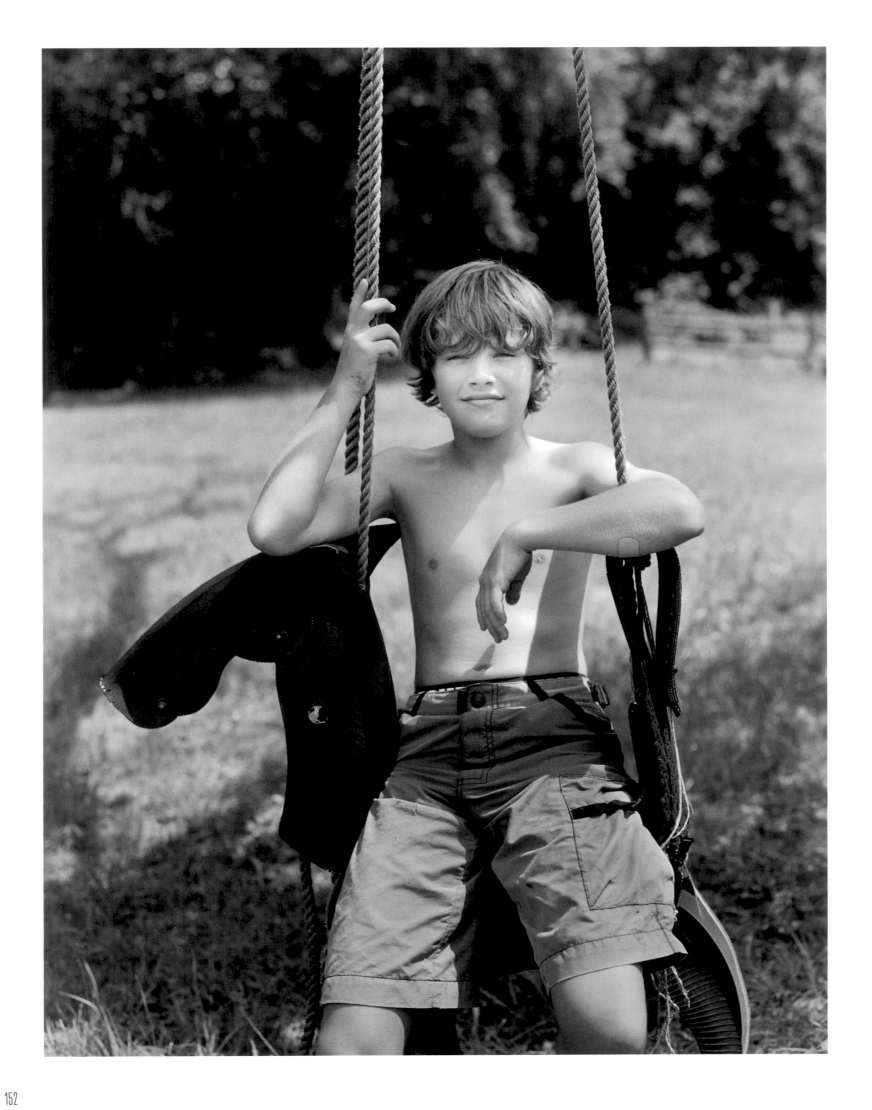

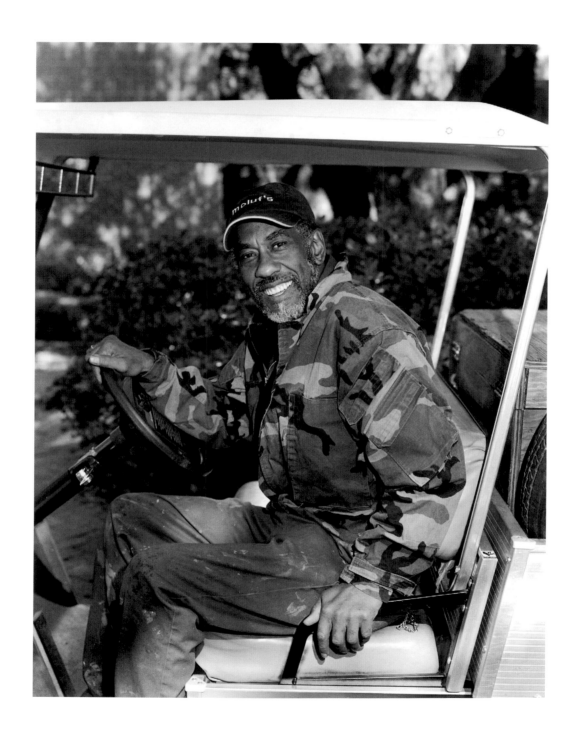

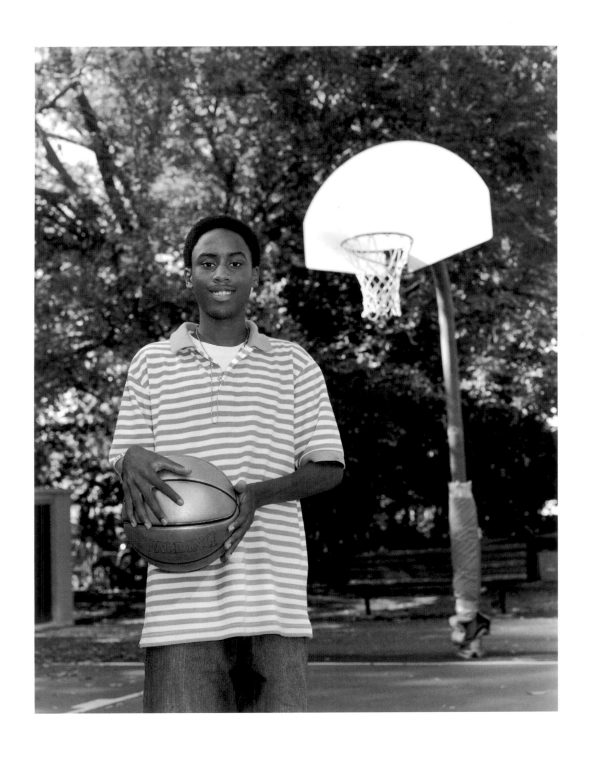

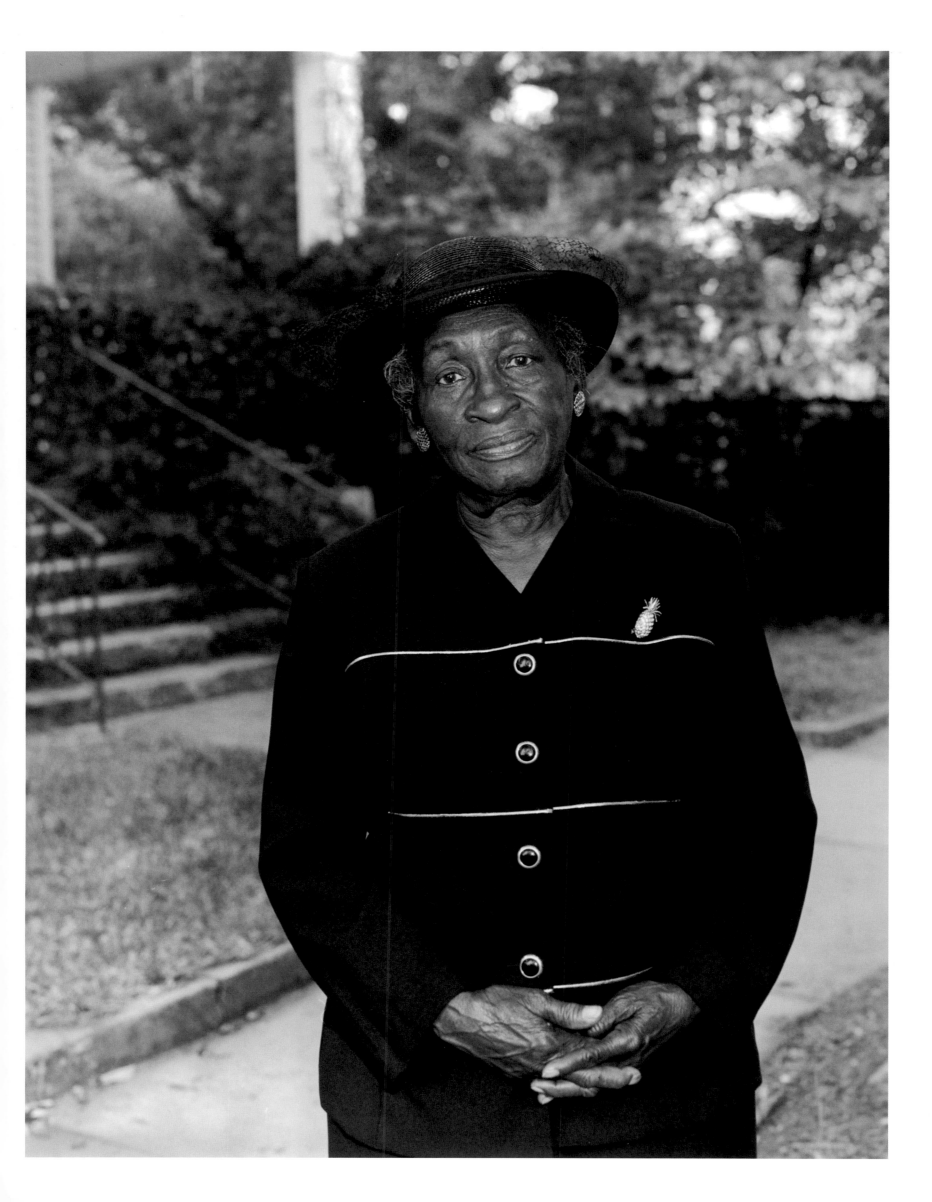

Sam Wang

My subjects are all contributors to the qualities of life in the state. They include a couple of painters, two sculptors, a filmmaker, a photographer, a retired art teacher, an architect, an architectural restorer, a gallery director, and an organizer of nature-based sculpture projects.

I chose to use my extremely wide-angle camera in an attempt to include the studios and settings connected with the respective creative activities. The resulting round images simply showed everything in front of the lens.

It has been a great experience for me to participate in this project. My regret is that we have only been able to cover a small number of worthy contributors to the arts in South Carolina, and that I was not able to include writers and musicians. Someday, I hope, those who view these images will remedy this.

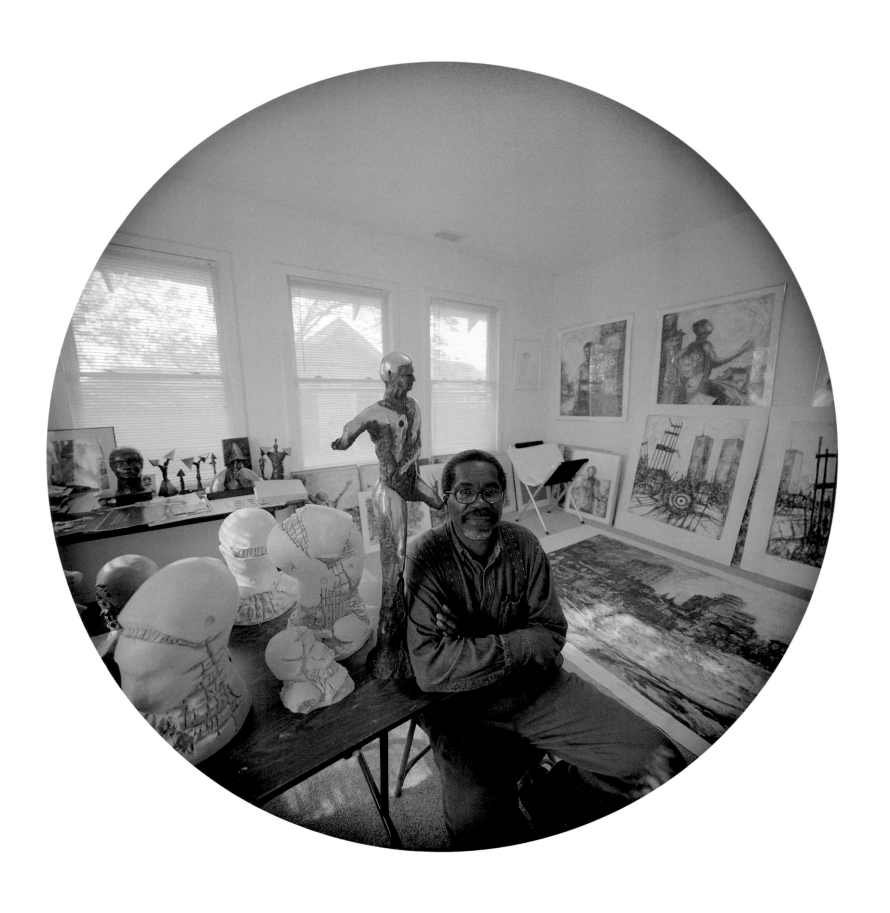

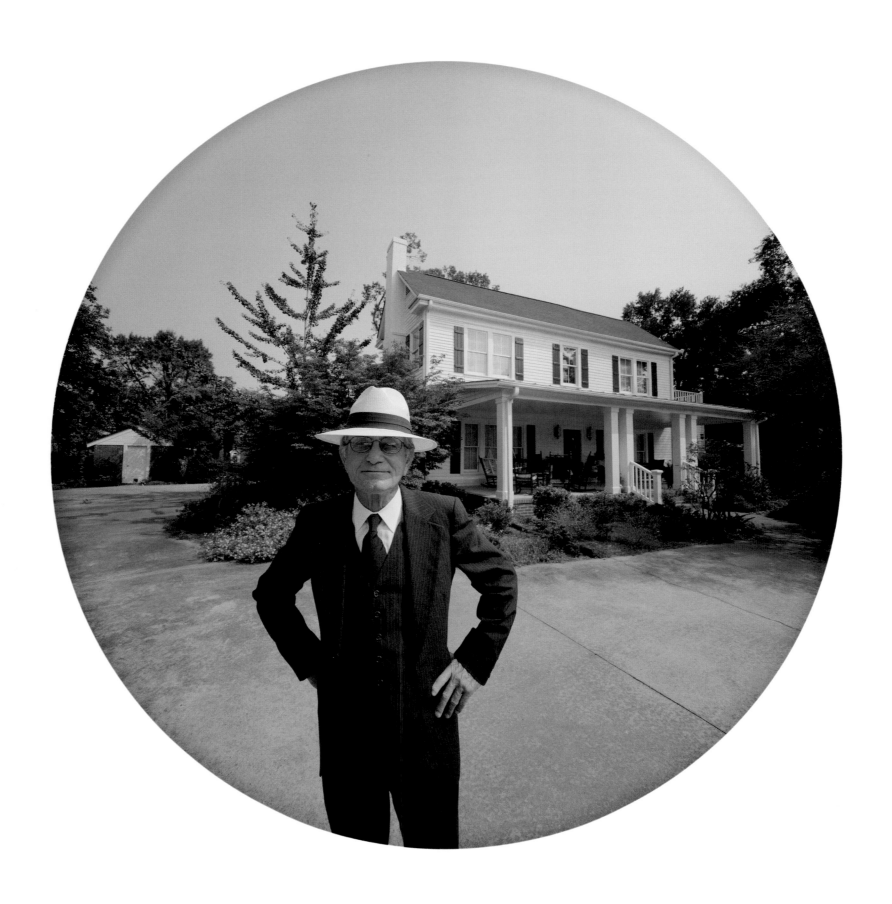

Cecil Williams

The excitement and honor of being asked to participate in the *Palmetto Portraits Project* motivated me to photograph a diverse group of friends, family members, and community servants who have contributed to the Midlands and Lowcountry of South Carolina. The photos in my collections came about sometimes from a single shot (Baby, and Scoville Family) to a full-blown session involving hundreds of images, such as that of Dr. Leo Twiggs. I think the light, color, composition, and facial expression of my subjects play integral parts in capturing a timeless and storytelling portrait.

(P. 162–163) Scoville Family, 2008. Orangeburg, SC.

(P. 164) Dr. Maisha Adderly, Claflin University, 2008. Orangeburg, SC.

(P. 165) Roberts, Claflin University, 2008. Orangeburg, SC.

(P. 166) Baby, Orangeburg, 2008. Orangeburg, SC.

(P. 167) Dr. Leo Twiggs, 2008. Orangeburg, SC.

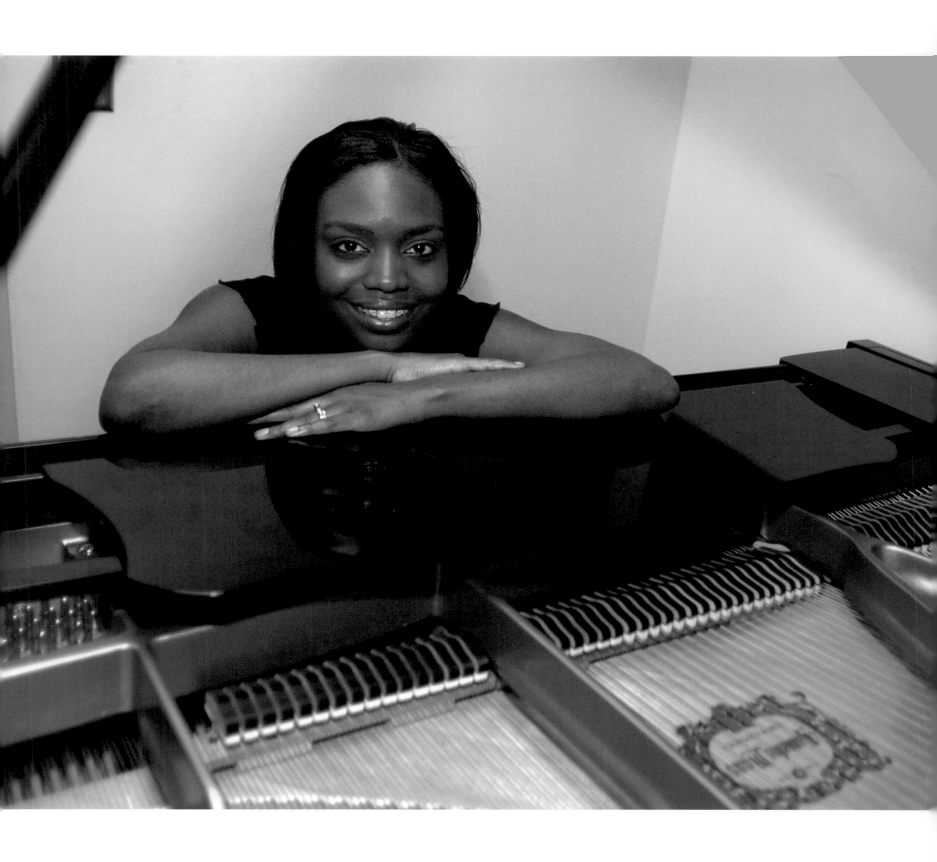

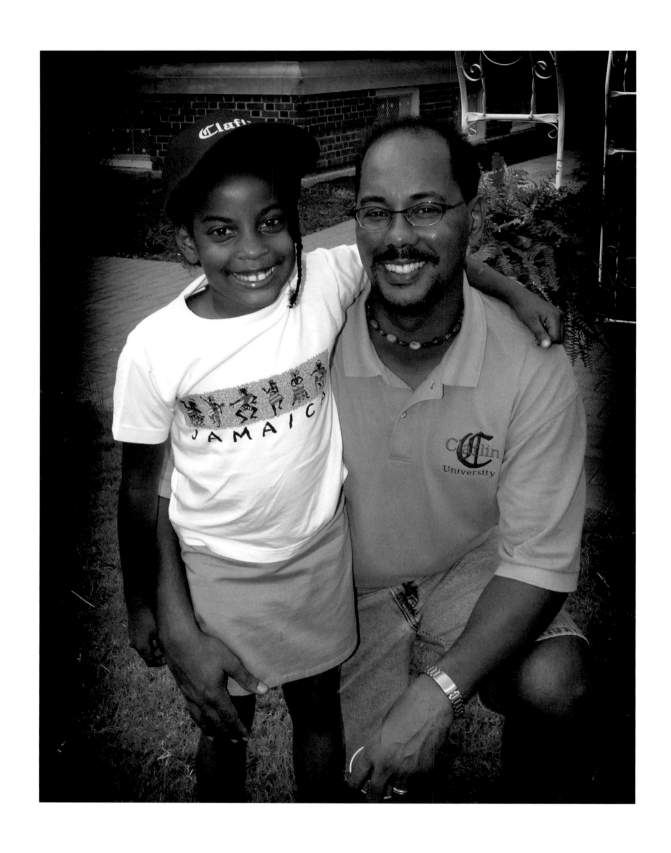

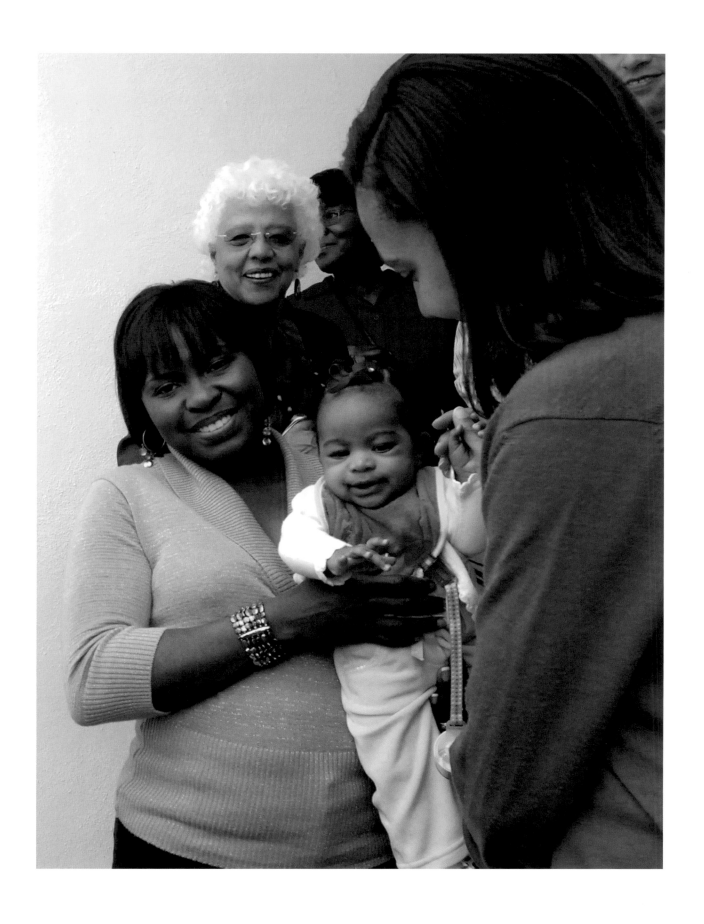

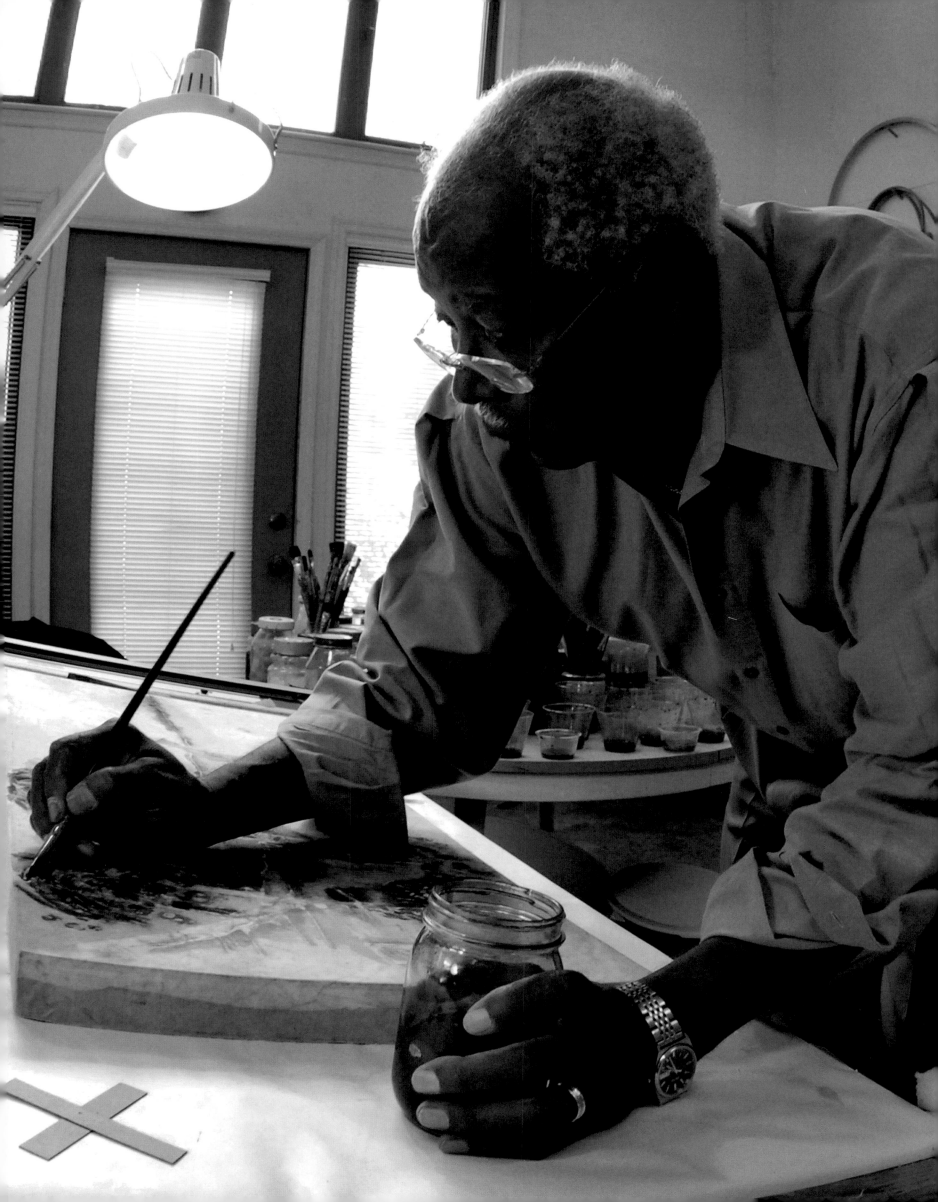

Artist Biographies

Jack Alterman

A native of Charleston, Jack Alterman opened Alterman Studios in 1980. He founded the Center for Photography, in 2002, to promote and teach the art of photography. Two years later, he developed and coordinated a multimedia exhibition, *Who Among Us,* that brought attention to Charleston's homeless population. It featured more than seventy-five individual and group portraits by more than thirty professional photographers. His 2005 one-man show *The Bridge Builders* showcased the diversity of the workers who constructed the new Arthur Ravenel, Jr., Bridge, in Charleston. That same year, he and artist Susan Romaine published the *Cornices of Charleston,* a collection of photographs by Alterman and corresponding paintings by Romaine.

Jeff Amberg

Jeff Amberg began his professional career in 1980, working for the Hilton Head *Island Packet* newspaper, and continued as a photographer with *The State,* in Columbia, from 1981 to 1989. He has been self-employed since 1990, when he started his own commercial photography business.

Gayle Brooker

Gayle Brooker, originally of Greenville, South Carolina, received a BA from the College of Charleston in 1999, where she double-majored in studio art and Spanish. She subsequently studied for a year at the School of the Museum of Fine Arts, in Boston, and completed her MFA in photography from the Rhode Island School of Design (RISD) in 2002. Following graduation, Brooker accepted a teaching position at the College of Charleston, and went on to be the sabbatical replacement for the head of the photography program for the 2003–4 school year. For the past three years, she was a photographer's assistant in New York, under the direction of James Baigrie, Dana Gallagher, and Mathew Hranek. While assisting, she still photographed on her own for weddings and editorials. Her work has appeared in *Victoria Magazine, InStyle Weddings, Modern Bride, Brides New York,* and *Brides New Jersey.* Brooker recently relocated back to her roots in Charleston, and continues to work as a freelance photographer.

Vennie Deas-Moore

As a documentary photographer, Vennie Deas-Moore's camera records stories, one image connecting to the next. When she first became a photographer-writer, she studied such 1930s' kindred spirits as Julia Peterkin, Zora Neale Hurston, Doris Ulmann, Dorothea Lange, and Walker Evans. She was taken by the stories written on the often nameless faces of people in the Great Depression. With her "Young South Carolinians" series, Deas-Moore is focusing on young people in downtown Columbia. She says, "Perhaps many years later, they, too, will tell a story."

Vennie Deas-Moore was a research specialist in immunology at MUSC in the early 1980s. In 1984, she left Charleston for Washington, D.C., where she worked at George Washington University in cancer research. There, she said, was where she was "bitten by the folk-life bug," attending classes in American studies. She returned to the state, to the University of South Carolina, as a guest curator at the McKissick Museum, and it was just a matter of time before she became a folk-life photographer and writer. She has published numerous articles and books, notably *Home: Portraits from the Carolina Coast.*

Brett Flashnick

Brett Flashnick graduated, in 2005, from the photojournalism program at Western Kentucky University, in Bowling Green. Over the past decade, working as a professional freelance photojournalist, he has received both regional and national awards, including first-place recognition from Columbia University, the Kentucky Press Association, Kentucky News Photographers Association, and South Carolina News Photographers Association. While in school, he won the 2002 College Photographer of the Year Award for sports photography and the 2003 William Randolph Hearst Award in the news and sports category. Among his clients are the State Media Company, Associated Press, *The New York Times, The Los Angeles Times, USA Today, The Washington Post, Sports Illustrated,* and *Golf Digest.* His photographs have appeared in *Time, Newsweek, Der Spiegel, National Geographic, People,* and on ESPN.com, MSNBC.com, and CNN's *The Situation Room* and *Anderson Cooper 360°.* Flashnick was included in the traveling exhibition *The American President,* presented by the Associated Press.

Squire Fox

Squire Fox first glimpsed a future in photography when he saw a captivating spread of Peter Beard in the African landscape. In the picture, this internationally famous photographer was posed in the mouth of an alligator while writing in his journal, a beautiful model nearby.

Born into a creative family, Fox was influenced by his mother, a painter, as well as his father and grandfathers, all furniture craftsmen. He graduated from the Savannah College of Art and Design with a BFA in photography, and continued his studies at the Maine Photographic Workshops, Lacoste, and Marseille, France. Fox moved to New York in 1993, and assisted Bruce Weber, George Holz, Gilles Bensimon, and Mary Ellen Mark. Since then, he has pursued an independent career and developed a client base that includes the magazines *Vanity Fair,* UK *Condé Nast Traveller, Travel & Leisure, Domino, Elle,* and *Town & Country,* among others, as well as W. W. Norton publishers and Lions Gate Entertainment Company. Fox lives with his wife and children in Charleston and commutes to New York.

Andrew Haworth

Andrew Haworth began taking photos as a child, after his mother gave him a Polaroid camera. He holds a master's degree in media arts (MMA) and a BA in journalism and mass communications from the University of South Carolina. He has worked as a journalist for more than twelve years, and received honors from the South Carolina Press Association for writing, photography, and, most recently, online video. His first solo photographic exhibition, in November 2006, at the McCrory Gallery, in Columbia, featured more than twenty silver gelatin prints that explored the frailty of the human condition and the cycle of renewal.

A lifelong South Carolina resident, Haworth is currently employed at *The State* newspaper, in Columbia, as a multimedia producer. In addition to continuing his exploration of photography in all forms, his recent interests include watching and writing about movies, and running. He and his wife, Jennifer, live in northeast Richland County with their dog, Sweetpea, a lab-mutt.

Molly Hayes

Molly Hayes's passion for making photographs began at twelve, when she wandered the woods behind her home, in Maine, with her father's old camera in hand. She moved south to attend the Savannah College of Art and Design, where she earned her BFA in photography in 2003. Since graduating, Hayes has lived in Charleston, working as a freelance photographer as well as assisting and traveling with other photographers for national and international advertising, print, and editorial assignments. Her work has been published and exhibited in Charleston, Savannah, and Maine. She enjoys learning about people by photographing them. This is a lifelong focus.

Jon Holloway

A Greenwood resident, Jon Holloway's photographs have been nationally and internationally exhibited and collected by museums and private and corporate collections. His work has appeared in numerous publications, including *America 24/7, South Carolina 24/7,* and *National Geographic.* His exhibitions include *Nature's Rhythm; 3500 Years: Native America; India: A Journey;* and *Cuba.* Holloway travels extensively throughout the U.S., Central America, South Africa, and India, documenting the natural history and heritage of the lands he visits.

Caroline Jenkins

A lifelong artist and native South Carolinian, Caroline Jenkins received a BA in dance theater from the College of William and Mary in 1981. She subsequently moved to New York, where she was a professional actress for five years, and then Los Angeles, where she worked in film, television, and commercial production. It was during her years out west that she discovered her passion for photography and for finding ways to translate previously learned elements of movement, composition, and light into her still images. Jenkins has worked as a full-time corporate photographer, and has freelanced from Key West to New York. She finds photography to be an incredible process to explore and express the human condition. At present, she lives in her hometown of Greenwood, South Carolina, with her husband, Ralph, her son, Jones, her dogs, Miki and Maggie, and a cat named Josh.

Julia Lynn

Julia Lynn's photography reflects her love of the outdoors, meeting new people, and storytelling. Her photographs are a blend of conceptual portrait photography, location photography, and documentary photography. Constantly scouting for the perfect location, she is especially drawn to the vibrant characters and historic architecture of her native South. The combination of a perfect location and an interesting mind can really bring a story to life on film. "Each photo should tell a complete story," says Lynn, "like a movie in a single frame." Elements, location, and character are all built around the story.

She particularly enjoys traveling, and does so for various photo shoots. Discovering new subjects through the lens of her camera—people, places, food, and cultures—inspires her. Every new experience brings forth new discoveries that may be interpreted through the camera. Originally from Roanoke, Virginia, Lynn graduated from the University of the South, in Sewanee, Tennessee, and the Portfolio Center, in Atlanta, Georgia. She currently resides in Charleston, working in the editorial, advertising, and corporate markets, and also pursues personal projects. She is a member of the South Carolina chapter of ASMP and teaches at the Charleston Center for Photography.

Nancy Marshall

A native of Atlanta, Georgia, Nancy Marshall is currently a resident of McClellanville, South Carolina. She taught photography at Emory University for seventeen years. In her career, she has received a National Endowment for the Arts/Nexus Artist Book Grant and the Southern Arts Foundation Fellowship for Photography, and was a fellow at the Ossabaw Island Genesis Project. In 1996, Marshall received her MFA in photography from Georgia State University School of Art and Design. Her work is in the collections of the High Museum of Art and the Montgomery Museum of Art.

Phil Moody

Twenty-three years ago, Phil Moody came to this country from Scotland, with an interest in photographing the working environments of ordinary people. "When I came to South Carolina, the textile industry was still flourishing, and I took an interest in photographing it, because it had formed the environment of the Upper Piedmont," he says. "Now, of course, things have changed dramatically, but I continue to document the effects of the textile industry on the Carolinas." Phil teaches in the department of art and design at Winthrop University, in Rock Hill.

Milton Morris

Since childhood, Milton Morris has had an unwavering love for photography. After earning a degree in business from Clemson University, he spent a year in New York working as a photographer's assistant. When he returned to South Carolina, he started his own business, photographing a wide variety of people and places for advertising, corporate, and editorial clients. While most assignments require digital capture, Morris prefers to shoot large-format film. He recently acquired a forty-year-old Deardorff 11x14 camera and had it fully restored. For the *Palmetto Portraits Project,* all images were captured on 8x10 or 11x14 film, using either the 11x14 Deardorff or a Horseman 8x10 view camera. When he is not behind the camera, Morris spends time with his wife and two sons.

Stacy L. Pearsall

Stacy L. Pearsall got her start as an Air Force photographer more than twelve years ago, at seventeen. During her time in the service, she traveled to more than forty-one countries, and attended S. I. Newhouse School of Public Communications at Syracuse University. During three tours in Iraq, she earned the Bronze Star Medal and Commendation with Valor for heroic actions under fire. Now retired from the military, she works worldwide as a freelance photographer, and is the owner and director of the Charleston Center for Photography.

Pearsall gained public exposure when she shared her experiences as a female combat photojournalist with Oprah Winfrey, on her television show, in February 2009. Her work has appeared in *Time, The New York Times, The Los Angeles Times, USA Today, Soldier of Fortune, Sports Illustrated,* and *Bahrain Times,* and on CNN and the BBC. Her photographs have also been featured in the Oscar-nominated PBS production *Operation Homecoming* and *GQ's* "This Is Our War." Her portrayal of combat experiences in Iraq, "Inside an Ambush," was published in *News Photographer,* the National Press Photographers Association's (NPPA) magazine in 2007.

Pearsall was one of only two women to win NPPA's Military Photographer of the Year competition, and the only woman to have earned it twice. The Air Force Band and PBS also honored her as the Air Force Veteran of the Year in a musical tribute to America's heroes. In Charleston, she was presented with the Trojan Labor American Hero Award for 2009. In 2007, Pearsall's project *Birth Control Glasses* was featured at *LOOK3 Festival of the Photograph.* The Halsey Institute of Contemporary Art presented a selection of her photographs in the two-person exhibition *War on Terror: Inside/Out—Photographs by Christopher Sims and Stacy Pearsall,* from January 23 to February 27, 2009. Among Pearsall's numerous clients are Barnes & Noble, BBC, Boeing, DSM Dyneema, Lockheed Martin, McDonald Douglas, PBS, Southparc Communications, and the magazines *Femmes Universelles* and *Skirt!*

Blake Praytor

Blake Praytor was raised the son of a naval officer in North and South Carolina. After college, an interest in architecture and design fueled his life's direction. His passion for photography was born while working on the interior design staff of the R. L. Bryan Company. To escape his then-current lifestyle, Praytor traveled to Nantucket, Massachusetts, in the summer of 1970, where he met a local photographer named Charlie Foler, who gave him his first camera, a 35mm Kowa Six. Soon after, he enrolled in the photography program at the California College of Arts and Crafts. In 1974, he returned with his wife, Margaret, to her hometown of Greenville, South Carolina.

Praytor entered graduate school at Clemson University, studying graphic communication, and printed and published several small books of his own work. He taught public school for a year before becoming the creative director for the Greenville County Museum of Art. During the next several years, he established a commercial studio in downtown Greenville, and was recognized as one of the top advertising photographers in the area. After twenty-five years in the commercial photography business, Praytor decided to close his studio and return to graduate school at Clemson University, studying under Sam Wang, where he earned his MFA, in 1998, at fifty-five. The following year, he joined the faculty of Greenville Technical College, and for nine years served as chairman of the department of visual and performing arts. He is now Lead Professor of Photography. Praytor continues to work with his first love, a Leica M3 Double Stroke with a 50-mm Dual Range Summicron.

Ruth Rackley

Documentary photographer Ruth Rackley grew up with her feet grounded in the red Carolina clay. The daughter of a missionary, she discovered a love of photography through the photographs her mother shared from her work abroad. Picking up the camera only seemed natural, and at an early age she felt at ease traveling and viewing the world through the lens.

The images Ruth Rackley produces tell the stories of the people she meets. For her, shooting is a quiet and emotional experience that allows her to focus on the nuances of her subjects and the decisive photographic moment. It's her think-feel-react way of photographing that allows the viewer to understand quickly and easily and to be able to relate so well to her images. Currently working as a freelance photographer, Rackley has traveled on assignment to Asia, the Caribbean, and Central America. She has won international recognition for her work from the WPJA (Wedding Photojournalist Association).

Kathleen Robbins

Kathleen Robbins is an assistant professor and head of the art studio area's photography program at the University of South Carolina. Her work has been widely exhibited, including the *2006 Ping Yao International Photography Festival,* in Ping Yao, China; it can also be found in several public and private collections, among them the Ogden Museum of Southern Art, in New Orleans. After receiving a MFA, in 2001, from the University of New Mexico, she taught at Delta State University, in Cleveland, Mississippi. In 2003, she joined the USC faculty.

Chris M. Rogers

Chris M. Rogers is a lifestyle photographer with an eye for the energy in a moment. As a 1986 graduate of Rochester Institute of Technology, with a degree in photography, his technical skills are expert and highly refined. Rogers has the ability to convey his ideas and enthusiasm, solve problems, and engage with subjects and clients to get outstanding expressive results in his work. Eager for every challenge, he is equally at home photographing models on a yacht in the Caribbean, cowboys herding cattle on a Montana ranch, or a pit crew changing tires at a NASCAR race. Just as exciting for the viewer are these straightforward portraits.

Rogers has been a freelance commercial photographer for more than twenty years, with numerous international, national, and local clients, notably Ford Motor Company, American Express, Kiawah Island Resort, Lexus, the Ritz-Carlton, and *Garden & Gun* magazine. In 2001, he moved from his longtime home in New York to Johns Island, where he lives with his wife and daughter.

Nancy Santos

Growing up in Massachusetts, Nancy Santos first caught the photography bug at six while reading *Life.* That was when she asked for her first camera, a Polaroid Swinger, but instead received a mint-green Girl Scout Brownie camera. After studying documentary photography at the Art Institute of Boston and freelancing for several years, she moved to Charleston, where she got a job as a photographer for the *City Paper.* She worked there for seven years. Santos has won several national AAN awards for her photo essays on local artists, the East Side, and the Gullah community.

Mark Sloan

Mark Sloan is a curator, writer, and artist. He has served as both director and curator of the Halsey Institute of Contemporary Art at the College of Charleston since 1994. He has directed two national nonprofit artists' organizations—The Light Factory, in Charlotte, North Carolina (1985–86), and San Francisco Camerawork, in California (associate director, 1986–89).

As a photographer, Sloan specializes in still life and portraiture. His photographs have been exhibited widely, including such venues as the High Museum, in Atlanta, and the Grand Palais, in Paris. His 2004 book *Rarest of the Rare: Stories Behind the Specimens at the Harvard Museum of Natural History* features his photographs of this storied collection.

Michelle Van Parys

A professor at the College of Charleston, Michelle Van Parys started the photography program at the college in 1997. Her photographs have appeared in exhibitions worldwide and are included in the collections of the Virginia Museum of Fine Arts, Nevada Museum of Art, and San Francisco Museum of Modern Art, among others. A twenty-year retrospective monograph of her desert landscape photographs, *The Way Out West,* was published in 2009 by the Center for American Places–Columbia College Chicago.

Sam Wang

Sam Wang was born in Beijing, China, and grew up in Hong Kong. He came to the United States after high school and attended Augustana College, in Sioux Falls. After receiving a MFA in photography, with a minor in painting, from the University of Iowa, he joined the faculty of the School of Architecture at Clemson University in 1966. There, he taught graduate and undergraduate photography and "art with computer," and helped initiate the MFA-DPA program that prepared students for the animation industry. In 2006, Wang retired from Clemson as an Alumni Distinguished Professor of Art.

Wang's art utilizes many photographic techniques and processes, including photo-silkscreen, platinum/palladium, gum bichromate, pinhole and "zoneplate," and digital imaging. He has taught workshops in photography and digital imaging at the Penland School of Crafts, University of Oregon, Notre Dame University, Appalachian Environmental Arts Center, and Nanjing Arts Institute, among others. His work is in the collection of numerous museums and educational institutions nationally.

Cecil Williams

Based in Orangeburg, South Carolina, Cecil Williams is a professional photographer. He started taking pictures at nine; by fifteen, he was a freelance photographer for *JET* magazine. Currently, Williams operates a photography and videography publishing business, while working as the Claflin University yearbook and university photographer. He is the author of three books, primarily based upon his experiences as a civil rights photographer. With a comprehensive photographic collection of the civil rights era appearing in 126 books, seventeen newspapers, and eleven television documentaries, Cecil Williams's photographs have perpetually preserved the African American experience throughout the second half of the twentieth century.

Afterword

Paul E. Matheny, III

Chief Curator of Art
South Carolina State Museum
Columbia, South Carolina

A century and a half ago, some American Indians believed that the camera had the ability to steal a person's soul. It must have seemed magical, when photography was first introduced, to see someone's image emerge on a blank piece of paper. In this century, the twenty-four photographers included in the *Palmetto Portraits Project* have performed their own creative magic to capture the soul of our state. Children and families, health-care and factory workers, farmers, religious leaders, performing and visual artists, and other community icons reflect the true human diversity that exists in South Carolina. All of these individuals and more are represented in this collection of exceptional photographs.

Since 2006, the South Carolina State Museum has served as a member of the selection committee of the Medical University of South Carolina's *Palmetto Portraits Project*. This four-year endeavor documented more than two hundred sixty individuals at work and at play across the state. When the university first contacted the museum about the project, I was reminded of the images in our collection taken by photographers working for the Farm Securities Administration (FSA) in South Carolina. This special commission was established in 1937 as part of President Franklin Roosevelt's New Deal, his attempt to ease the pain of the Great Depression that followed the 1929 stock-market crash. At least four photographers working with the FSA visited South Carolina, spending a considerable amount of time here between 1936 (pre-FSA) and 1943.

The FSA documented individuals in a specific place and time and recorded the stories and images of Americans, including South Carolinians, during a pivotal period of change. The *Palmetto Portraits Project* bears striking similarities to that time. Our contemporary photographers have captured brief moments, both digitally and on film, that preserve them, potentially, forever. The photographs embody the essence, if not the soul, of the subjects, and stimulate the imagination of the viewer, much like the FSA images. These recent depictions of South Carolinians do not reflect the same sense of struggle found in the earlier, much more desperate FSA images from across the United States; they capture the community and culture that emerged from those earlier challenges and look at them a few generations later.

Originally, MUSC's project was conceived to create photo-based works of art to fill space on institution walls and act as reminders to both students and educators about whom they serve in their immediate community. When the project began in 2006, however, no one could have predicted that the country would, once again, be facing widespread financial challenges and periods of great change, thus forging another parallel between the FSA and the *Palmetto Portraits Project*.

Our photographers have preserved images of South Carolinians in their daily routines. Some of the images depict business owners and workers living in small communities and in situations that potentially could disappear in an instant. Sweetgrass-basket makers, cast-net makers, hatmakers, blues and jazz musicians, oystermen, crabbers, shrimpers, and other local tradition-bearers have faced more than their share of challenges for survival in recent years. Now, their images and rich history have been preserved for posterity.

Some of the participating artists do not consider their work to be closely connected to documentary photography or photojournalism but, rather, look at their subjects strictly through the purity of the portrait. These images are not about the documented story of the person in the portrait but the relationship of the photographer to the sitter. The purpose is to create a striking image. In the twenty-first century, the portrait-making medium has exchanged oil paint and brushes for lenses and pixels. Some of these photographers have approached this assignment much like a nineteenth-century portrait painter may have done, to capture—simply and beautifully—someone's likeness.

It is easy to generalize the identity of a state and forget the details of individuals and their contributions that create the culture of "who we are." The *Palmetto Portraits Project*—through the vision of the photographers who were familiar with, and comfortable within, the state's varied communities—gained access to people and stories that could easily have slipped through our consciousness and become lost.

The South Carolina State Museum has been given the opportunity to care for a complete collection of the photographs. These important works of art will be exhibited and preserved for future generations in our permanent collection, so that the images and stories of these people can be appreciated and studied years from now.

The South Carolina State Museum is grateful to the Medical University for trusting us with this responsibility, and also to the Halsey Institute at the College of Charleston, which was greatly involved in making the project a reality. We look forward to exhibiting this collection in its entirety for the first time, in April 2010, and, beginning in 2011, traveling the exhibition across the state.

It will be interesting to see what these images reflect when they are viewed again in the future, and what we will learn from—and how we will be inspired by—the soul of a state that has been visually captured by the *Palmetto Portraits Project*.

(P. 173) Joseph Nelson, 2009. Johns Island, SC.
Photographer: Chris M. Rogers

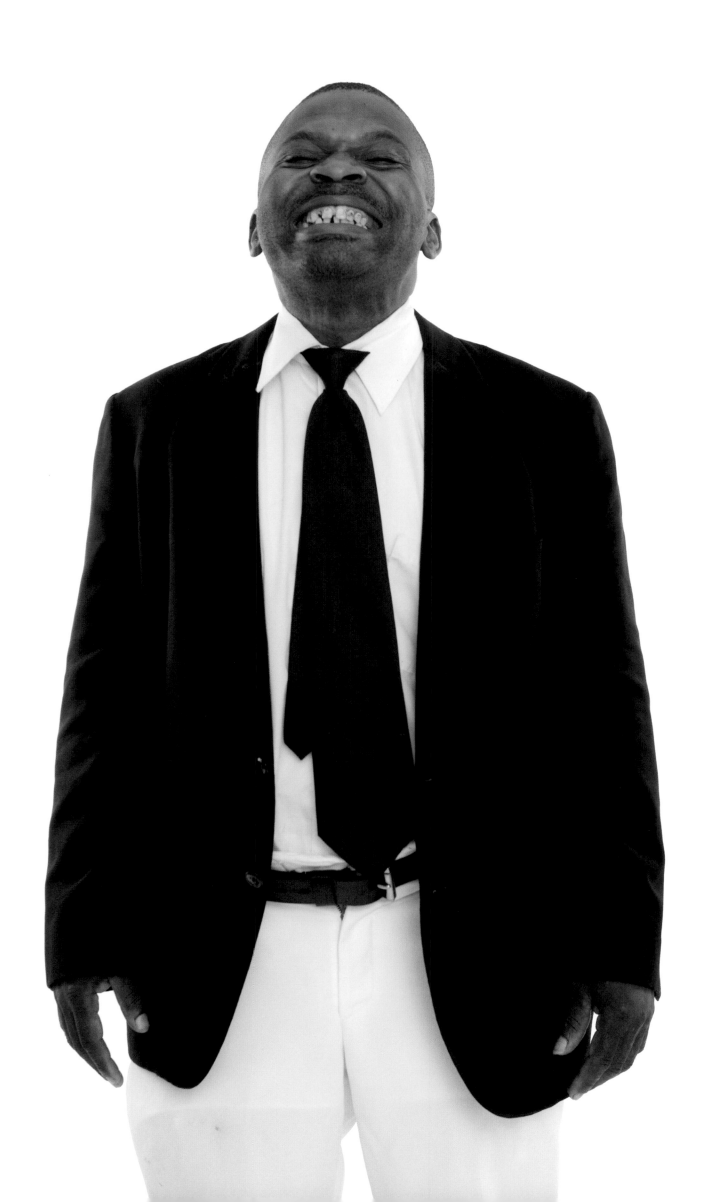

Acknowledgments

On behalf of all of the project participants, I extend a special thank you to Leslie Kendall of MUSC. We owe a great debt to her organizational skills, patience, and generosity of spirit. She was the liaison between the Halsey Institute and MUSC, as well as the public face for the photographers at the selection events. Leslie made certain we were well organized, well hydrated, and well fed. And with grace and aplomb, she efficiently and competently produced all of the printed brochures for each year's iteration. We also wish to acknowledge the participation of Allen Creighton and FUJIFILM Manufacturing U.S.A., Inc. Their financial contribution, as well as gifts from Bev and Wally Seinsheimer and several anonymous donors, has made this catalogue possible.

We wish to thank the original members of MUSC's Art Committee: Jack Alterman, Nicholas Drake, Brie Dunn, Leah Greenberg, Ray Greenberg, Leslie Kendall, Paul Matheny, Susan Romaine, Sally Smith, Jack Thomas, Kathy Turrisi, Michelle Van Parys, and Ashley Watamura. Although not all of these individuals were directly involved with the *Palmetto Portraits Project*, the outcome would not have been as successful without their foresight and involvement.

Several individuals deserve recognition as catalysts in this four-year project—among them: Leah Greenberg for creating a nurturing and convivial atmosphere at each of the selection events, and for wise guidance during the entire project; Roberta Sokolitz, for assisting with the gathering and editing of all written materials; Majken Blackwell for design assistance with the PPP IV brochure; Rebecca Silberman for help in ways too diverse to chronicle here; and Buff Ross, our web designer extraordinaire, whose excellent website, palmettoportraits.musc.edu, will allow people throughout the world to learn about our efforts.

Kudos to Gil Shuler, Tina Garrett, and Mark Lawrence of Gil Shuler Graphic Design for their incredible commitment; not only has Mark Lawrence created an elegant, yet vital design for the catalogue but we greatly appreciate the group's ongoing contributions to our publications program at the Halsey Institute. We are also indebted to Anne Norris, the graphics intern at Halsey, for providing much needed coordination and facilitation for this publication. Patty Pettit and the printing staff of R. L. Bryan have served us beyond the reasonable call. We are proud of our South Carolina partners for bringing the project to such a beautiful conclusion with the publication of this book.

Thanks must go to Charles and Jackie Ailstock of Artizom Framing, in Charleston, for the outstanding archival framing of all the photographs on display at MUSC. I also offer my gratitude to committee members Jack Alterman and Michelle Van Parys; each helped shape this project in innumerable ways. Paul E. Matheny, III, chief curator of art for the South Carolina State Museum, shone as a true triple threat: He demonstrated an early and eager commitment to the concept on behalf of the state, contributed his considerable insights along the way, and organized the exhibition of the work at the museum. As the inspiration for this project, the students, faculty, and staff of the Medical University of South Carolina have helped us understand the ways in which these images can enrich an educational environment. A special statement of praise goes out to Ray and Leah Greenberg for their overall vision and steadfast encouragement to the individual photographers. This ambitious project might easily have remained a great idea that never got acted upon were it not for their fierce advocacy and commitment. Most important, the subjects and the respective photographers deserve a nod for their willingness to participate in something so much larger than themselves. Future generations will salute you.

Mark Sloan
Project Director

(P. 175) Clementine Ravenel, 2009. Johns Island, SC. **Photographer: Chris M. Rogers**

(P. 176 top) Bakari Sellers, SC State House Representative, 2009. Columbia, SC. **Photographer: Brett Flashnick**

(P. 176 bottom) William O. Holloway, 2004. Greenwood, SC. **Photographer: Jon Holloway**

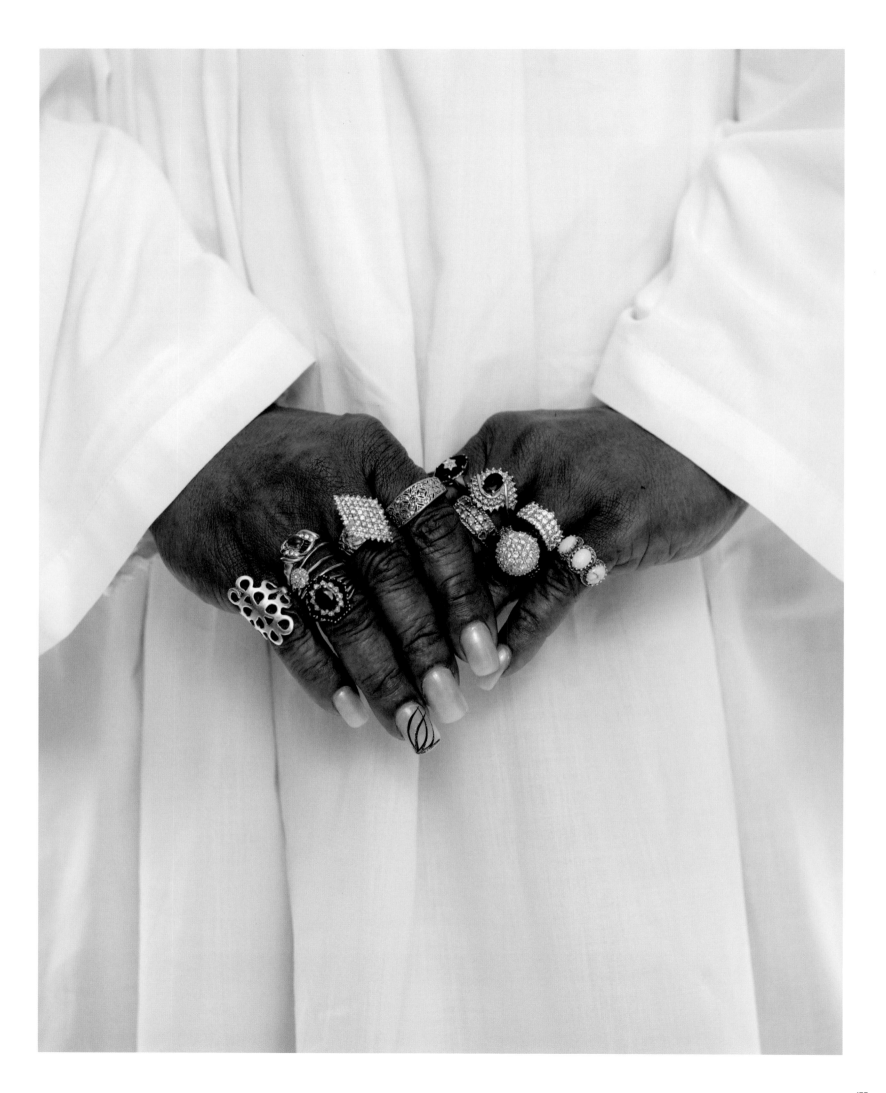

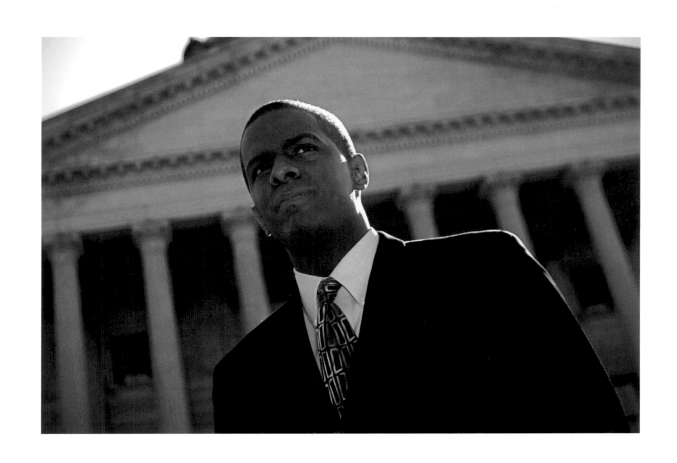

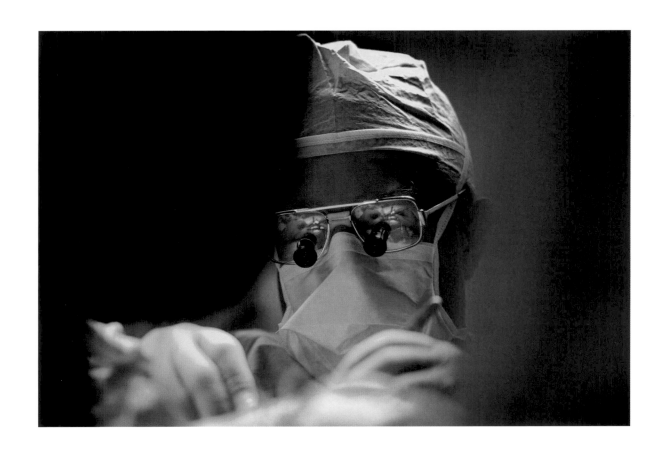